9KU [DOL]

R49397

THE
PAUL HAMLYN
LIBRARY

WITHDRAWN

DONATED BY
THE PAUL HAMLYN
FOUNDATION
TO THE
BRITISH MUSEUM

opened December 2000

Moved to Anthropology Library 2017

WITHDRAWN

D1645513

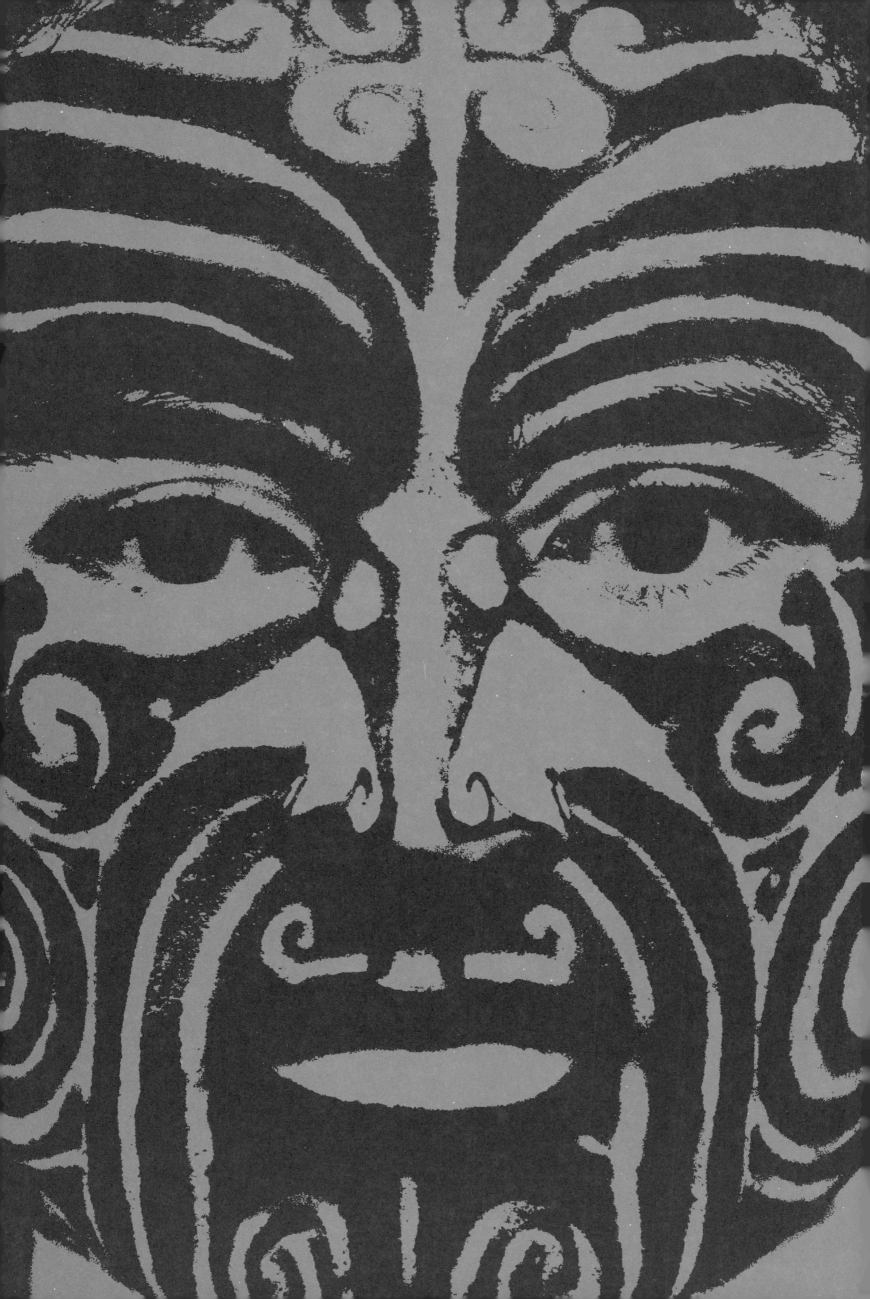

Tribes

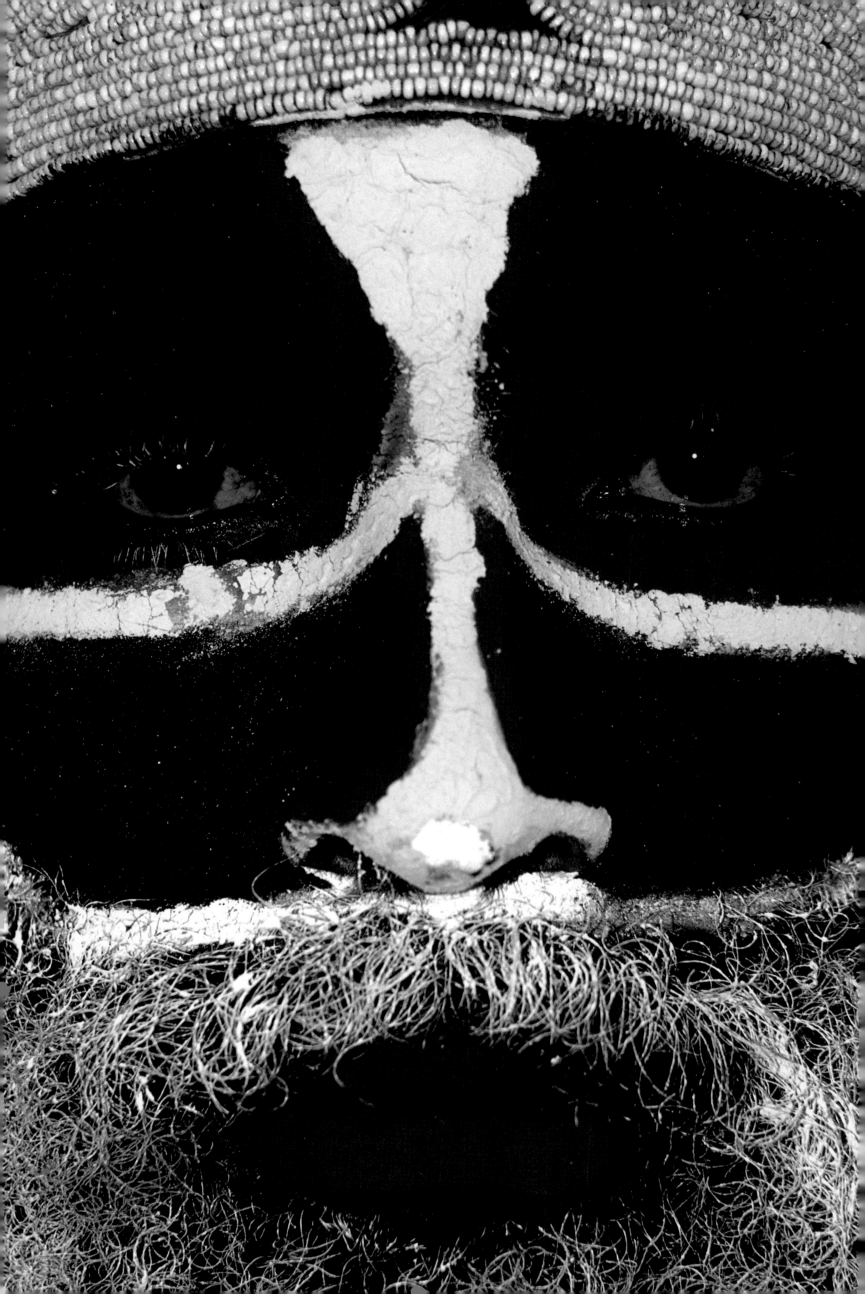

Tribes

BY ART WOLFE

with DEIRDRE SKILLMAN

Introduction by DAVID MAYBURY-LEWIS

Foreword by IMAN

THAMES AND HUDSON

REFERENCE ONLY M49297

In memory of Ellinor Wolfe

and

Joan Skillman

 THE BRITISH MUSEUM WITHDRAWN THE PAUL HAMLYN LIBRARY 306.08 WOL

First published in Great Britain in 1997 by Thames and Hudson Ltd, London

Copyright © 1997 by Art Wolfe

Any copy of this book issued by the publisher is sold subject to the condition that it shall not by way of trade or otherwise be lent, resold, hired out or otherwise circulated without the publisher's prior consent in any form of binding or cover other than that in which it is published and without a similar condition including these words being imposed on a subsequent purchaser

All Rights Reserved. No part of this publication may be reproduced or transmitted in any form or by any means, electronic or mechanical, including photocopy, recording or any other information storage and retrieval system, without prior permission in writing from the publisher

British Library Cataloguing-in-Publication Data
A catalogue record for this book is available from the British Library

ISBN 0-500-54215-5

Printed in Japan

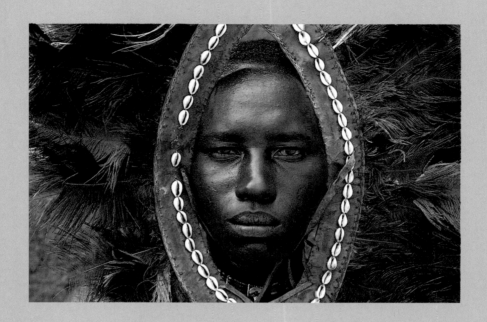

(*above*) MAASAI MORAN

(*frontispiece*) MENDI MAN

Contents

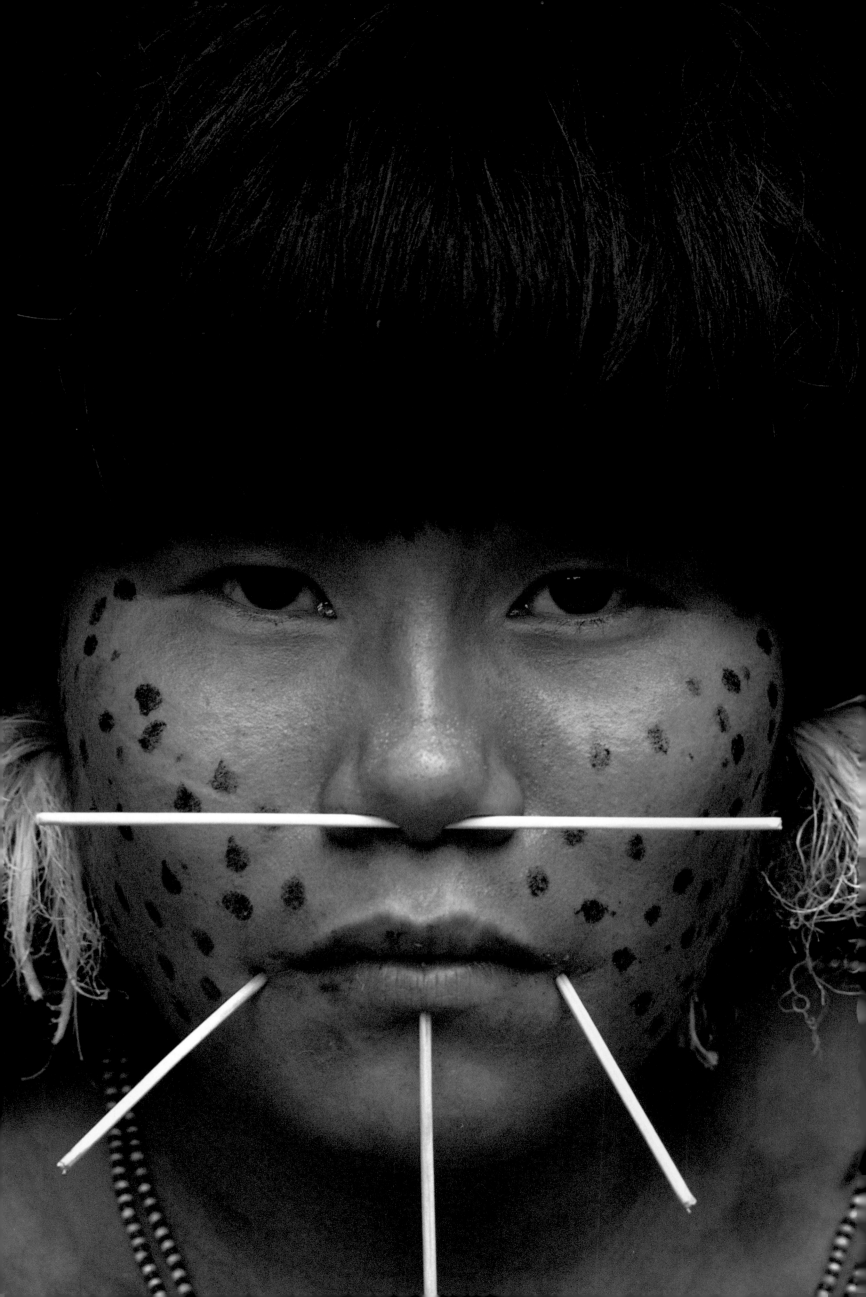

Acknowledgments

Sincerest thanks to the many people
who made *Tribes* possible:

Julian Kelly Alvarez

Mary Jane Anderson

Chief Aritana—President, KUARUP-Oganização
 Indígena do Xingu, Caixa Postal 81, Canarana,
 MT, 78640-000 Brazil, Tel/Fax 55 65 478 1855—
 Donations will be accepted for tribal projects
 within the Xingu Indian Park.

Simon Cabrera

Percy Casper

Frank Cullooyah

Scott "Gonzo" Gates

Dr. Omar Gonzáles—Dirección de Asuntos
 Indígenas, Ministerio de Educación, Venezuela

Dr. Herman Luis Soriano—Corporación de
 Turismo de Venezuela

Dr. Cesar Naranjo—CORPORTURISMO, Venezuela

Elena Colmenares—CORPORTURISMO, Venezuela

Logan Gillette

Luis Gorrín

George Hare

Dave Howard

Earl Hunter

Mike Jacobs & Cathy Schloeder

Juan Carlos Lopez

Ian Mackenzie

Polynesian Cultural Center, Oahu, Hawaii

Bob Red Elk

Ellen Reichsteiner

Timothy Riley

Rosita Roden

Shane Siatoga

George Small—Mpala Ranch/
 Smithsonian Research Center, Kenya

Gary Stolz

Greg Sutterlict

Tjapukai Dance Troupe, Australia

Albert Thomas

Laurie Thomas

Governor Elmer Torres—Pueblo de San
 Ildefonso, New Mexico

David Turton

Special recognition to the office staff at Art Wolfe, Inc.:

Mel Calvan Ray Pfortner

Christine Eckhoff Craig Scheak

Gavriel Jecan

A portion of the proceeds from *Tribes* is
being donated to Cultural Survival for
the benefit of indigenous peoples worldwide.

(opposite) YANOMAMÖ WOMAN

Photographer's Preface

LIKE MOST AMERICANS OF MY GENERATION, I grew up with the television. My family was the first on the block to acquire a small "black and white," and suddenly I had more friends than I knew what to do with. Besides providing a lesson in basic sociology, the television was a mesmerizing window to the world. I remember most fondly the travelogues—in particular the travels of Lowell Thomas. Each week Lowell took us along as he journeyed up uncharted rivers and across unmapped mountains, often visiting remote villages along the way. Sometimes native peoples emerged from dense jungles along the riverbanks, then suddenly disappeared— allowing us only the briefest of glimpses. Needless to say, I was glued to the set.

I hoped someday that I would be able to follow in Lowell's footsteps and travel to some of those exotic lands. Over three decades later, I have traveled far and frequently, visiting forty-six countries and seven continents.

In 1992 I was one of two principal photographers for a book supported by the United Nations and published by the Sierra Club entitled *Endangered Peoples*. The author, Art Davidson, addressed many issues confronting indigenous peoples throughout the world. He detailed how political indifference, land loss, and the lure of modern technology had combined to undermine the cultural integrity of many indigenous cultures.

While I traveled and photographed for *Endangered Peoples*, journeying into the highlands of New Guinea, across the savannas of Africa, and up the tributaries of the Amazon, I was intrigued by the spectacular varieties and yet uncanny similarities of the people I encountered. Specifically, I was drawn to the elaborate body adornment and ceremonial dress that these cultures have developed over untold millennia. Feathers, skins, leaves, bones, and natural pigments decorate the human form in such an elaborate

manner that they rival the most sophisticated couturiers. This flamboyant style and unparalleled pageantry became the inspiration for *Tribes*.

Body adornment as a subject for a book is hardly my own invention. I am forever indebted to Malcolm Kirk, whose *Man as Art* is a stunning record of New Guinea's Highland tribes, and Angela Fisher for her unsurpassed work in *Africa Adorned* and Carol Beckwith, who collaborated with Fisher on the magnificent portrayal of Africa's indigenous cultures in *African Ark*. *Tribes* is both a tribute to their work and a testament to the diversity of mankind.

Once I made the decision to devote myself to *Tribes*, I had to narrow the photographic approach, as I could be easily distracted by other aspects of tribal life. In order to maintain a coherent interpretation of the people I photographed, I decided upon a strictly aesthetic point of view, and settled upon three distinct perspectives. The first was the proverbial big picture: using wide angle lenses allowed me to take in ceremonial dances, promenades, and the individual within a landscape. The second was the macro view: getting up close and personal to detail ear-piercing, tattoos, and scarification. The third was the mid-range telephoto, decidedly the most useful and pleasing perspective.

It has often been said that the eyes are the windows to the soul. Certainly they are the first thing we notice when we meet someone, and often they become the barometer to which we respond. Eyes can frighten, comfort, and hypnotize. From a confusion of color and texture, the eyes leap forward to stare straight into those of the viewer. The connection is both immediate and, at times, quite unnerving.

The 80–200mm zoom lens truly defines *Tribes*. By narrowing in on a face, I was not only able to eliminate distracting elements, but I could accentuate the power and dignity of the subject. The subject's eyes often provide an unsettling challenge to the viewer, offering an intense truth in the gaze and therefore leading to a more compelling image. This approach seemed exceptionally appropriate for *Tribes*. While most photographers ascribe to the theory that candid portraits are best, I decided upon a different tack

because I wanted to heighten the tension between the subject and viewer. I deliberately sought the "in your face" approach.

The consistency with which I used the telephoto perspective has allowed me to present these different peoples in a more balanced way. By concentrating upon body adornment, I was able to highlight an individual's pride and dignity regardless of personal wealth or social stature. Acreage, houses, and possessions are not what *Tribes* is about. It is about equality and continuity and diversity. *Tribes* allows the viewer to fully appreciate the keen sense of self as well as place that indigenous people truly have.

It was surprising to me to discover that some of the tribes that had the least wealth displayed some of the most impressive adornment. The Kayapo, living in Brazil's Amazon Basin, have very little accumulated wealth. As hunter-gatherers and limited agriculturists, they must periodically relocate village sites in search of more productive areas. Since their largest domesticated animals are small dogs, they carry all their possessions themselves. The accumulation of personal objects, therefore, is not very prudent.

On ceremonial occasions, the Kayapo undergo an amazing transformation. They don headdresses of brilliantly hued macaw feathers and paint themselves in remarkable patterns with a startling red vegetable dye and sooty charcoal. The effect is dazzling, but equally important, they are not weighed down by elaborate costumes and cosmetic cases.

The Karo tribe inhabiting the remote, arid lands of southwestern Ethiopia also have very little accumulated wealth other than their herds. They too are often on the move, seeking better pasture for their cattle and goats. At first glance their grass huts, clustered upon the harsh, unforgiving landscape, would not be associated immediately with a decorative lifestyle. Yet the Karo are an extremely colorful people. Both men and women have wonderfully crafted hairstyles, replete with feathers, beads, and woven grasses. Ears are heavily pierced while arms and legs support many metal bands. On special occasions the entire tribe will paint themselves in beautiful designs using red, black, and white pigments made from local minerals. The Karo are indeed rich in cultural tradition.

While the Karo and Kayapo represent cultures that have remained for the most part both isolated and intact for countless generations, others have been absorbed into Western culture. The difficulty has been for these tribes, such as the Native American and Aboriginal, to maintain cultural traditions while leading modern lives.

It is important to understand that all the tribes portrayed in this book are our contemporaries, and like us, they have the ability to adapt, to succeed, and to fail, just as we do. The notion that isolating these peoples so that they will maintain their traditions in a pristine environment is a hopelessly romantic one. No place on earth is safe from the outside, and tribal peoples themselves hardly wish to be mired in a time warp. What they want most is to be able to adjust their lives in a manner most fitting with their traditions, yet be a part of the modern world.

In an era of accelerated change and the penetration into remote areas by an aggressive, industrialized world, it is inevitable that many of these cultures will lose their uniqueness, slipping into oblivion. Although *Tribes* touches on some of the problems confronting these peoples, I do not attempt to present it as an indictment of political and environmental degradation. Instead I aspire to document the triumph of spirit and creativity of mankind.

As I reflect upon all the miles and destinations behind me, this indelible image stands out. Deep in the Xingu Indian Park of Brazil dwell the Kamayura. Their village is near the park's headquarters, where I set up a tent. One night as I prepared for bed, I noticed a bluish light reflecting upon the rainforest trees shadowing the buildings. Upon closer inspection I discovered that the light's source was a small black and white television hooked up to a generator. Half a dozen Kamayura children were peering through the screened window, watching a Brazilian soap opera. Needless to say, they were glued to the set. The moment was startling, the irony haunting.

Art Wolfe
SEATTLE, WASHINGTON, 1997

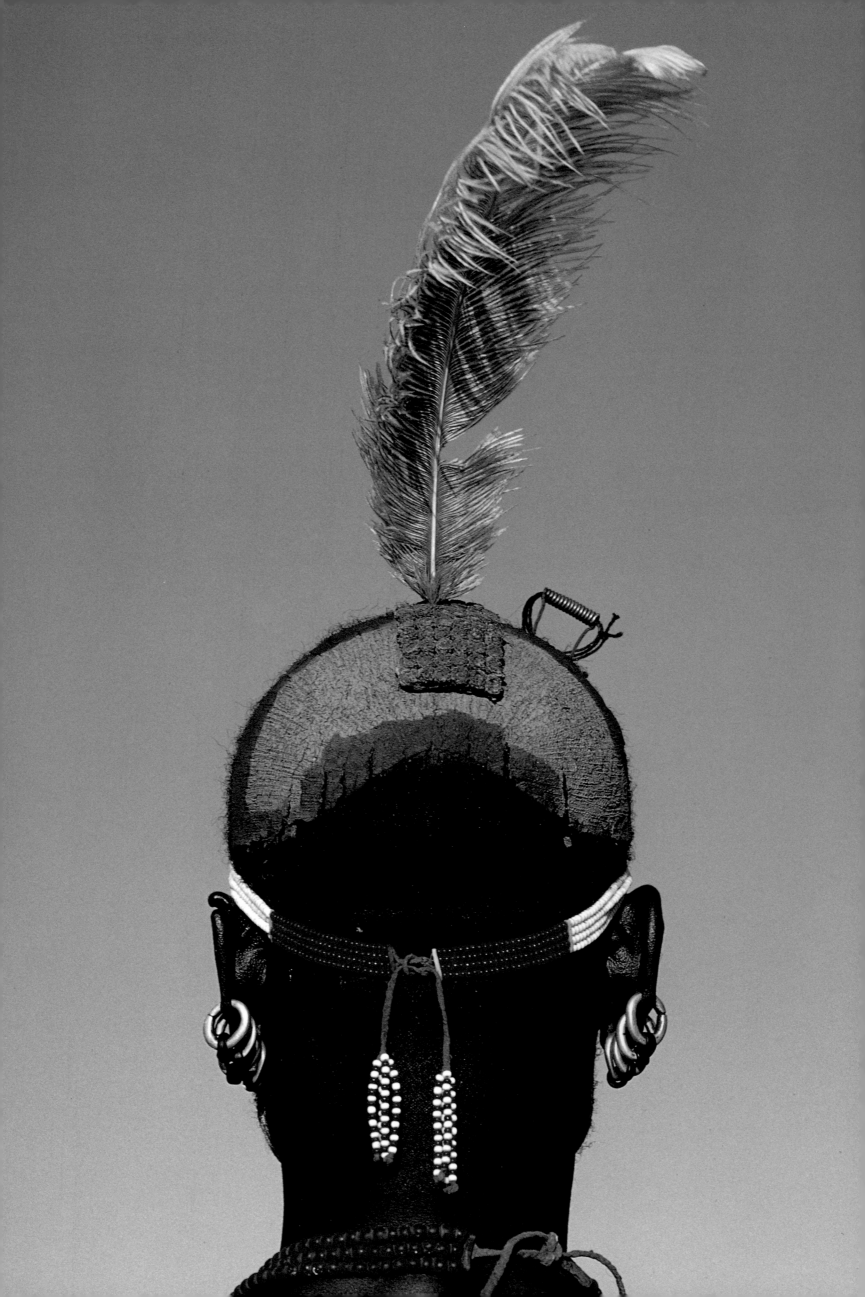

Introduction

BY DAVID MAYBURY-LEWIS

Cultural Survival and Harvard University

IN THE BEGINNING we were all tribal. Human beings lived in relatively small groups that fed themselves by hunting and gathering. Later, when the emergence of major civilizations enabled larger settled populations to live in and around towns and cities, tribal peoples were those on the peripheries. They were marginal, seen from the condescending viewpoint of those at the centers of civilization, but they were not always weak. The Germanic tribes challenged and eventually destroyed the Roman empire. The Mongols posed a constant threat to China, one that even the Great Wall was incapable of repelling. It was the development of modern, industrial civilization that drastically changed the balance of power. As early as the sixteenth century, small groups of Spanish soldiers, with their cannon, their superior swords, their armor and their mounted knights found they could defeat much larger numbers of Indians and carve out a vast empire in the Americas for their king. By the nineteenth century this modern, industrial civilization gave such advantage to those who enjoyed it that they could and did conquer much of the world. This was not merely a military conquest, though it was that. More important, industrial civilization has taken over the world of the late twentieth century affecting the attitudes and the lives of all who live on this planet.

Yet, as always, there are peoples who are marginal to the process. They are the modern tribes. They certainly appreciate the benefits of manufactured goods, but not enough to want to enter the industrial economy. They know all too well the power of the state, yet they struggle to retain as much of their autonomy as they can. Most of all, they prize their ways of life and the sense of identity that these provide. It is perhaps this quality, above all else, that makes them fascinating to those of us who venture out from time to time and briefly share their lives. These are people whose ways of life remind us of alternative possibilities, of roads not taken in our own corners of the industrial world.

(opposite) KARO MAN

Our industrial civilization was born out of the creativity of the Renaissance, with its scientific advances and its hitherto unheard-of emphasis on the rights and dignity of the individual. It has brought us power over nature and material well-being such as could hardly be imagined two centuries ago. But we have paid a price for these achievements. We have moved from a world of personal relationships to one in which impersonality is the order of the day; from a world in which people mattered to a world in which they are expendable; from a world preoccupied with the nature of society to a world preoccupied with the workings of the economy. This whole process of modernization has so completely defined our world that it is difficult for most of us to imagine what life would be like if we could step outside of it. Yet that is precisely what we do when we visit tribal peoples. They are not only those least affected by the modernization that defines our lives, but often enough they reject the values on which our powerful civilization is based.

Tribal peoples pay a heavy price for standing aside. They have been, and all too often still are, despised as savages who ought to be eliminated lest they impede the "progress" of our all-consuming civilization. That meant they could be deprived of their lands and their livelihoods and massacred if they attempted to resist. Nowadays such genocidal policies are no longer politically correct (though they are still practiced in some places). Yet it is still generally assumed that tribal societies "stand in the way of development," which in the modern world is considered by most governments to be somewhere between a sin and a crime. For example, people who practice swidden agriculture are regularly accused of impoverishing the soil of their homeland. Yet this technique of burning off the vegetation and planting gardens in the areas cleared, then moving on (often round in a circle) to repeat the process elsewhere, is one that lets the soil rest. The soils become exhausted only when settlers crowd in on the swidden agriculturalists and force them to restrict the radius of their rotation. Similarly, nomadic herders are regularly accused of creating deserts through overgrazing, despite the fact that they have developed their way of life over centuries precisely as a sustainable adaptation to semidesert conditions. Real desertification sets in only when settlers press in on the nomads and force them into smaller and smaller grazing areas.

Such accusations are mere rationalizations. The main reason why the modern world resents

tribal peoples is because they are there, because they are in the way. They are in the way of land-grabbers, mining interests, ranchers and settlers. They are in the way of those grandiose development projects that flood people's lands or destroy the environment with the excuse that this will benefit others elsewhere. Above all, they are in the way because they are thought to undermine the state—whichever state they find themselves—because of their struggle to maintain their own ways of life. A state that permits them to do so tolerates a certain cultural pluralism within its midst, and many modern states refuse to do that.

So, who are these people who insist on marching to their own drum, even if that means being left behind by—or worse, still being crushed by—our modern industrial civilization? That is what this book shows us. Art Wolfe's suberb portraits enable us to empathize with individuals who look back at us with a confidence that is all the more remarkable when we know what they have experienced. These men and women, living in circumstances we would find uncomfortable, bounded by horizons we might consider narrow, whose ways of life are under perpetual threat, nevertheless seem to know who they are and to be comfortable in that knowledge. Their aesthetic flair is obvious. So too is the individuality of the people in the photographs. They may live in societies which take the common good more seriously than we do and in which, for better or worse, people are forever enmeshed in a complex weave of rights and obligations. They may live in societies more respectful of tradition than ours. Yet these individuals are not slaves to custom nor are they swallowed up in the collectivity. Their strong personalities stand out. These are people who know our civilization and have learned to cope with it, but who are not overly impressed by it. When we share their lives, however briefly, they lead us to reflect upon our own.

Foreword

by Iman

THE POPULATION of my native country, Somalia, does not include people who practice body ornamentation comparable to what Art Wolfe spectacularly presents here in *Tribes*. Nevertheless, being an African and from the same continent as many of the book's subjects, I am compelled by pride to offer a few words of respect.

Tribes is an invaluable contribution to both readers and connoisseurs of fine photography for reasons well beyond the fact that the book is a collection of portraits as exceptional as it is beautiful. The real value of *Tribes* is its ability to satisfy the delicate challenge of brushing aside the veil that obscures the book's subjects from the modern world without appearing to treat them as primitive curiosities.

When I arrived in the United States in 1972, simply being from Somalia was enough to generate rumors regarding my "discovery" that were as fantastic as they were absurd. According to some, I was discovered herding goats across the Horn of Africa. According to others, I was a Somali princess who had dwelled in splendor, albeit buried amidst the darkest corners of Somalia. In reality, I was a political science student at the University of Nairobi, in Kenya. It was the shepherdess and the princess stories, however, that the press printed and not the political science truth. Africa has always been one of the "civilized" world's favorite places on which to project imaginary fantasies.

Having worked as a model in the fashion industry for sixteen years, I was in constant interaction with the same magical element of life that inspires each photo in *Tribes*: the expression of individuality. One of the chief ingredients of any fashion show or fashion sitting is the art of makeup; it is as essential as the clothing. When I was still modeling, it was not at all unusual to have my makeup done six or seven times in one day. Depending upon the mood the designer wished to convey, my personality metamorphosed with each stroke of the makeup artist's brush.

It is wonderful, then, to acknowledge that from the runway of a haute couture designer to a tribe in the depths of the Brazilian rainforest, we all share in common a basic human desire to present ourselves as something beyond what we are. Our worldly conditions may differ dramatically, but as human beings we are comprised of stock impulses, no matter our society's level of industrial evolution.

It is not possible to examine *Tribes* without being struck by the deep beauty of the body makeup and elaborate ornamentation. Behind this fantastic ornamentation exist the people themselves, and it is from here that each portrait receives its power. Body decoration enables each person to present a wholly unique persona specifically created to express both individuality and group unity. By incorporating both fanciful and mundane elements from everyday life, *Tribes* identifies the universal desire to imbue ourselves with more than what we are born with. There is little difference between the Huli man's brilliant headdress and the Western man who wears a favorite blue polo shirt, except, of course, that the Huli man is showcasing a work of art of the highest form of self-expression.

Ironically, indigenous people who ostensibly have so little express far more than the rest of us could ever hope to with our Western ornamentation. Compared to the elaborate beading and intricate coloring and painting of *Tribes*'s Panga man, how effective are our Western means for expressing ourselves? We limit our self-expression to what is retailed on the department store garment rack or makeup counter.

In the end, *Tribes* is remarkable for its ability to remind us that, miraculously, indigenous people still exist. It seems that with each step technology takes, individuals are further and further separated from the community and placed instead in an isolated world of their own, governed by any number of technological devices. *Tribes* is a valuable reminder of the power and wonder of both the individual and the community, as well as a testimony to the significance of symbols in societies around the globe, symbols that personify our membership in our community and the world at large.

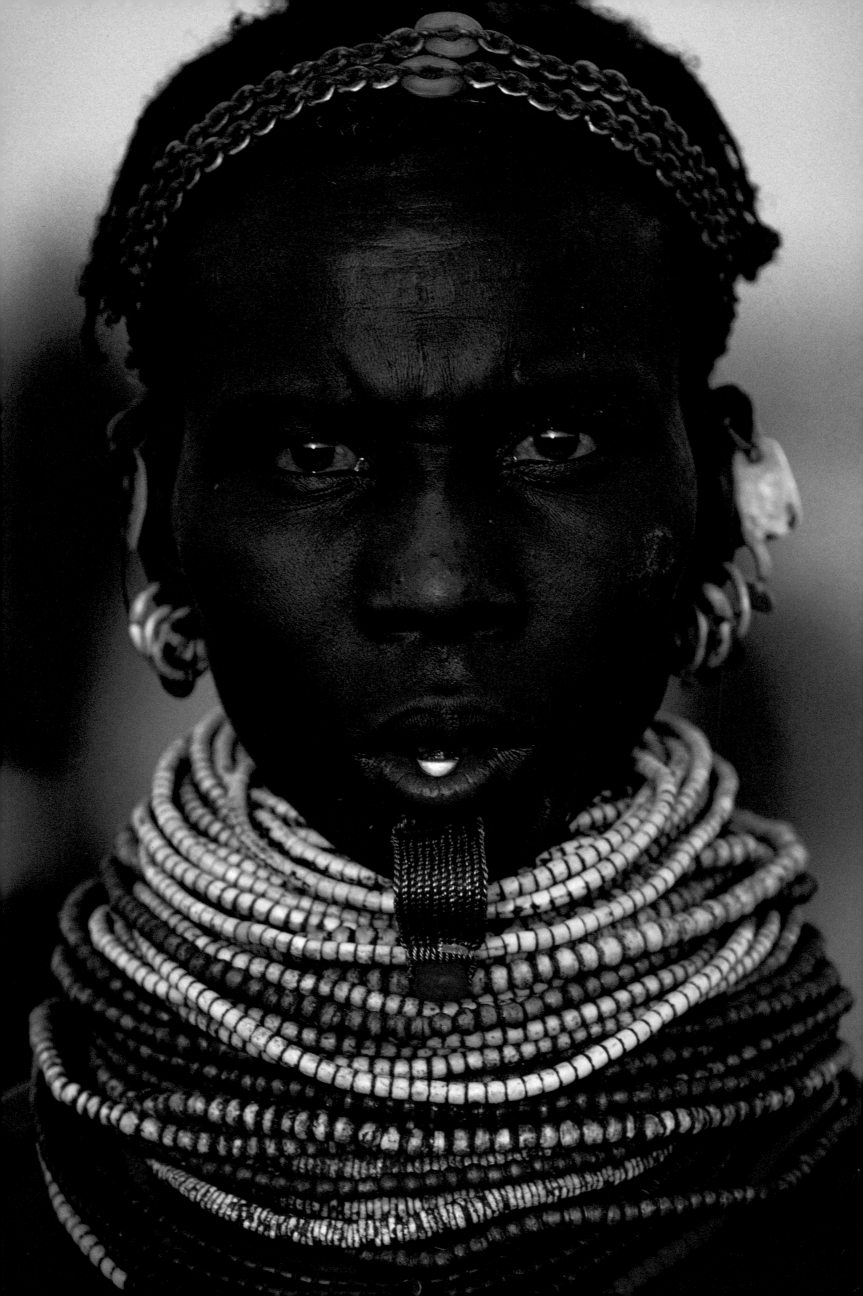

Tribes of the Lower Omo River

ETHIOPIA

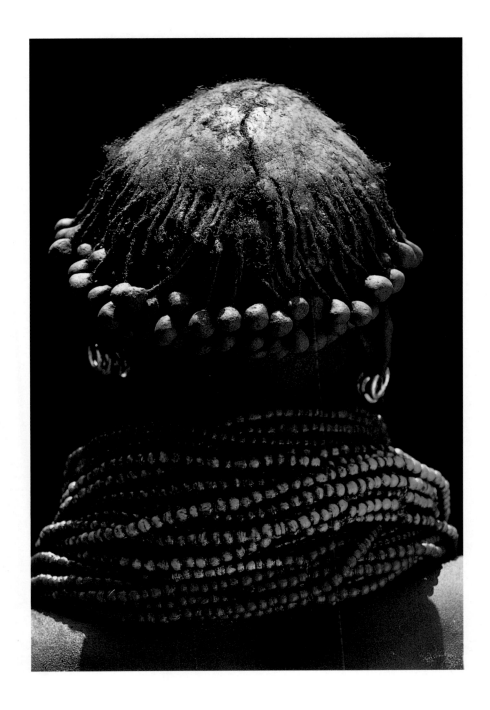

(opposite and above) BUMI WOMAN

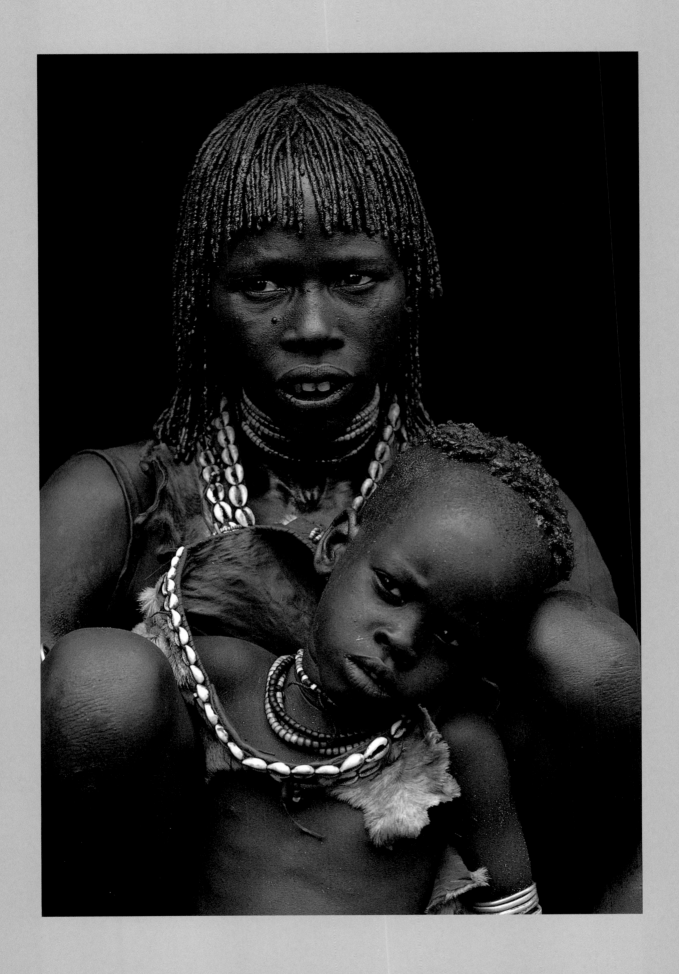

HAMAR WOMAN AND CHILD

(opposite) SURMA MEN AND CHILD

(page 28) KARO MALE BODY PAINTING

(page 29) KARO MAN

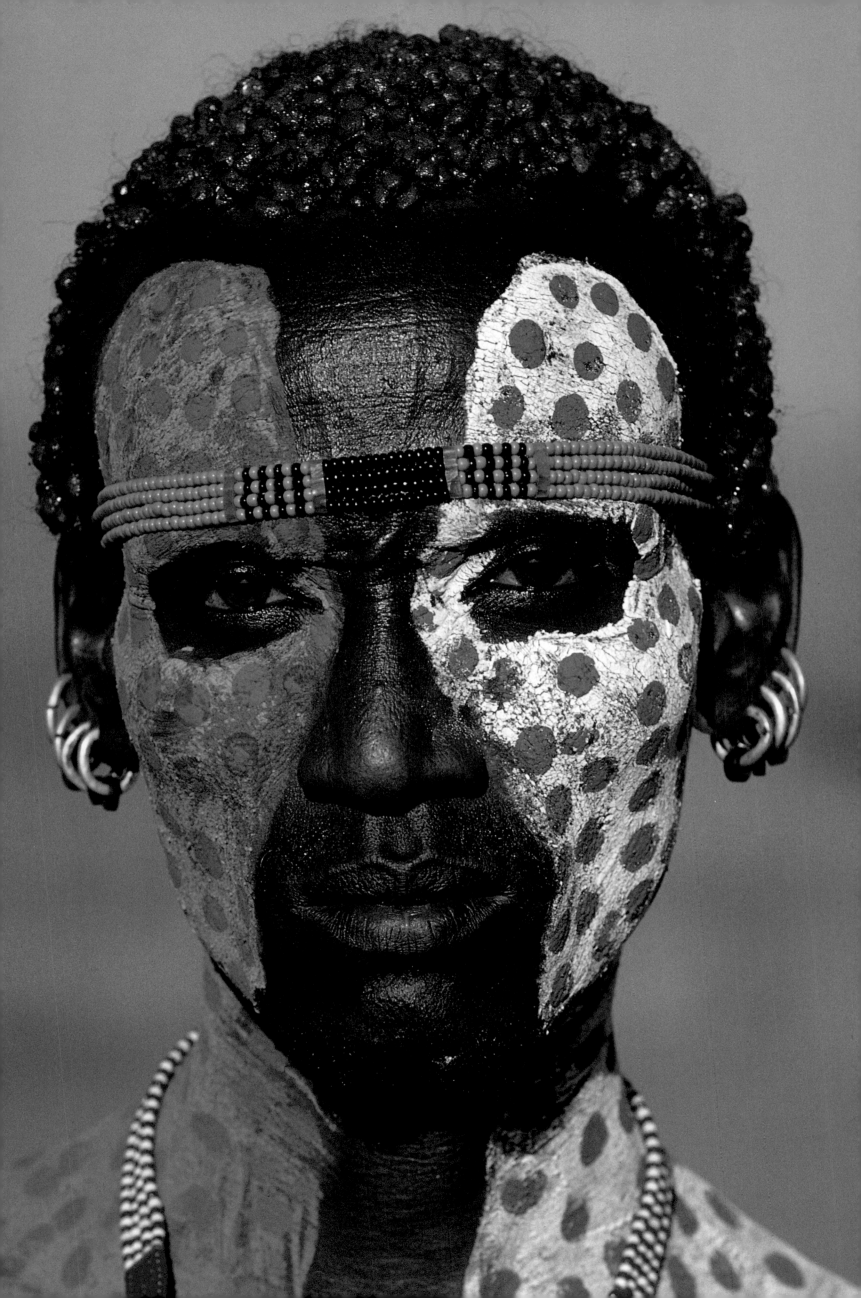

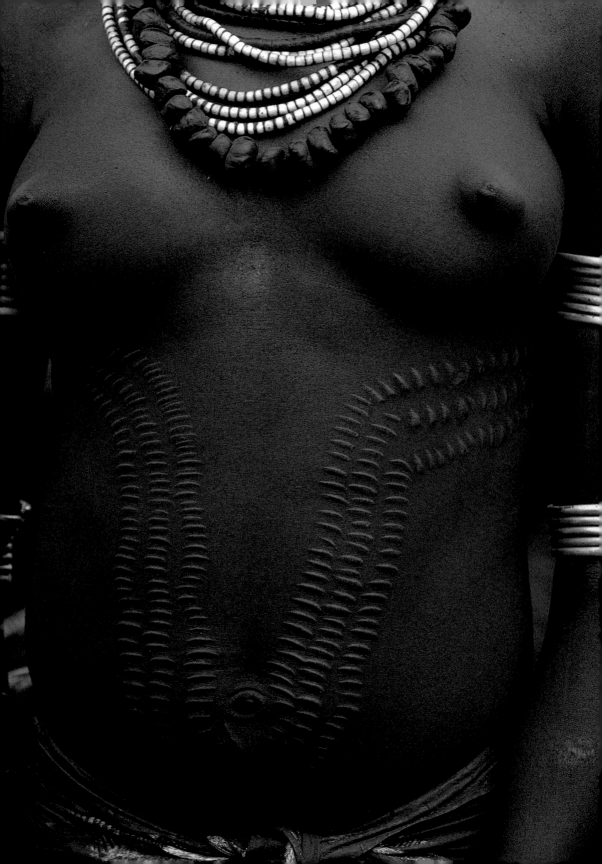

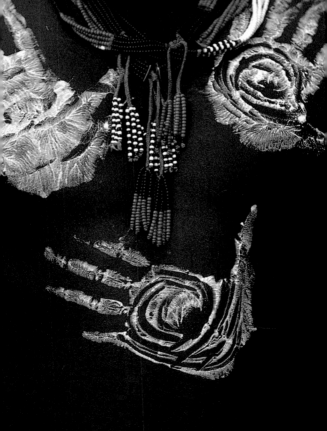

(top and bottom) KARO MALE BODY PAINTING

(page 32) KARO WOMAN

(page 33) KARO MAN

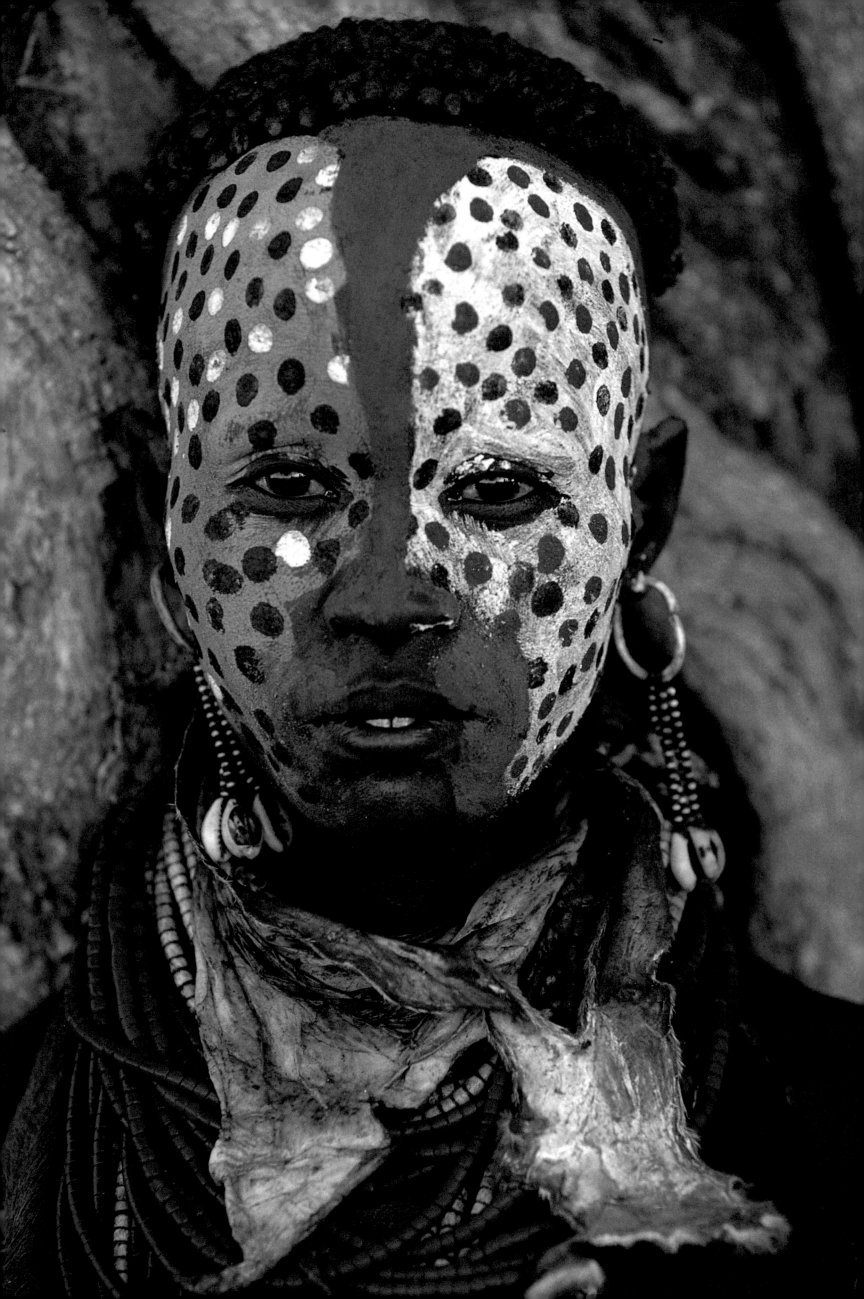

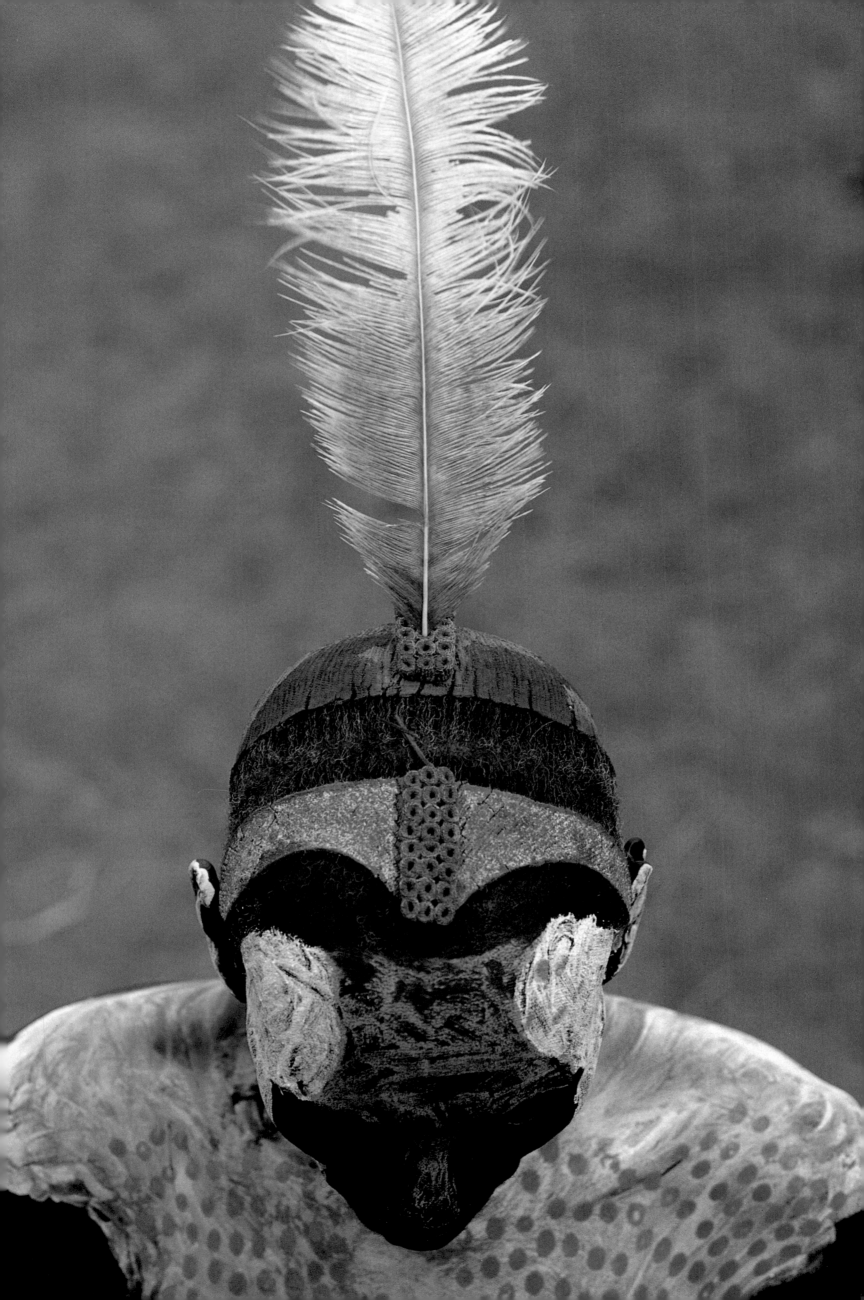

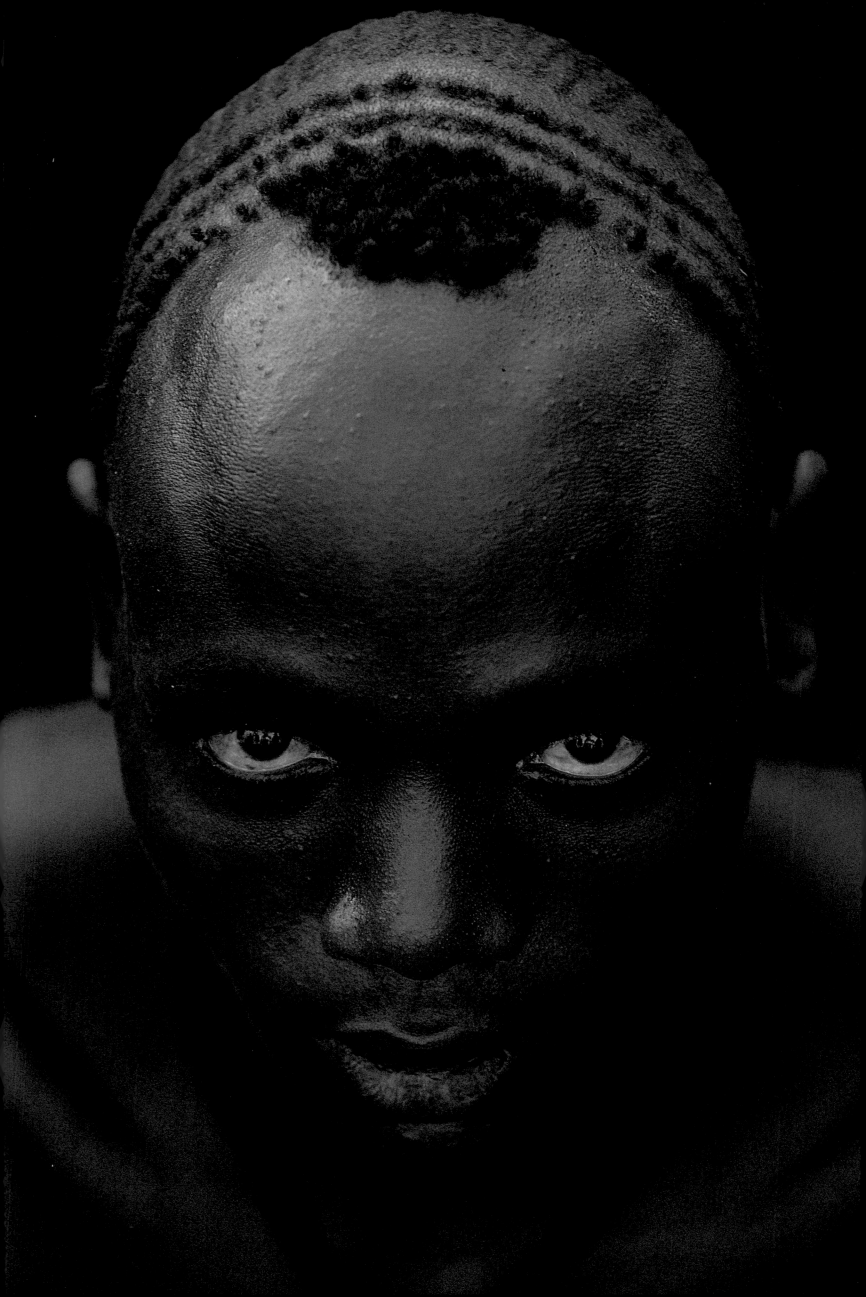

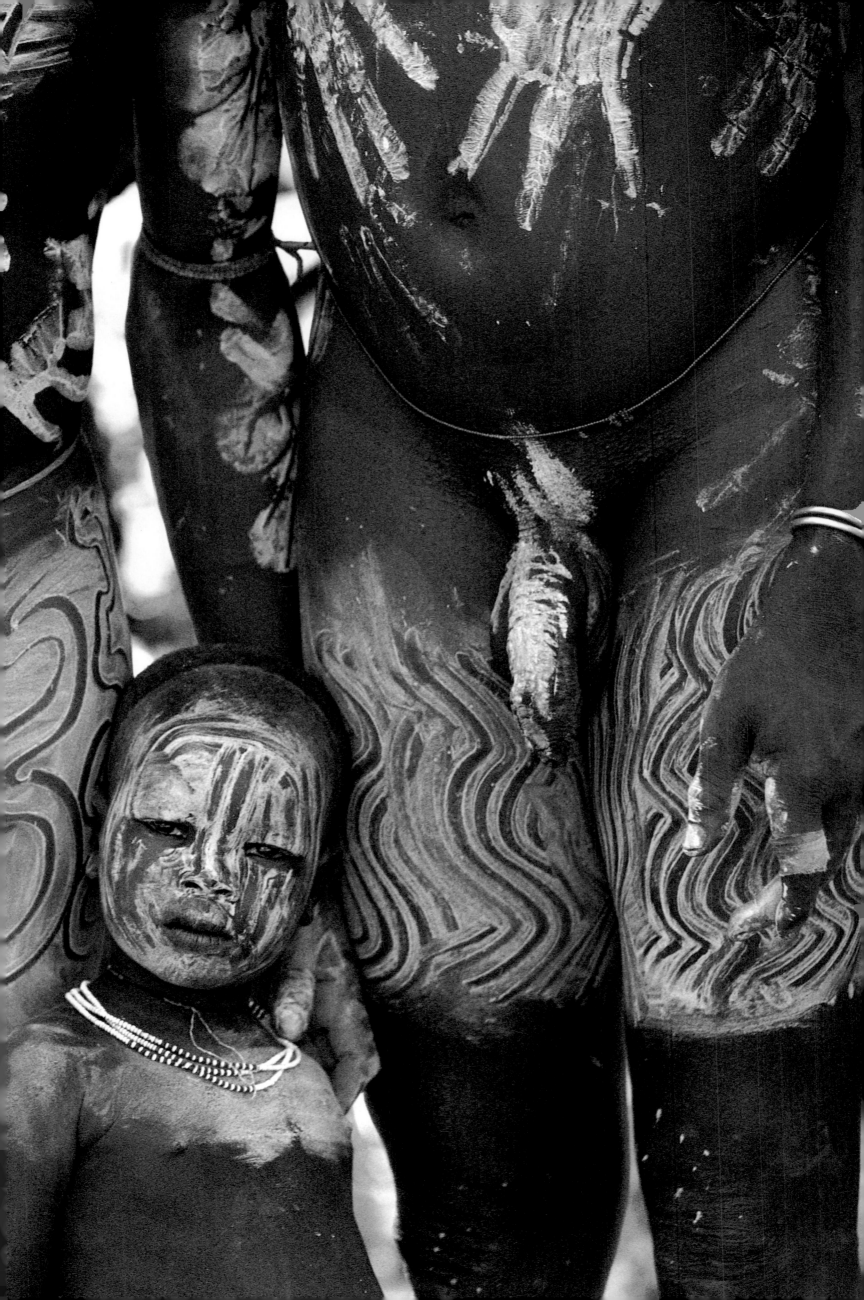

I N THE FIFTH CENTURY B.C., Herodotus wrote that the Ethiopians were the "tallest and best-looking people in the world." Although he had a narrow scope of the world, his words carry an element of truth to this day.

The various Nilotic tribes (a classification of people living in the environs of the River Nile) inhabiting the Omo River region are among the most fascinating in the world. They are seminomadic pastoralists, and their herds of cattle and goats are the focus of their lives. Internecine warfare is rife among them: if you are a Karo and you cross to the Bumi side of the Omo River, you will be killed, and vice versa. The weapon of choice once was the spear, but now they often carry AK-47s, or antiquated rifles for the less fortunate. They bear the weapons with an undeniable, if frightening, flair. Their violent existences are further heightened by some of the most flamboyant body painting and scarification practiced anywhere. In a region marked by bloody conflict and meager pastoralism, their bodies become the canvas of their self-expression.

The Omo and Mago National Parks have been established as the Ethiopian versions of the popular parks of Kenya and Tanzania. Like the Maasai of the Serengeti, the tribes of the Omo River have found themselves at odds with those who wish to relocate them from tribal lands. However, pastoralists and wildlife have coexisted for thousands of years, and to displace the indigenous peoples causes only more trouble and misery. A more positive approach, advocated by two Wildlife Conservation Society biologists I met in the Omo, is to directly involve the tribes in the conservation of the parklands.

At night we camped within a couple miles of each village. In the morning we had great difficulty entering a village because everyone would gather about us, wanting to have their pictures taken. Finally, we would just have them assemble so I could photograph them en masse and relieve any concern that anyone would be excluded. They were all so proud of their appearances, and the spirit of one-upmanship prevailed.

In comparison with other shoots I undertook for this book, filming the Omotic tribes was infinitely simpler and less pressured; I was not faced with the prospect of photographing dozens of tribes in mere hours, such as at a Native American powwow or a Papuan singsing. While it was certainly not all leisure in Ethiopia, I was better able to concentrate on single subjects, and I could recharge both physically and mentally between villages.

The Bumi

Bearing their scars with pride, the Bumi will engage any tribe in battle to defend their prized riverfront property; they will cross the Omo to harass the Hamar and Karo, and even go north to raid the Mursi whenever they can. Injuries are a testament to clashes survived, which is no small feat. The Bumi seemed to be the most heavily armed—with Kalashnikovs—because they have interacted the most with the Sudanese Liberation Front.

Scarification establishes tribal identity within the Bumi and enhances their physical appearance. Both sexes highlight their eyes and cheekbones with fine *pointilles*, and the women beautify their torsos with raised scars in organic and geometric designs, which hold sensual appeal for the men. Some patterns resemble scorpions, while others are linear, emphasizing the torso and encircling the waist. The extensive scarification of the men attests to the high degree of hostility throughout the region. Only after they have killed an enemy do they undergo the ordeal.

To achieve the desired knobby welts, the skin is cut with a hook or, much preferred, a razor blade, and rubbed with ash to create a small infection in each wound. The infection will enhance scar tissue growth, and once the skin heals, it will be permanently raised.

The Hamar

It is an understatement to say that most Hamar men and women are extremely aware of their looks. They paint their bodies with ochre (impure iron ore), and ornament themselves with skins, strings of beads, and shells. The women wear thick coils of iron on their arms and heavy iron torques, called *esente*, around their necks. Esente are engagement presents and are indicative of a future husband's wealth.

Hair grooming is very important. Women roll their locks with fat and ochre and twist them into individual strands, a style that is attractive to the opposite sex. For men, however, the styling signifies status, bravery, and courage. Clay buns plastered directly on the head are worn only by men who have killed an enemy, such as a neighboring Karo or a dangerous animal like a large cat. Remade every three to six months, the buns are worn up to a year after the kill. Earrings, too, are significant as they indicate the number of wives a man has. The Hamar men are also noted for their elaborate, fanlike hairstyles, which are

braided and decorated with ostrich feathers. The hair is instrumental in the social lives of the Hamar: when a man dances, he cocks his head at a woman, and she flicks her hair at him.

The Karo

The Karo are perhaps the poorest and most endangered of the tribes of the Omo River. At first glance, their domed grass huts clustered upon the arid, unforgiving landscape would not be associated with lively decoration. Yet the Karo are one of the most colorful of a region full of colorful peoples. It seems as if they incorporate all the style elements practiced by the Omotic peoples into their own glorious cosmetology.

Both the men and women have marvelously crafted hairstyles, replete with feathers, beads, and ochre. The clay buns of the men are similar to those of the Hamar, making it difficult to differentiate between the headpieces of the two tribes. Special macrame feather holders are seated in the clay buns for ceremonial decoration. The ostrich plumes most prized by the men are a sign of bravery. Women cut their hair short, roll it with ochre and fat, and shave their hairlines so it appears they are wearing closefitting caps. Also in common with the Hamar, the Karo heavily pierce their ears and coil their arms with tight spirals of metal.

On special occasions every tribe member is painted with striking designs using rusty red pulverized ochre, black charcoal, yellow mineral rock, and white chalk. First a base coat is applied to the body, which is then decorated with spots to imitate the graphic feathers of the guinea fowl or the fur of the leopard. Dots or hand prints can be applied on bare skin as well. Tribes from around the world use the hand motif. It is one of the most ancient signatures of the artist.

Like the Bumi, the Karo use scarification as both a beauty accent and a badge of courage. The women scar their torsos to accent the curves of the body and to give alluring texture to the skin. However, if a man's trunk is scarred it means he has murdered a foe; if he is scarred on a shoulder, it signifies he has killed specifically an enemy woman.

The Karo are fearless when it comes to incorporating modern elements into their traditional adornment. Observing closely, one can discern nails used as lip ornaments and pen caps as necklace bangles, so heavily ochred they become unrecognizable.

The Mursi and Surma

The Mursi and Surma are not only close neighbors, but they are on neighborly terms, an anomaly in the Lower Omo. What instantly identifies these two tribes is the distinctive lip plate worn by the women. Six months prior to marriage a woman's lip is pierced by her kinswomen and progressively stretched over a year's time to accommodate the plate. Two incisors are pulled so the plate fits securely against the lower teeth. Women fashion their own plates from clay, color them with ochre and charcoal, and bake them in a fire. A young woman's bride-price, determined by her family, is identified by the size of her "labial jewel," and it is only removed at mealtimes, in the company of other women, and when sleeping.

Several reasons for the adoption of the lip plate have been put forth by anthropologists. Some believe that in centuries past the mutilation discouraged slavehunters by diminishing the marketplace value of captives, and when slaving died out, the practice continued. The Mursi and Surma believe that evil enters the body through the mouth, so other observers maintain that the lip plate was instituted to prevent this from occurring. Popular theory holds that the size of the plate indicates the number of cattle necessary for marriage.

The Mursi utilize little adornment as compared to other Omotic tribes, but their subtle features reflect both the candor and hardship of tribal life. I photographed one man as he sat quietly in the doorway of his dwelling and just slowly and gently gazed up at me, holding himself as steady as a rock. It was a very long exposure, but remarkably, everything turned out sharply, and the light played off his clean features. However, when I indicated to a Mursi woman that I wanted to photograph her, she stopped me, disappeared for a moment, and returned with wildflowers threaded through her earlobes. I wanted to take a straight, unadorned shot of her, and she would have nothing of it.

When it comes to body painting, the Surma are pure artists. There is little symbolism involved in their adornment. Body painting not only intimidates adversaries, but reaffirms close social bonds; it is not uncommon for children to paint themselves as twins. In the hands of the Surma a mixture of white chalk and water becomes a monochromatic primer, and somehow the simplicity of the elements becomes the grandest design of all. In essence, the human form loses its animal sense and is transformed into living sculpture.

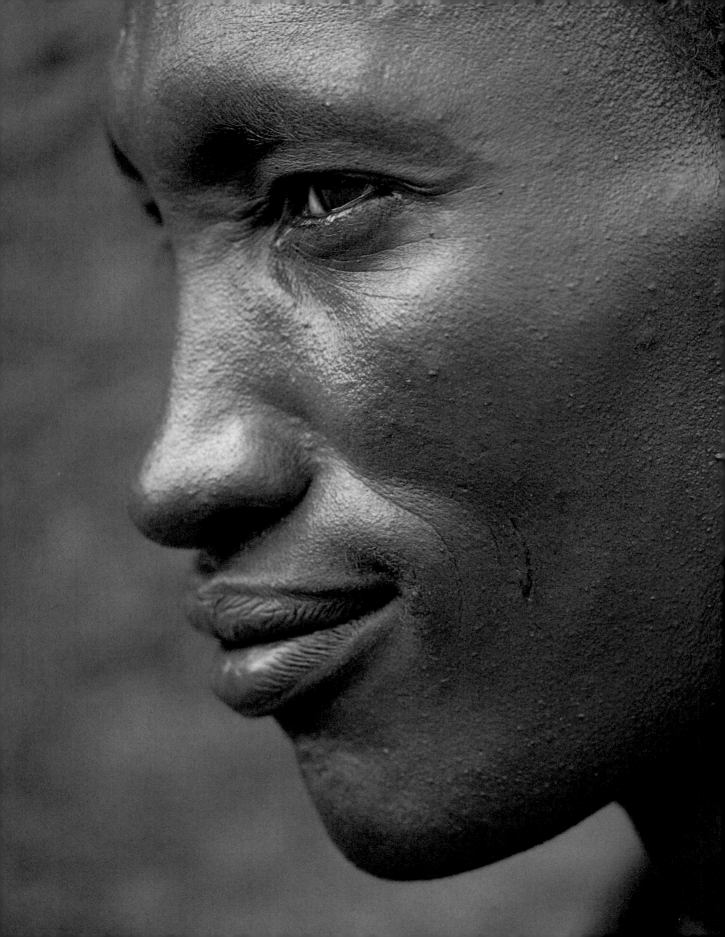

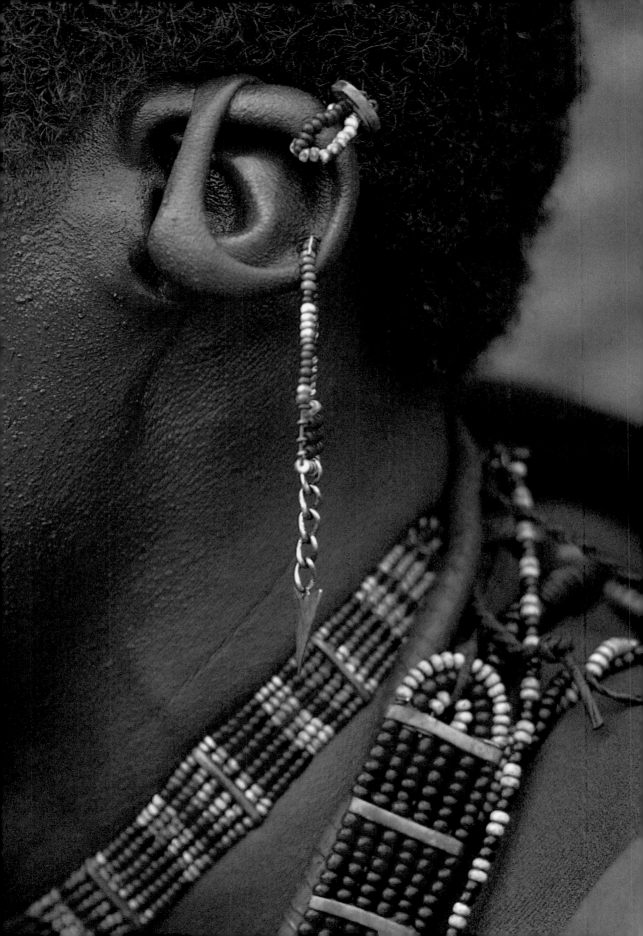

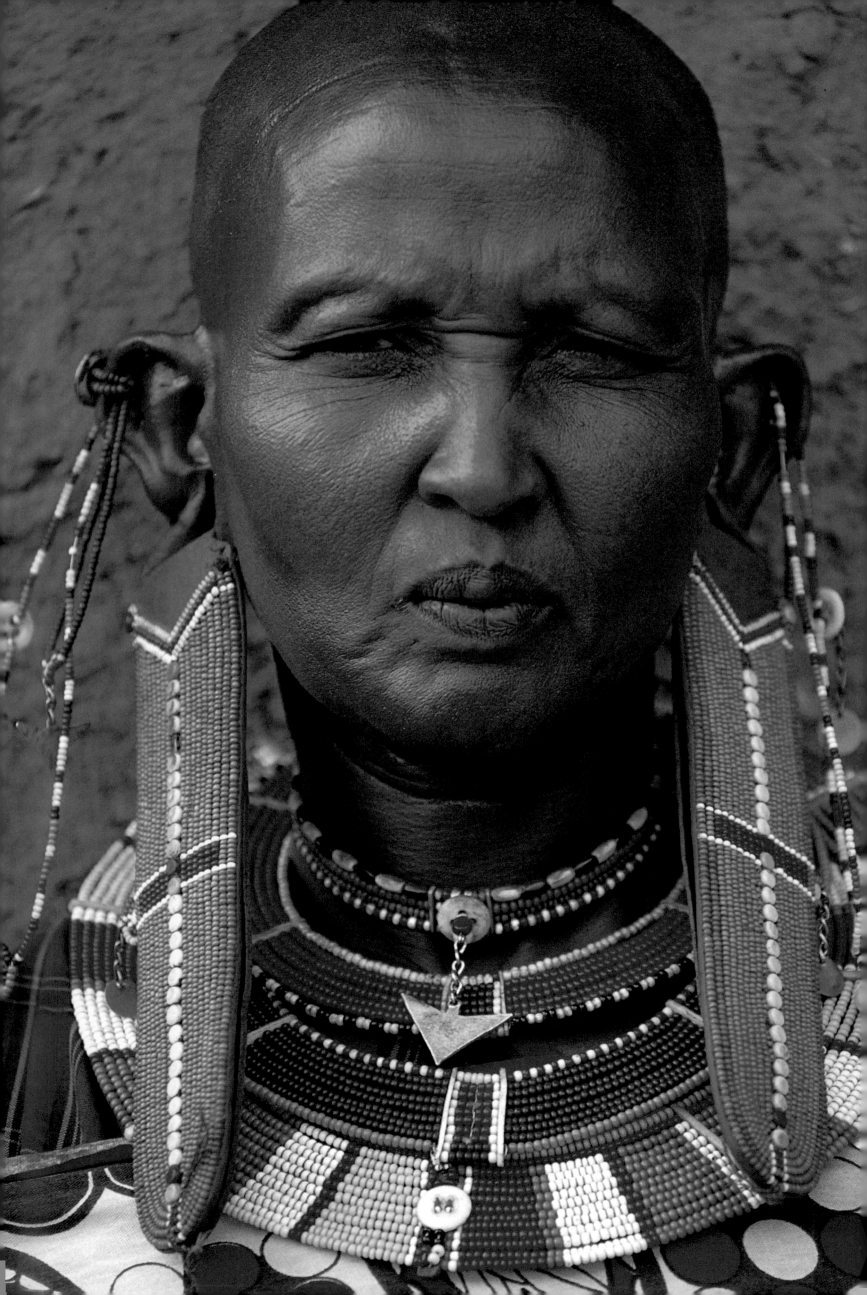

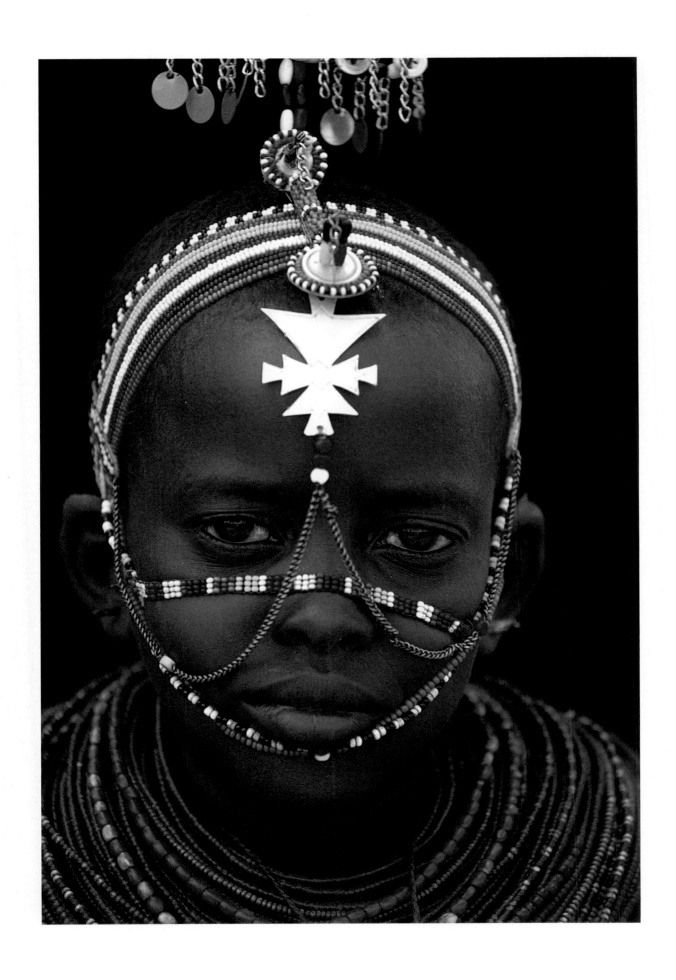

SAMBURU GIRL

(*opposite*) MAASAI WOMAN

ANTHROPOLOGY LIBRARY
THE BRITISH MUSEUM

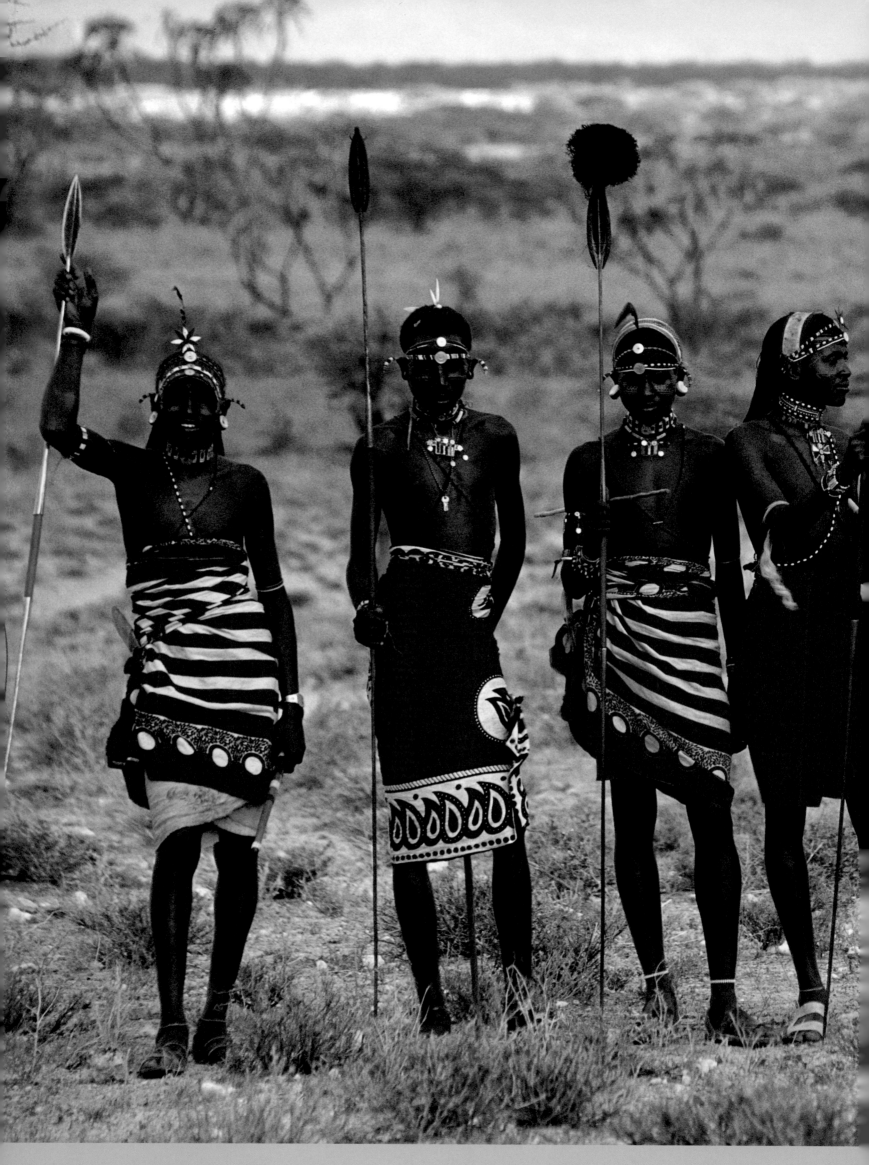

SAMBURU MORAN

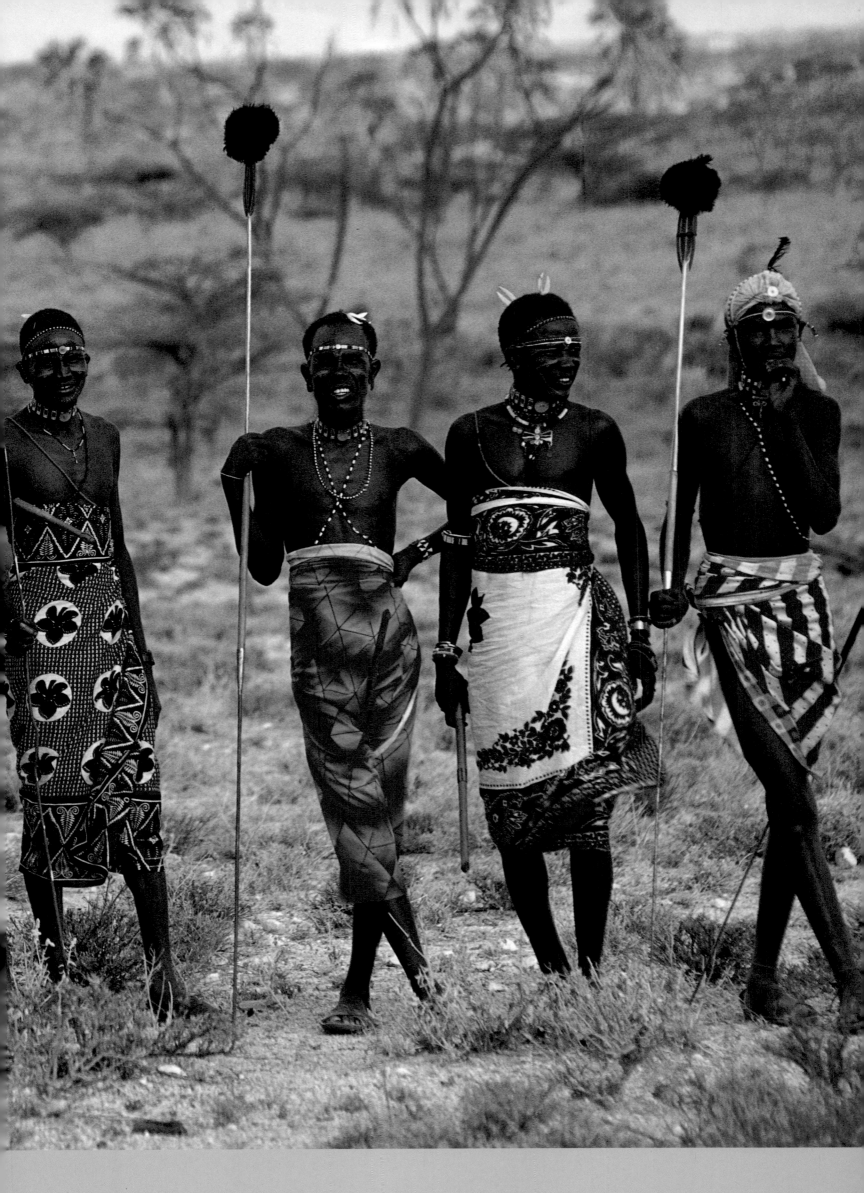

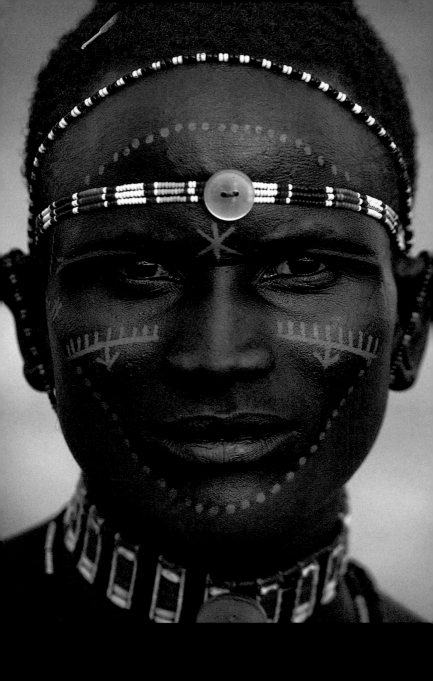

SAMBURU MORAN

(opposite) MAASAI MORAN WEARING AN ENKURARU

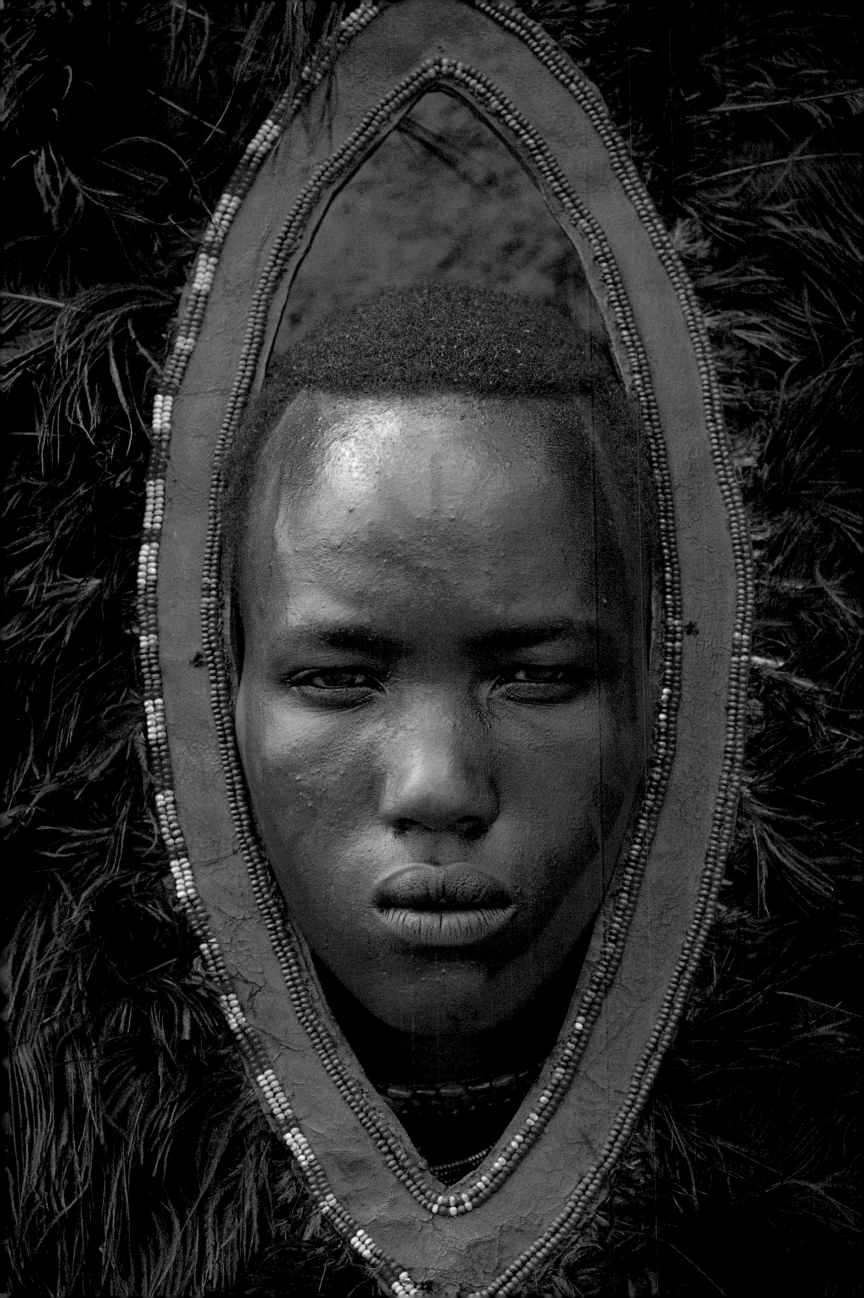

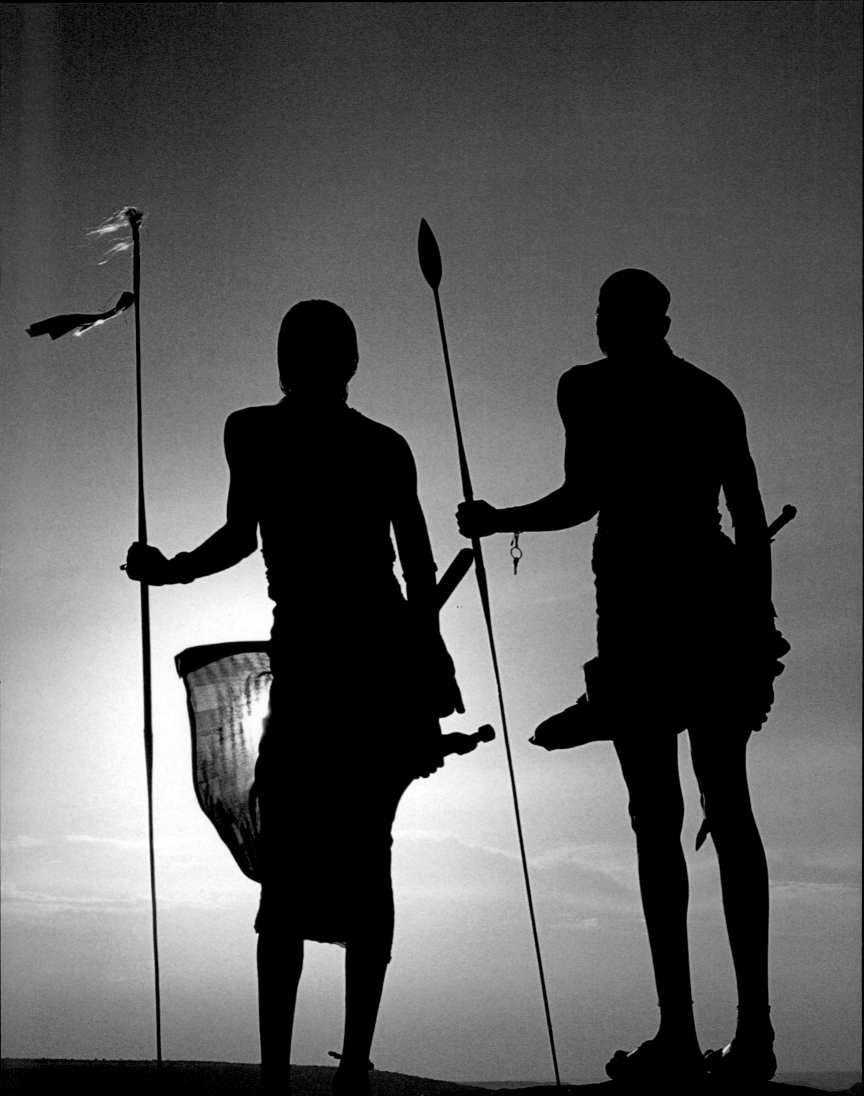

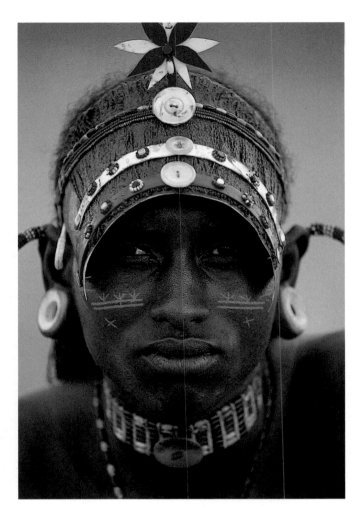

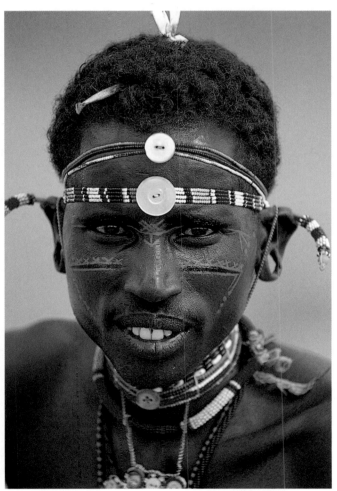

(top) SAMBURU MORAN WITH ILMASI WALA HAIRSTYLE

(opposite and bottom) SAMBURU MORAN

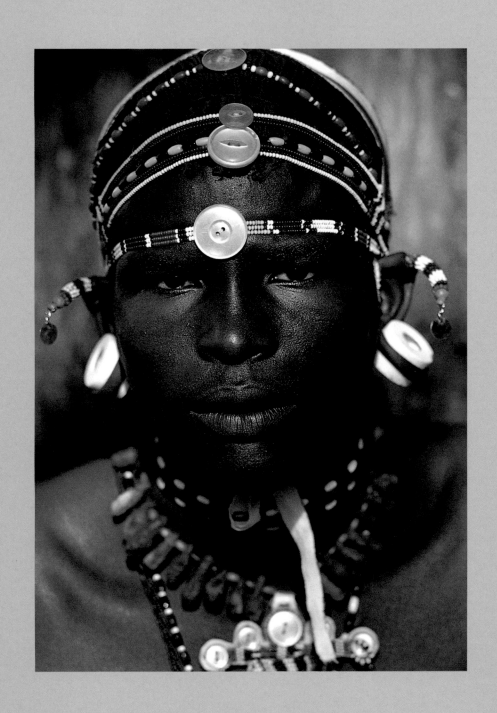

SAMBURU MORAN

(*opposite*) SAMBURU WOMAN

50

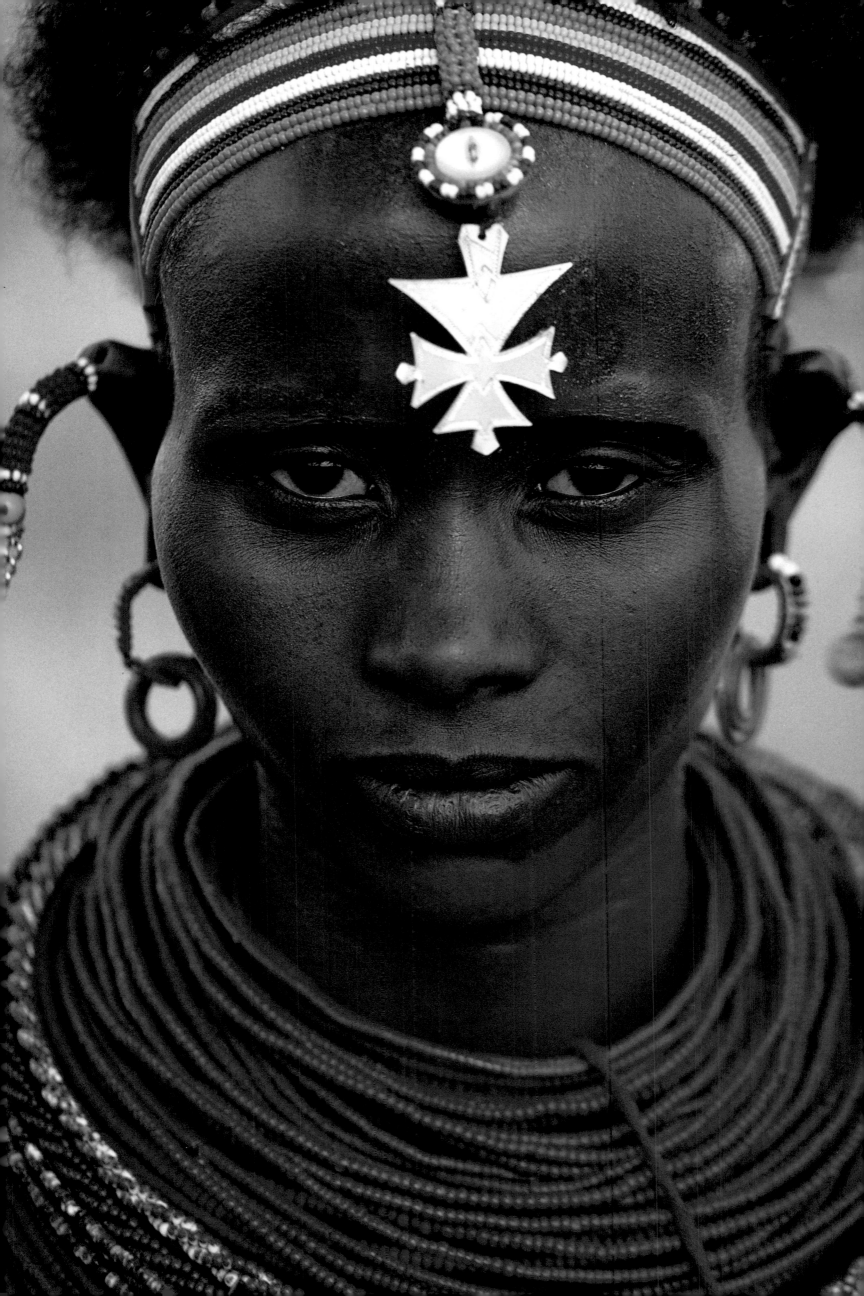

LIKE THE TRIBES of the Omo River, the Maasai and Samburu of Kenya are Nilotic peoples, and their lives are centered around their livestock, sheep, goats, and cattle. The blood of the bull and the milk of the cow bring them a graceful, unmatched strength, and the size of the herd bestows wealth and status upon the owner.

The Maasai and Samburu are closely related in both language and tradition. Meaning "speakers of the Maa language," the Maasai are nomadic pastoralists, wandering throughout the year in Kenya and Tanzania's Rift Valley. The Samburu, like the Maasai, are also speakers of the Maa language and pastoralists, moving across the mountainous terrain of north central Kenya with their herds. One meaning of Samburu is "butterfly," which is fitting for such a transitory people.

The Maasai are one of the proudest peoples I have ever met, physically and culturally standing taller than other groups in the region. Before the arrival of the Europeans, the Maasai were able to dominate the Rift Valley, raiding other tribal lands as far as the coastal city of Mombasa. Their warlike fevers are now cooled by modern realities, and their traditional lands now divided between three countries. The Maasai are so politically savvy that they have been able to rebuff attempts by the governments of Kenya, Tanzania, and Uganda to make them settle permanently and assimilate into society.

While the Maasai have felt the full effects of European colonialization and tourism, the Samburu have lived in relative isolation in an area that was closed to foreigners until a few years after Kenyan independence in 1963. They are a conservative people, clinging to the ways of their ancestors in a quickly changing world. Although the remoteness of their lands has spared them from an influx of outsiders, younger generations realize that they will be forced to adapt to new ways in order to survive, and do not want to see their cultural heritage replaced by an inferior system of values. Resistance to change is hardly a backward sentiment; the Samburu simply understand that they have the best lifestyle for a rugged terrain.

"Age-sets" are the basic institution of social integration for the Maasai and Samburu. Every three to four years the Maasai open a period when boys of similar ages are circumcised, thus forming a permanent social grouping. In the succeeding years, the age-set members will pass through ceremonies marking changes in their social status. Together they will become junior warriors, senior warriors, junior elders, and senior elders.

The Samburu age-sets are instituted at rare intervals. Every ten to fifteen years groups of boys and men between the ages of fourteen and twenty-four are initiated into adult life together; despite their age, the men still rank as boys until they are publicly circumcised. Over a lifetime men move through a hierarchy of social stages, each lasting about fifteen years. From childhood to warriorhood to elderhood, the pattern of relationships is set in comforting and grounding ritual.

Both the Maasai and Samburu tribes practice ritual circumcision on boys and girls: on boys when they enter the junior warrior age-set, and on girls prior to marriage. The clitoris is thought to be a male vestige, and it is thought that if it is left intact, a woman will remain sterile. Female circumcision is also seen as a way of discouraging infidelity in marriage. In comparison to the simple operation performed on boys, it is radical surgery and the cause of extreme discomfort and many health problems for women.

Maasai Moran

The *moran*, or warriors, are the most celebrated age-set of Maasai and Samburu society. A strong dignity is apparent in the moran, their faces framed by ostrich feather headdresses, called *enkurarus*. Warriors who have not yet killed a lion wear ostrich feathers, while those who have wear the lion's golden mane. Originally worn during raids and wars to give the warrior the psychological and physical advantage of added height, however, the lion-mane headdresses are now outlawed by the Kenyan government.

Because artistic pursuits such as sculpture and painting demand a settled existence, the Maasai have turned to their bodies as a means of creative expression. When I showed them photographs of the Dani of Irian Jaya, the moran professed amazement. They were particularly fascinated by the boars' tusks the Dani wore in their noses. The moran declared that they would never think of disfiguring themselves in such a manner. Not only was it aesthetically unpleasing to them, but it would mar the handsome contours of their faces.

Maasai Tribeswomen

The age-set system is less complex for women, involving only the passage from childhood to womanhood at puberty. When they are young and uncircumcised, women are lovers to the moran. Shortly before mar-

riage, women are circumcised, but without the ceremony attendant at the male circumcision. Only as their sons pass into warriorhood do women gain status within a clan.

Maasai women regularly shave their heads to attract attention to their abundant jewelry. Flat neck collars are made from strands of beads spaced with strips of cowhide. For the symbol-conscious Maasai, blue beads symbolize God as "the color of the sky where He lives," and green beads represent "vegetation after rainfall," standing for peace. Beaded ear flaps indicate that a woman is married. Her husband will never see her without them.

Samburu Moran

The moran are the most striking members of Samburu society. Privileged and pampered for fifteen years between circumcision and true adulthood, these young men enjoy a convivial and unstructured way of life. This is the best time in the life of a Samburu man, viewed nostalgically by clan elders.

To photograph this particular clan, I found the chief and explained my project to him. He shrugged and stated that the moran were out in the hills, and it would probably be next to impossible to gather them together. After all, he said, they are teenagers, and they can be difficult. After showing them portraits of other tribesmen I had photographed, he managed to draw them in for my camera, although I think the mirrors on my jeep were too irresistible a temptation for the primping and preening moran, who are, as the chief said, much like teenagers the world over.

One young man sported a visorlike hairstyle called an *ilmasi wala*. He had lengthened his hair by entwining it with sisal string. Many Samburu moran have more elaborate hairstyles than their Maasai counterparts—some take as many as three days to coif. The moran also adorn their ears with ivory rings and coat themselves liberally with ochre and grease, which protects them from insect bites, the sun, and other skin irritations. The beaded necklaces are made by their many girlfriends. Many moran forge long-term relationships with their mistresses, whose faithfulness is a matter of prestige and honor to the moran. The moran freely adapt modern materials to traditional uses; one young man wore in a stretched earlobe a white lid to a Venus Cold Creme jar. The years of self-absorption do come to a close, however. As a moran eases into adulthood and becomes a junior elder, he will bestow most of his ornaments on the moran of the next generation.

Just before dispersing back into the hills, the moran casually posed for my camera. They wore brightly colored cotton *shukas* and held spears, the symbol of their manhood.

Samburu Moran Herdsmen— Mpala Ranch, Nanyuki

The Mpala Ranch is a sprawling complex, a preserve for both wildlife and Samburu tradition. Posted on a massive granite outcropping called a *kopje*, two moran keep an eye out for predators and an eye on their herds. In the modern era, being a moran means much more than warriorhood; many now work as herdsmen and traders, though they will not miss the opportunity to play.

At the end of the rains when the grass is lush, a group of moran will beg off herding and disappear into the bush. There they will amuse themselves and eat copious amounts of meat. This huge intake of protein and fat may give most Westerners thoughts of a heart attack, but it gives them the endurance and strength they need for their physically demanding lifestyle.

Samburu Tribeswomen

Samburu men are of the opinion that women do not have enough beads until their chins are supported by their necklaces. By the age of sixteen young women should have garnered enough beads to inspire a marriage proposal. The Samburu are a fiercely patriarchal society and, unlike the indulged boys, girls are raised within strict confines. In adolescence a young woman will become a moran's mistress, although she will marry someone else. Marriages are always prearranged by elders and are never based on love.

On the day I photographed them, one woman had adorned herself with red ochre and heightened her brows with a black dye of grease and ashes; both women were wearing pendants shaped like stylized birds. These Samburu live on the outskirts of Samburu National Park, so they are somewhat used to people traveling through and photographing them. Understandably, they get tired of it, but I think bringing my portfolio and demonstrating my sincerity greatly helped in persuading the chief to gather the young people together for these portraits.

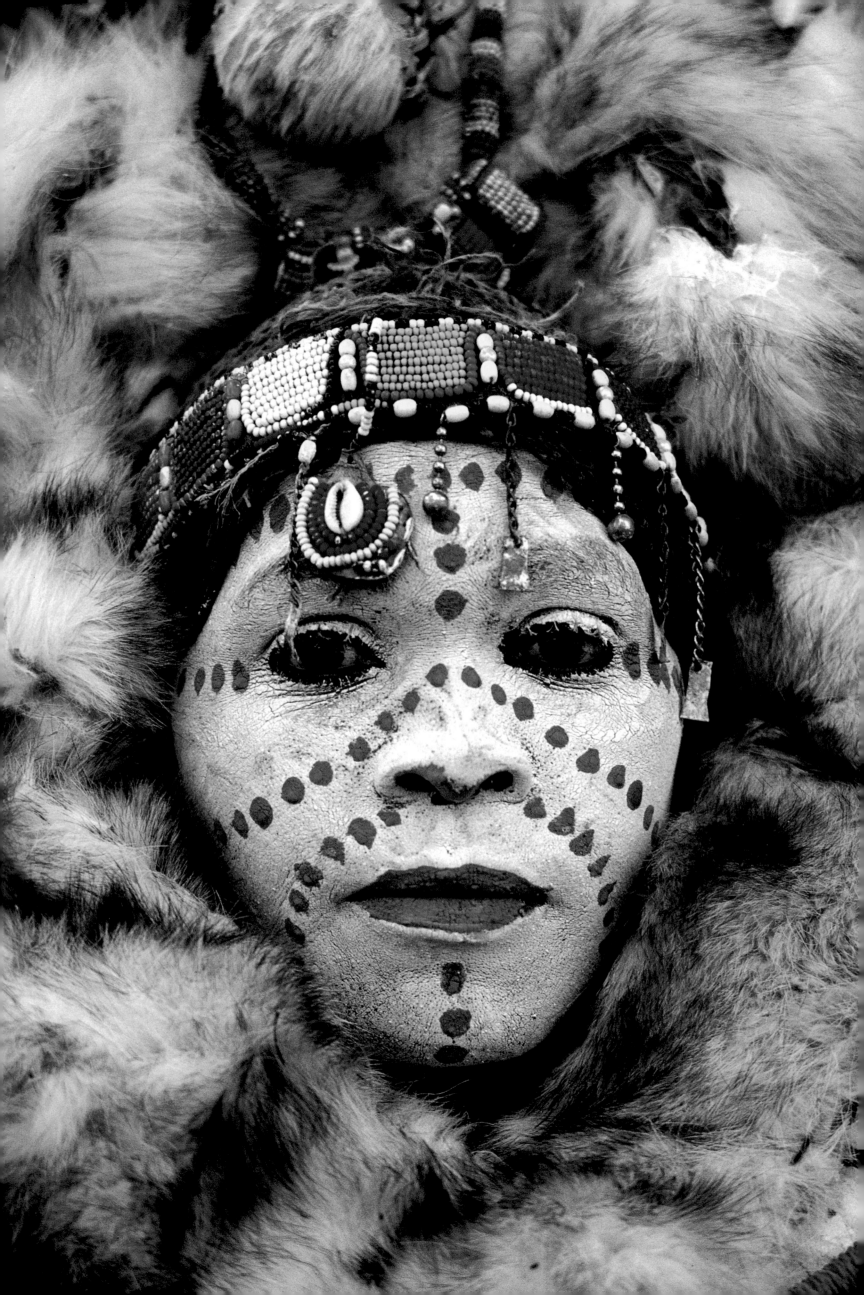

Kikuyu Ingoma Dancer

KENYA

UNLIKE the Nilotic Maasai and Samburu, the Kikuyu are Bantu, a family of peoples occupying equatorial and southern Africa. Residing near Mount Kenya, they are easily the largest ethnic group in Kenya, accounting for about 20 percent of the total population. During the 1950s the Kikuyu led the drive for Kenyan independence from Britain; Jomo Kenyatta, Kenya's first president, was a Kikuyu.

As a settled, agricultural people, the Kikuyu are looked down upon by the pastoralist Maasai. Traditionally, these two tribes have been in constant conflict with one another, but during peaceful interludes there was much intermarrying and trading, both cultural and commercial, between them. For example, nearly all words relating to cattle in the Kikuyu language are borrowings from Maa.

The Kikuyu take great pride in their appearance. They use body paints extensively for ceremonies and practice scarification. *Ingoma*, or dances, are used for many occasions: to attract the opposite sex, to celebrate various rites of passage, or to entertain and honor certain age groups. Singing and various musical instruments accompany the dances; the Kikuyu oral tradition is rich in both stories and song.

The dancers cover their bodies in white clay, believing it deflects the rays of the sun and gives them the strength to perform longer. They also highlight their faces with crimson ochre and wear the traditional *thumbi*, or headdress, made from monkey fur.

(opposite) KIKUYU DANCER

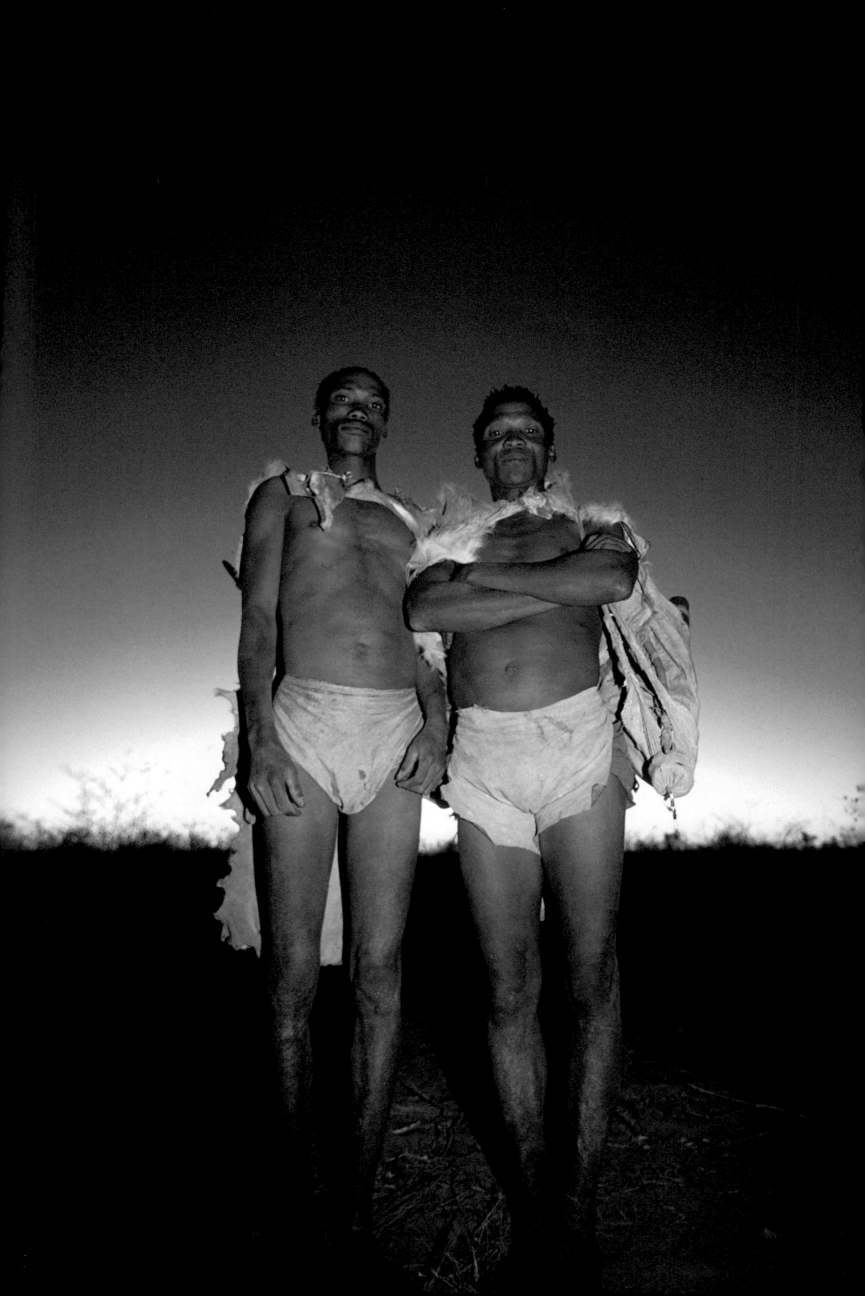

The San of the Kalahari

BOTSWANA

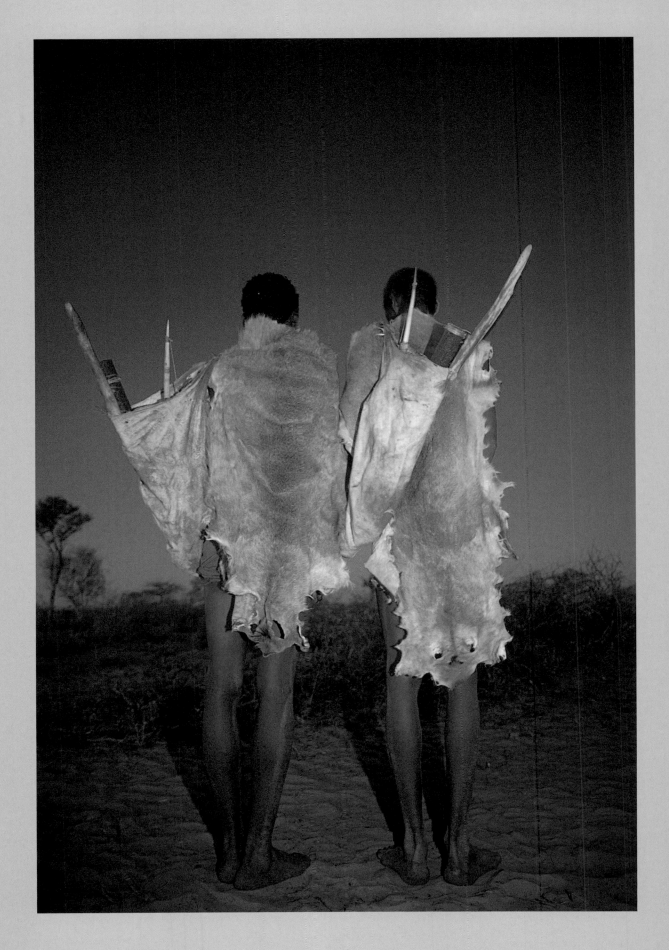

(opposite and above) SAN TRACKERS

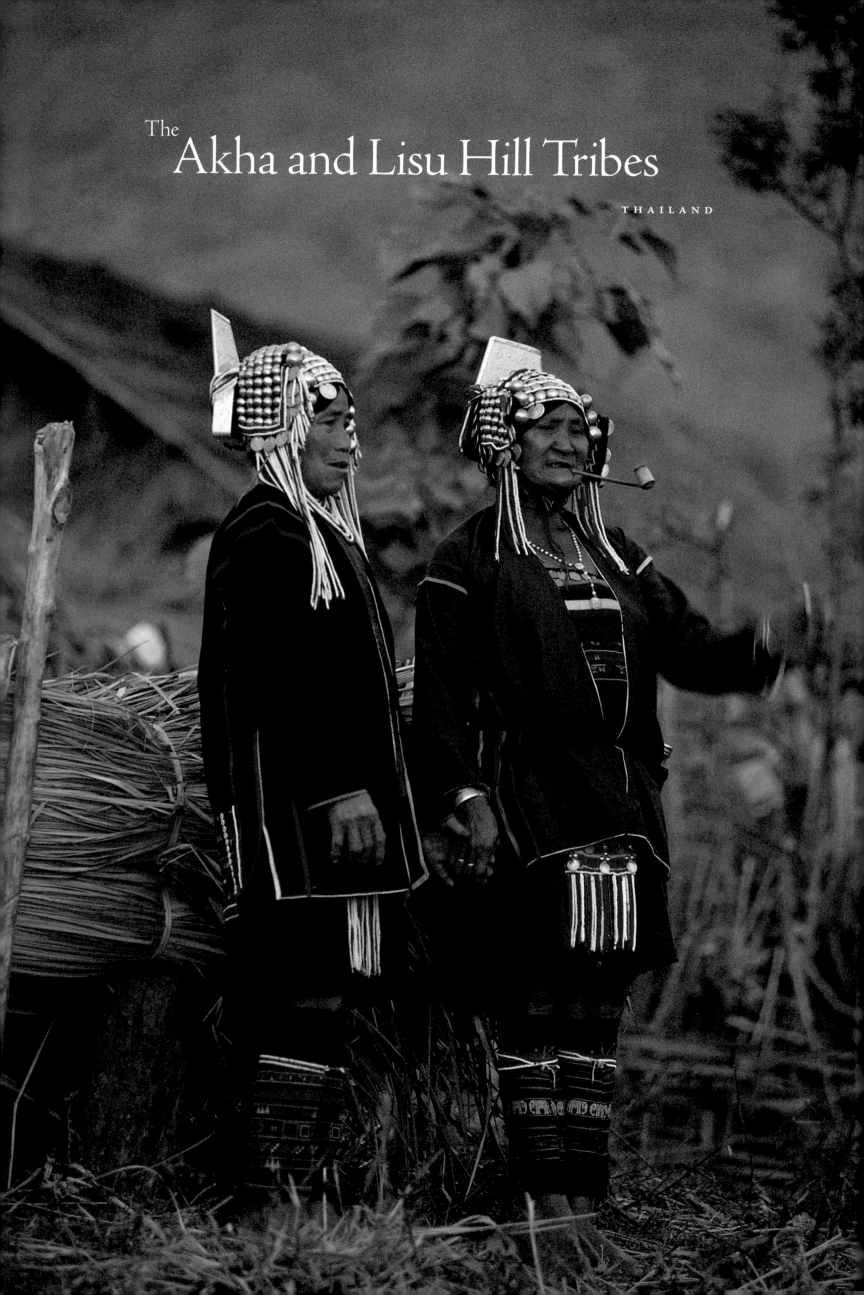

The
Akha and Lisu Hill Tribes

THAILAND

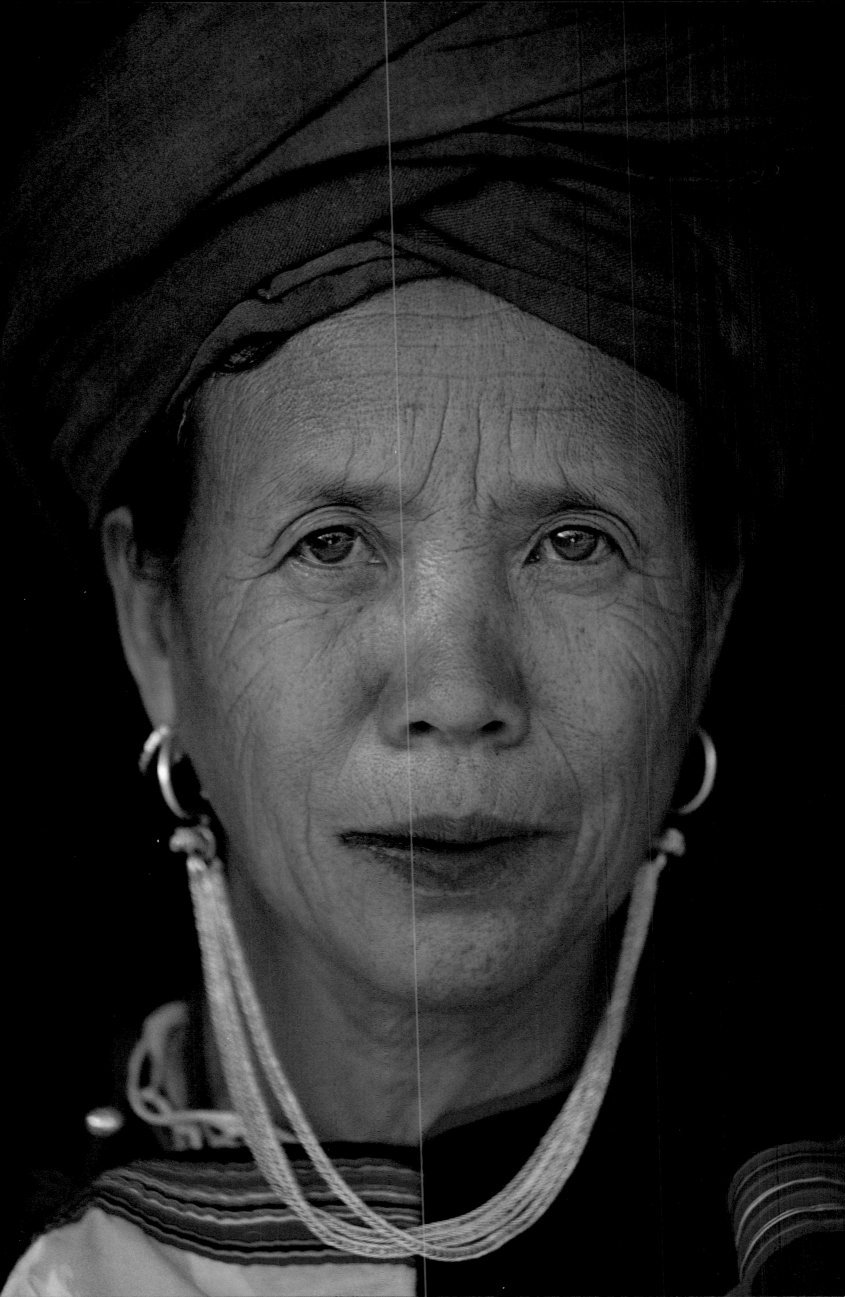

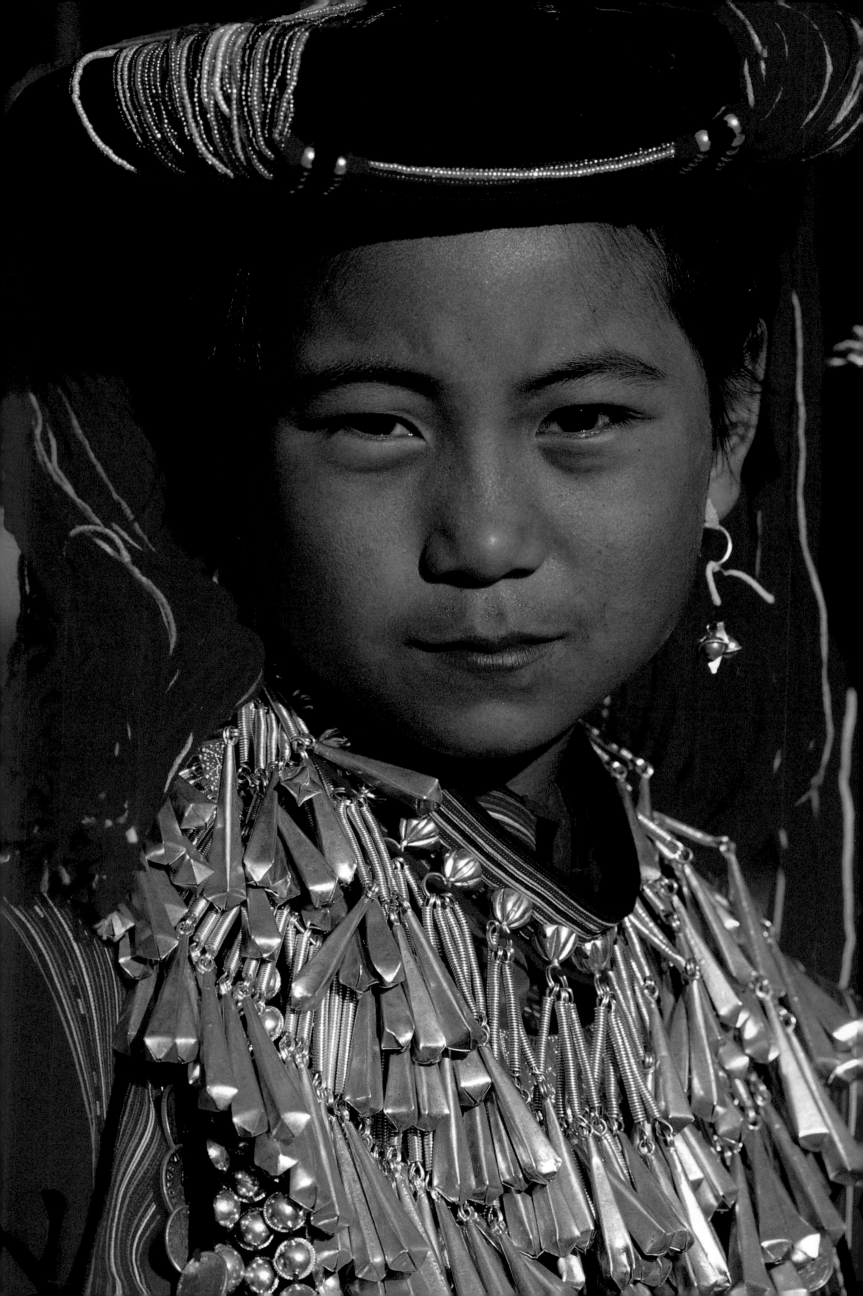

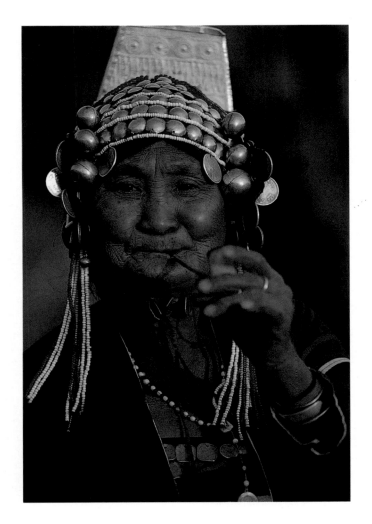

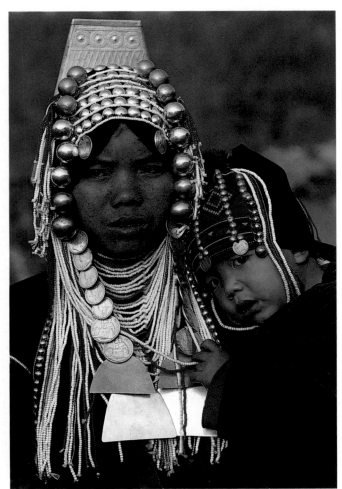

(top) AKHA WOMAN; *(bottom)* AKHA WOMAN AND CHILD

(page 60) AKHA WOMEN; *(page 61)* LISU WOMAN

(opposite) LISU GIRL

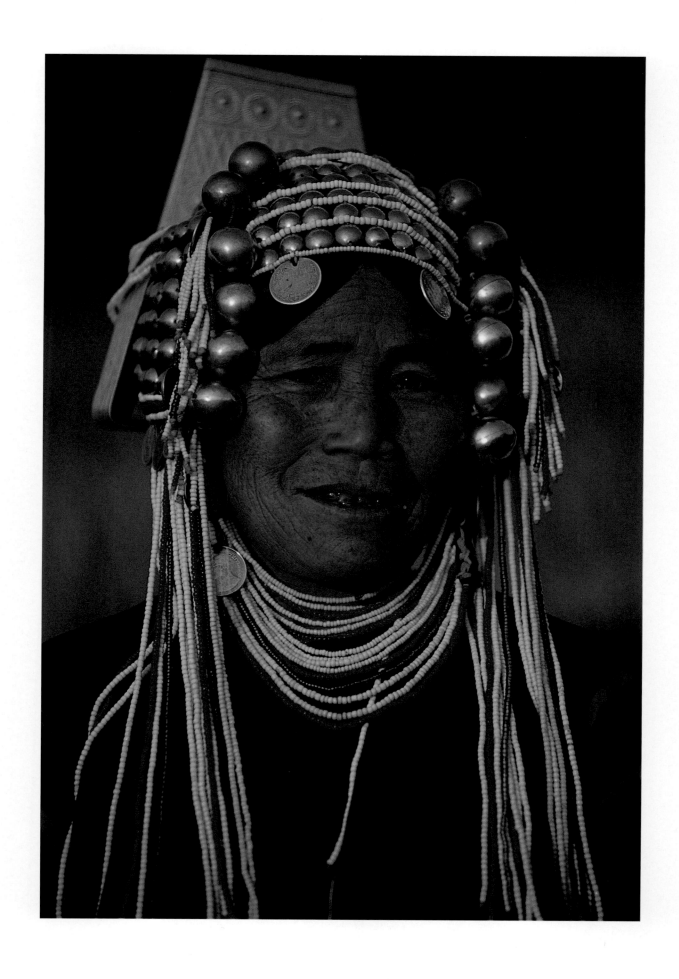

AKHA WOMAN

(opposite) LISU MAN

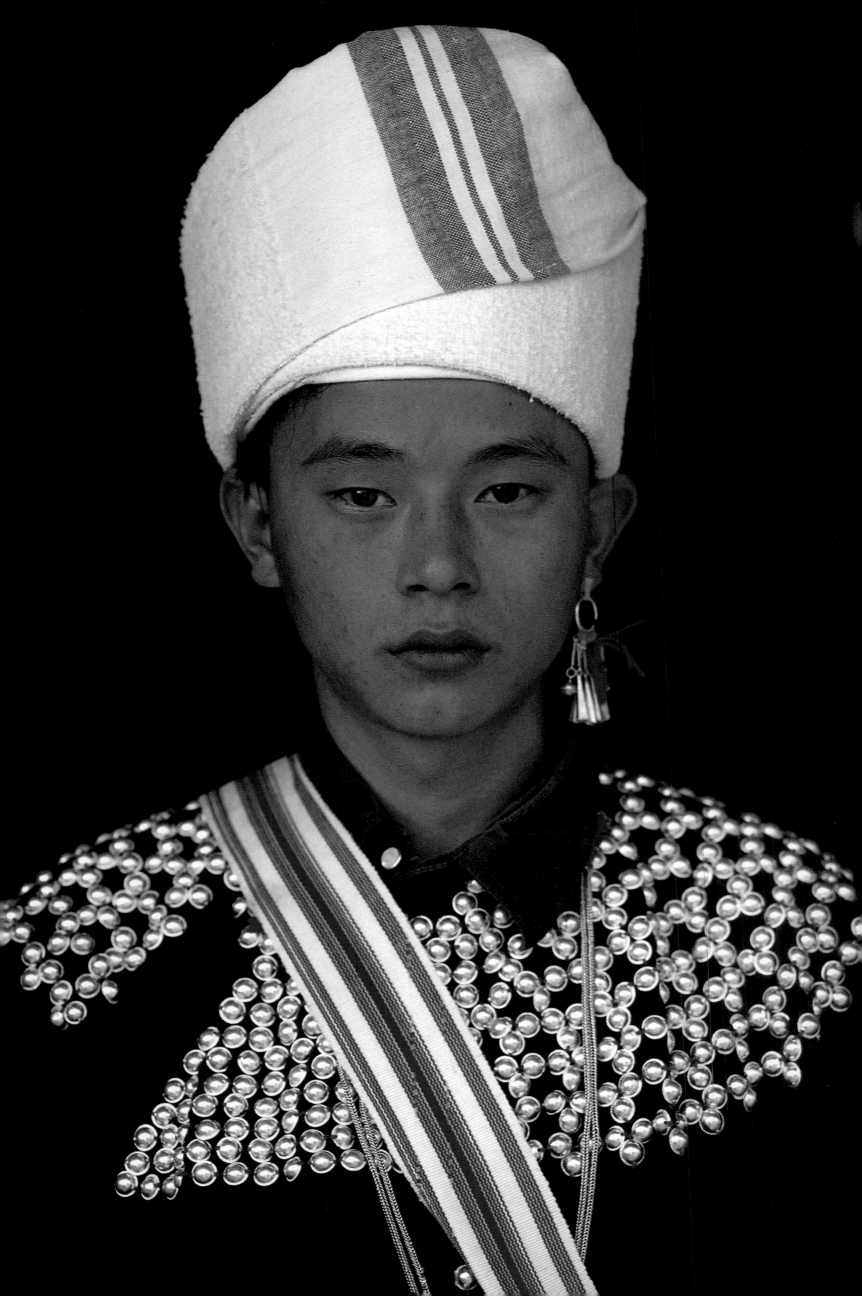

For CENTURIES the many tribes of the hills have wandered throughout the Golden Triangle where Thailand, Burma, Laos, and China come together. The land is a ruffled mass of mountains at the confluence of the great Mekong and Mae Kok Rivers. In the northern reaches of Thailand are six diverse tribes, of which the Akha and Lisu are perhaps the most colorful and distinctive.

The Golden Triangle conjures up images of opium poppies and their scourge; the history of opium and its refined products is a lurid tale of colonial war and addiction. The production of opium has been outlawed in Thailand since 1955. However, when the government took away their main cash crop, the hill tribes were forced to turn to other income sources to support their subsistence-level existence. Legislation and pressure from foreign governments have eradicated much of the centuries-old trade; it now exists on a much smaller scale farther back in the hills.

For hundreds of years the hill tribes led a nomadic existence throughout the Golden Triangle. They knew the mountains where they grew poppies and the mountain valleys where they cultivated rice; they moved on only when the land was exhausted. For centuries this style of life was viable. As modern times approached with modern borders, most hill tribes were forced to settle more permanently. The mountains can no longer recover from the combined effects of swidden (slash and burn) agriculture, which by itself does not harm the soil, and exploitation by extensive logging interests, which has a far more deleterious effect. Illegal logging has done more harm to the environment than all the hill tribes combined. An influx of refugees from Myanmar and lowlanders from southern Thailand, combined with high birth rates, has also significantly increased the population. The hill tribes are proud of their well-built villages, though, and insist they do not need to move anywhere again. The unspoken codicil to this is: *Even if we wanted to move, there is nowhere for us to go.*

Indeed, the hill tribes are caught in a paradox. The state is the legal owner of most of the mountainous land in northern Thailand, thus most tribal peoples do not own the land on which they farm and dwell. To secure ownership is a bureaucratic nightmare, plagued by delays and expense, which the hill tribes can ill afford. Considered both squatters and drug producers by the government, the hill tribes have had to battle against severe discrimination, and even forced repatriation into Myanmar.

The Lisu and Akha are new to Thailand in the twentieth century. The largest migration came at the time of revolution in China, and later refugees came fleeing war in Indochina, and oppression in Myanmar. In a strange twist, the Vietnam War led to greater understanding of the hill tribes. The political interest of the United States in this sensitive region resulted in the hill tribes becoming some of the best-studied and most recognized tribal peoples in the world.

Once pariahs, the hill tribes have become an asset to tourism, although it is mainly the lowland tour operators who are profiting. More than once I passed through villages where Thai girls were dressed in hill tribe garb to attract unwitting travelers. I smiled at the opportunistic nature of these girls, pretending to be a tribal people looked down upon in Thai society in order to make a few *baht* modeling for tourists.

What makes the dress of the Akha and Lisu so unique and impressive is the silver they wear. Since they amass it from birth, silver becomes a part of them, giving them both the proprietary feel of ownership and the sensual feel of weight and coolness.

The Akha have a more traditional hill tribe appearance. Being the most recent arrivals from Myanmar, they have some of the richest and most colorful costumes. The women's elaborate headdresses, jingling with silver, are deceiving because the Akha are the poorest of the hill tribes. However, they prefer to think of themselves as the most spiritually rich. All hill tribes worship a myriad of spirits, and the Akha believe in hundreds, those of the sun and moon, fields and livestock, trees and mountains, and spirits of people, both good and evil. To placate these many spirits, the Akha make frequent offerings and have many religious festivals.

Indeed, to look at the everyday dress of Akha women, they appear to be a wealthy people. Tight-fitting indigo-dyed homespun cotton caps worn from birth are decorated with anything that catches the eye: coins, feathers, fur, bright tassels, and strings of seeds. At puberty, the dress of the sexes diverges—the young men wear simple black turbans and the young women simple headdresses. While the men's headgear remain plain, the women collect silver and other ornaments with which to adorn their headdresses.

The height of a headdress is a proportionate sign of wealth; in the Akha village I visited, the women attach a hollow silver plate, delicately beaten with designs, to the back of the hat, which gives a distinctive angular look to the head. Depending upon the family wealth, the headdress is encrusted with either silver or aluminum, draped with coins, and festooned with bright tassels. Some headdresses weigh nearly ten pounds, yet are worn all the time—to labor in the fields, to festivals, to bed, and only removed for cleaning, repair, and hairwashing. This practice is all a part of the *Akhazan*, or Akha Way, the very heart of the people and their customs.

One would think crime would be a larger factor than it is when women wear family fortunes on their heads. In less remote areas, the villagers wear half and bury half for safekeeping. But it would offend the spirits and the spirit of the proud Akha tribeswoman not to wear her finery. As well, many villages are remote, and the women do not venture far, going only to the fields. It is extremely rare for a woman to leave the village. When men do business in town, they don lowlander clothing to blend in with the Thai population.

Although the Akha and Lisu now live within close proximity to one another, they are exceedingly different. The Lisu are competitive and combative; Lisu battalions were some of the most decorated in World War II. They also have a rather telling myth of origin:

> There was a great flood, and the only two survivors were a boy and his younger sister who were saved by riding out the flood in a large gourd. Upon finding that they were the last human beings left in the world, they realized that they were the only hope for the future of mankind. However, they believed an incestuous relationship would be wrong, so they looked for signs indicating whether they should marry or not. First they separated two stones from a grain mill and rolled them down the opposite sides of a mountain. When the stones reached the bottom, they continued to roll around the mountain until they came together. This result convinced the two that it was proper for them to marry. Their union produced many children, who became the progenitors of all the different tribes. As there was one girl short, the Akha man had no wife, so he went into the jungle and married a monkey.

The Lisu are determined to assimilate into Thai society; they send their children to Thai schools, marry lowlanders, and definitely perceive themselves as modern. The goal is assimilating without losing tribal identity. Hill tribe children attending Thai schools are not allowed to wear tribal clothing or speak their native tongue. While a Thai education is a positive unifying force leading to greater opportunity in the future, it also pulls children away from their culture.

As the silver plate of the Akha headdress is distinctive, so are the ruffs of silver with which Lisu women adorn themselves. They call them flower buds, and their light, jingling sound is music to the ears. To keep their bright shine, the silver is rubbed once a year with ashes, then polished with a cloth.

Like the Akha, the ornamentation of Lisu men is subdued compared to the women's. Their white turbans are wrapped towels, stiffened with inserts of cardboard. The Lisu women more than make up for the men's reserved decoration with turbans rolled from yards of black cloth and hung with dozens of tassels and silver.

Hill tribes now borrow designs so freely from one another that it has become nearly impossible for an outsider to identify a design as belonging to any one tribe. Some designs are being lost as poorer villagers sell off their jewelry to tourists or exchange it for trade goods. Also, fewer silversmiths are now at work; where once each village would have its own silversmith, one silversmith now services many villages. The result is that unique traditional designs of the few become the standard for many. The best example of this is the half-sphere stud. These are seen on the costumes of most hill tribes, and all believe them to be part of their culture. The difference lies in how they are used: the Akha use them on their headdresses, the Lisu on their vests. Whatever the origins, the effects are magnificent.

Embroidery and other textile work, once the domain of women, is now being executed by men. The Akha are particularly known for their nearly black indigo dyes, and the Lisu for their intricate banding and sewing of fabric. Tourism has made hill tribe handicrafts valuable commodities. Men used to spend their leisure time making traps and nets for the animals of the forest, but game is now scarce; crafts for the tourist trade are now the best means to provide for their families.

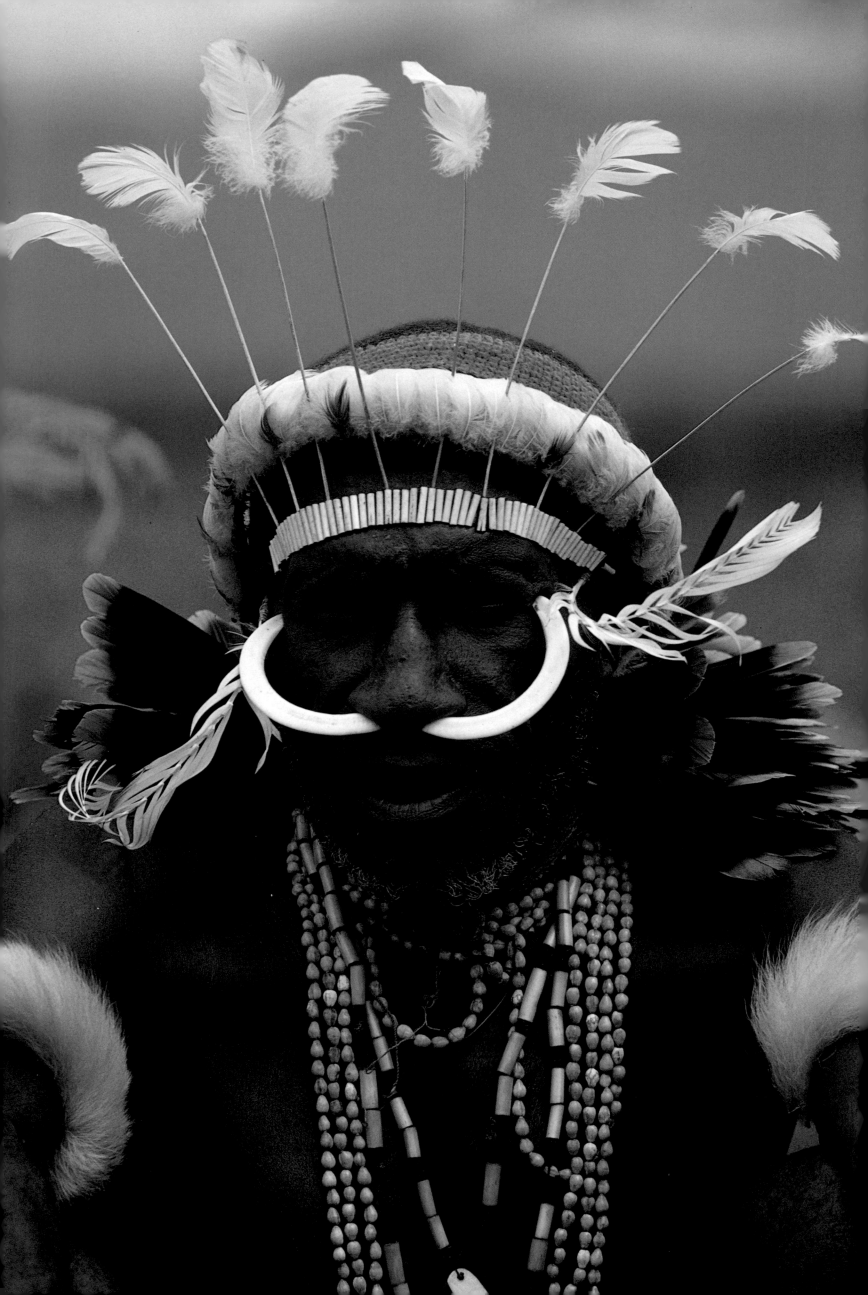

The Dani of the Grand Valley

IRIAN JAYA, INDONESIA

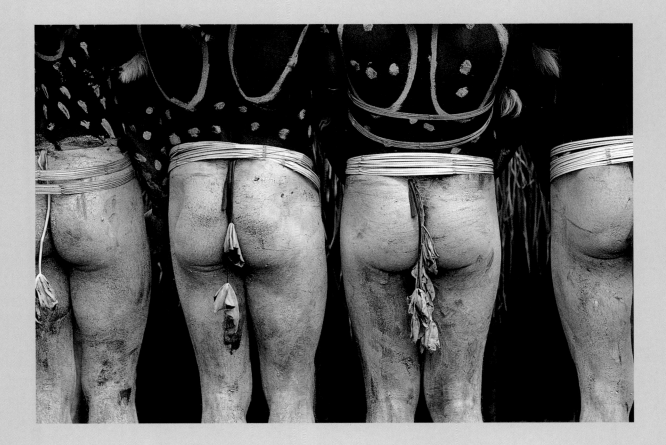

DANI MEN

(*opposite*) DANI MAN

ANTHROPOLOGY LIBRARY
THE BRITISH MUSEUM

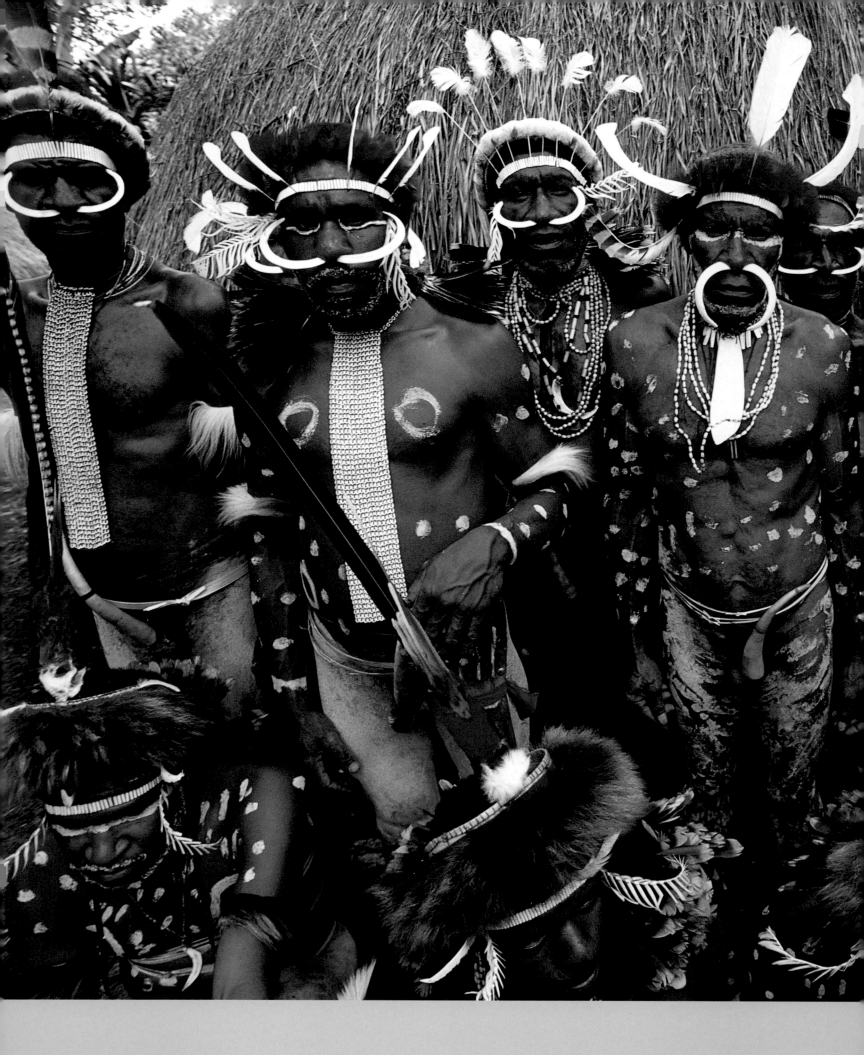

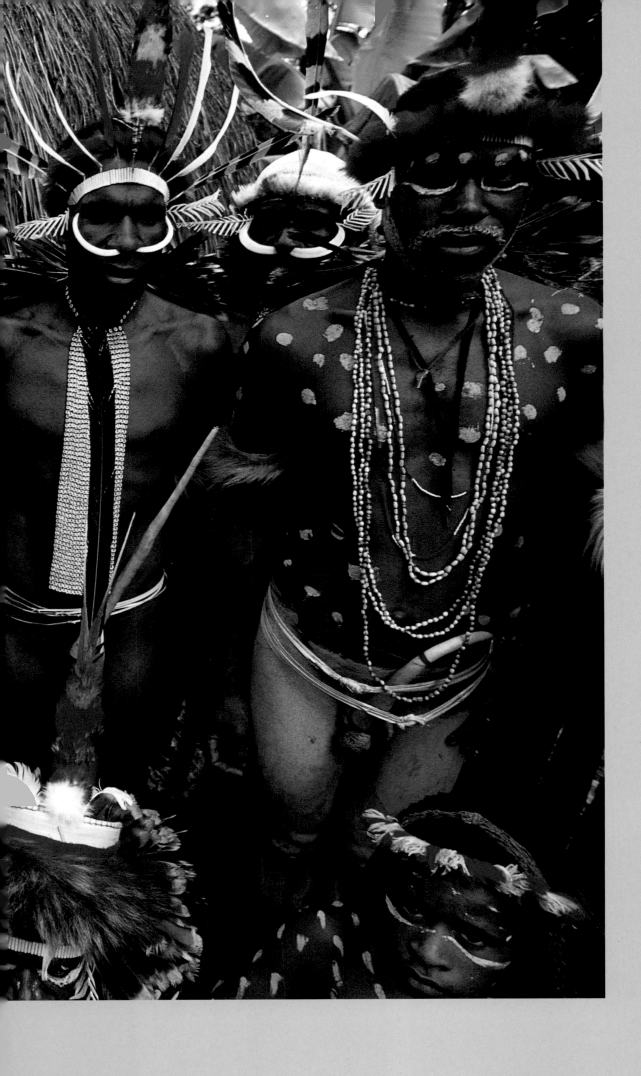

DANI MEN PREPARED FOR FEAST

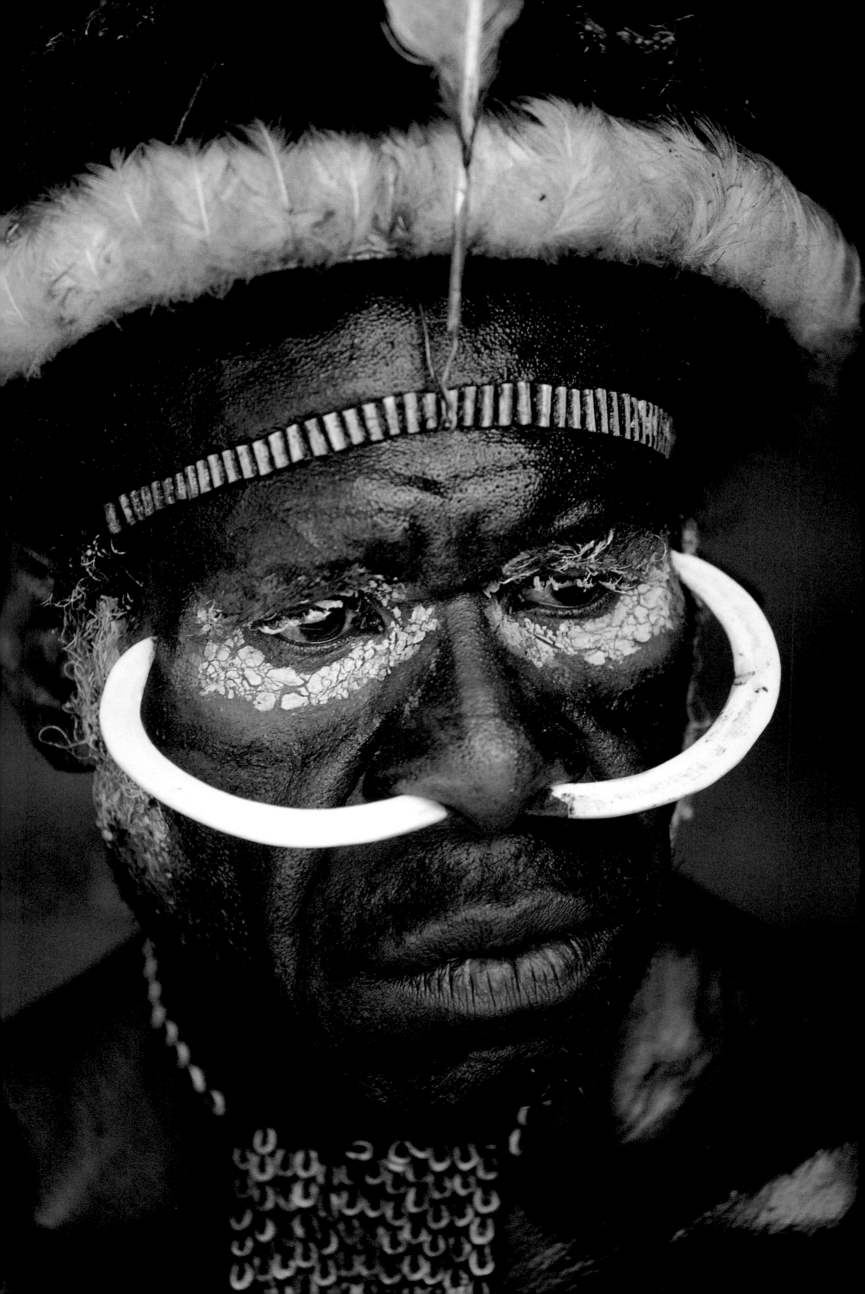

INHABITING THE ONCE REMOTE highlands of Irian Jaya, the Dani are an extremely successful agricultural people, perhaps the oldest continuous farming society in the world. Like many tribes around the world, the Dani have resisted governmental pressure to accept modern Western dress, instead wearing traditional adornments of distinctive penis sheaths, or *holim*, boar's tusks, and elaborate feathered headdresses.

To create the holim, the Dani carefully shape gourds as they grow on the vine. The holim is the only essential garment the men wear, and every man has several in his wardrobe. When he turns six, the Dani male adopts the holim as a sign of sexual modesty. What is remarkable about this covering is that it is not a focus of sexuality or eroticism (any such inference is a Western one), but instead a form of self-expression. If he wants to indicate amazement during an emotional conversation, a Dani will noisily flick the holim with his fingernail, punctuating his words.

Despite their fierce appearance, the Dani were some of the most pleasant people I have ever photographed. As a gesture of goodwill, I purchased a couple of pigs for the chief. The following day a pig-killing ceremony was conducted, and a lavish feast was prepared for the entire clan. Pigs are extremely valuable; the more pigs, the more prestige for the owner. They are used in reinforcing familial bonds and purchasing wives; once the pig is butchered, every part of the animal is utilized for food, magic, or decoration.

After eating the pig meat, each person wiped his hands on himself and neighbor. Not only is this done to promote health and improve the healing ability of the skin, it also promotes heat retention in the chilly Grand Valley nights. The Dani also rub pig grease into their hair. Mixed with ash, the glossy palette of grease becomes a cosmetic for beautifying the skin. Other colors such as gray and red are made from various clays mixed with water and are applied in the same way.

Like the Kayapo of Brazil, the Dani recognize and embrace the opportunity to expose their culture to the outside world, and they enthusiastically welcomed my documentation of their ceremonies. The alien rule imposed upon them by the Indonesian government is despised. In the past, Jakarta has carried out various operations to force the Dani to dress like Javanese and live in concrete block houses instead of their traditional straw and wood round huts. The Dani met these paramilitary operations with much resistance, and many of them were ruthlessly murdered in this struggle.

The Dani are most famous for their glorious ritual warfare, during which hundreds of warriors—shining with pig grease and determination as one witness put it—face off. Although this practice has been curtailed by the government, they continue to stage mock battles. Warriors adorn themselves with headdresses of tree kangaroo fur and feathers, necklaces and bibs of cowry shells, and they carry spears up to five meters in length. In the past, real warfare was highly regulated: there was no fighting at night and both sides would withdraw in the noonday heat to chat, smoke, and rest. While battles were bloody, deaths were few because the incoming arrows and spears wobbled and were easy to see. It was an extremely individualistic endeavor as well; warriors would prove their mettle by dashing solo into the fray, getting in a few licks and retreating. Dani battle has been described as aggressive behavior without aggressive emotions: antagonists were rarely angry with each other, they merely wanted to show off. Raiding was a completely different matter: free of ritual and extremely bloody, day or nighttime raids effectively silenced the enemy.

Today the Dani are one of the many tribal peoples facing the modern reality of foreign encroachment. The government is building a highway into the Grand Valley. Although construction has come to a grinding halt at the edge of a seemingly impassable swamp, it is only a matter of time before modern technology overcomes this physical barrier, allowing more immigrants to flood into the valley, seeking economic prosperity and land. Even now, Indonesian workers have streamed into Wamena, the main city of the region. As disturbing as these radical changes are, they have made Wamena a fascinating place, as are all places that mix the old and new, the traditional and modern: the sight of the Dani wearing their holims makes for sharp contrast to the Indonesians in their T-shirts and shorts. The Dani are resilient, and they may very well survive these modern changes, mingling new ways with the old and forging fresh, uniquely Dani customs.

(opposite) DANI MAN

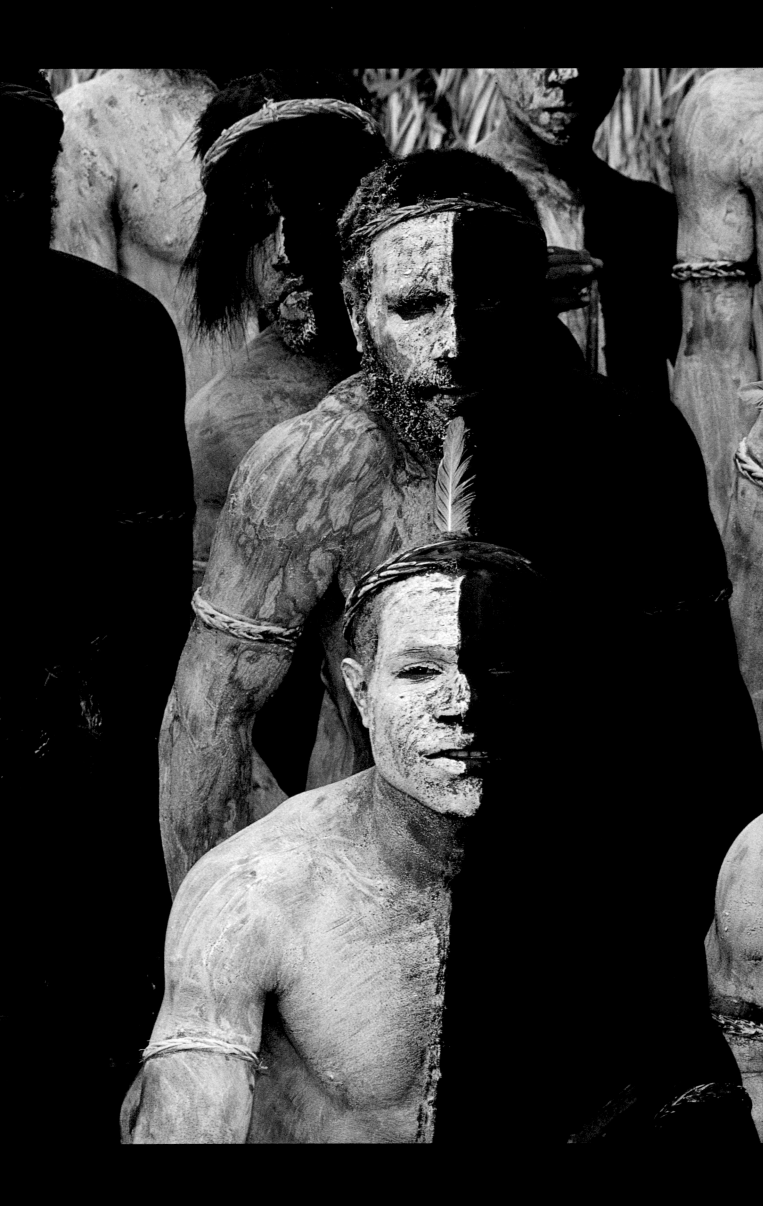

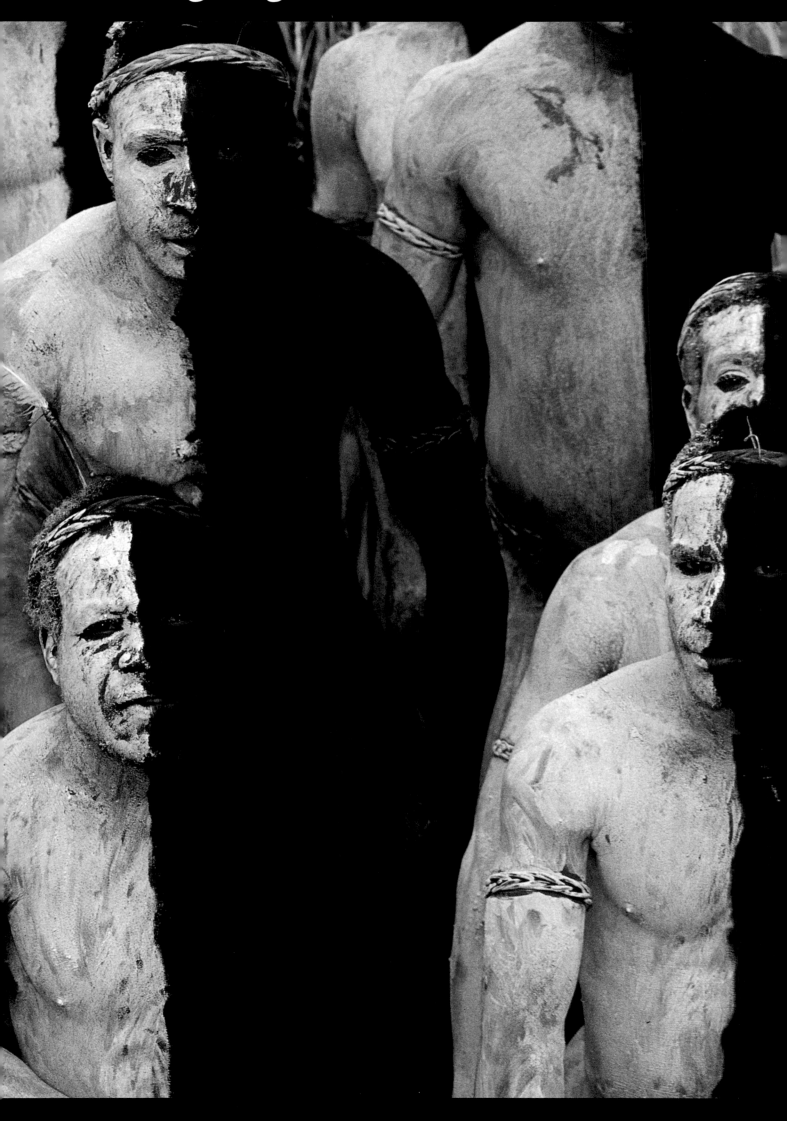

Singsing

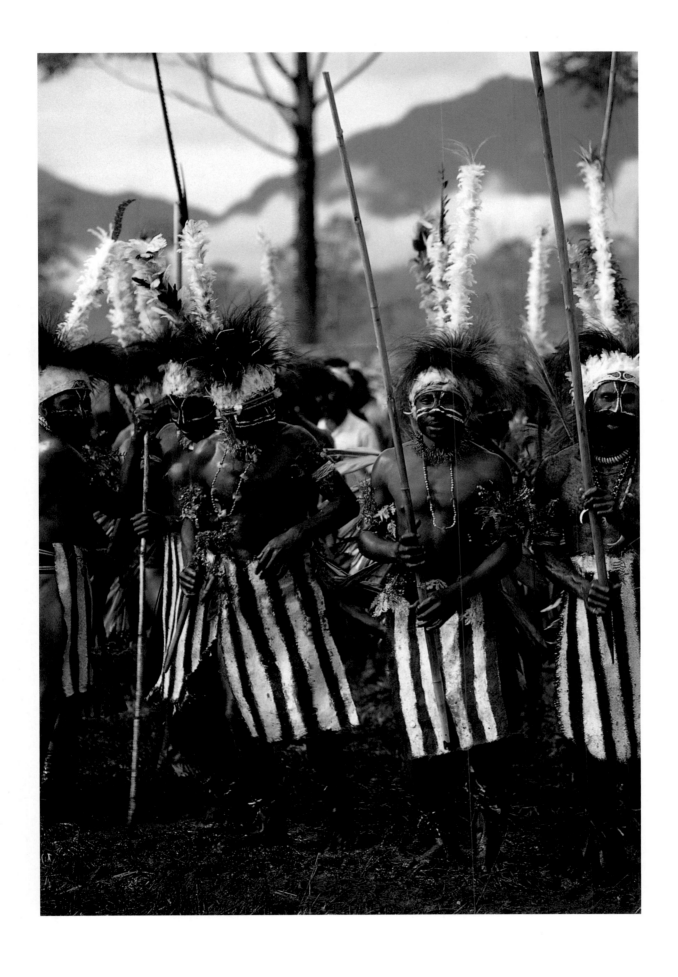

(previous pages) SIMBU DANCERS

SIMBU MEN

(opposite) SIMBU MAN

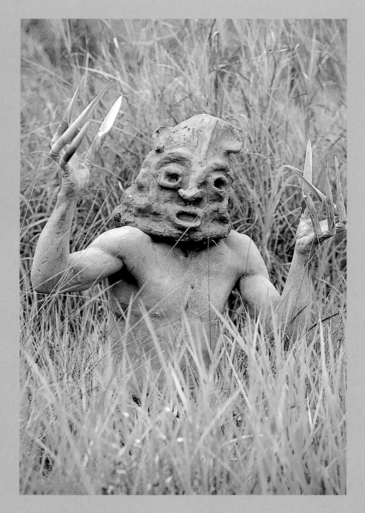

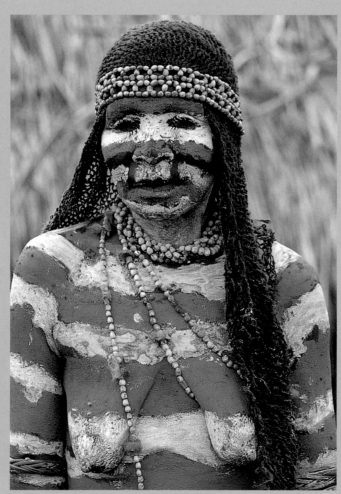

(*top*) ASARO MUDMAN; (*bottom*) EASTERN HIGHLAND
WOMAN IN MOURNING ADORNMENT

(*opposite*) ASARO WOMAN

78

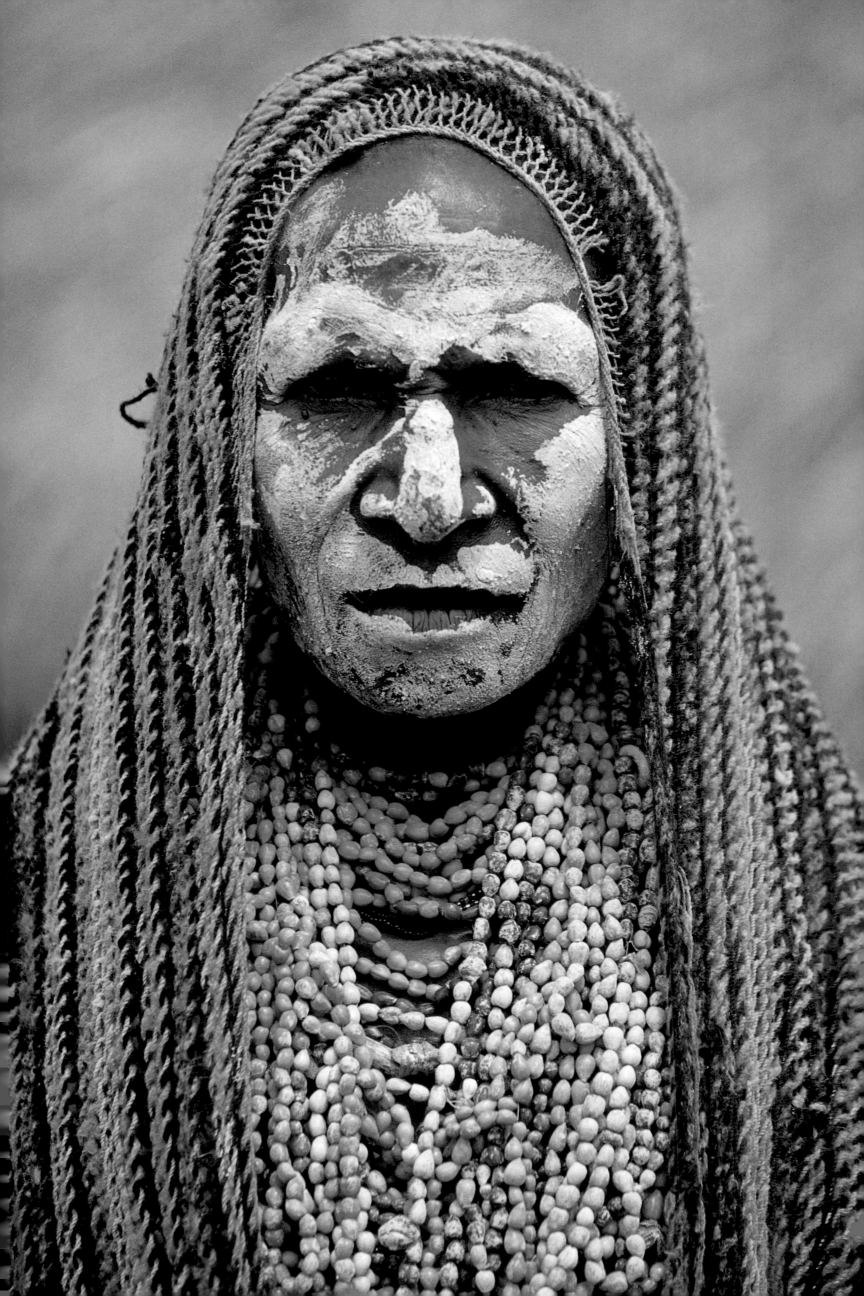

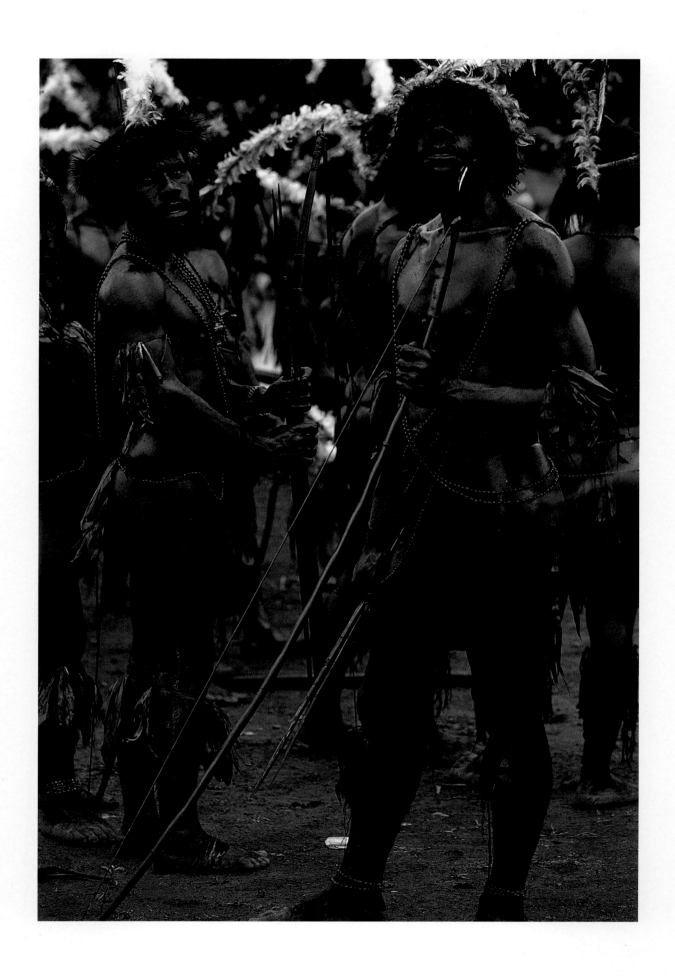

BOMAI WARRIORS

(*opposite*) BOMAI WARRIOR

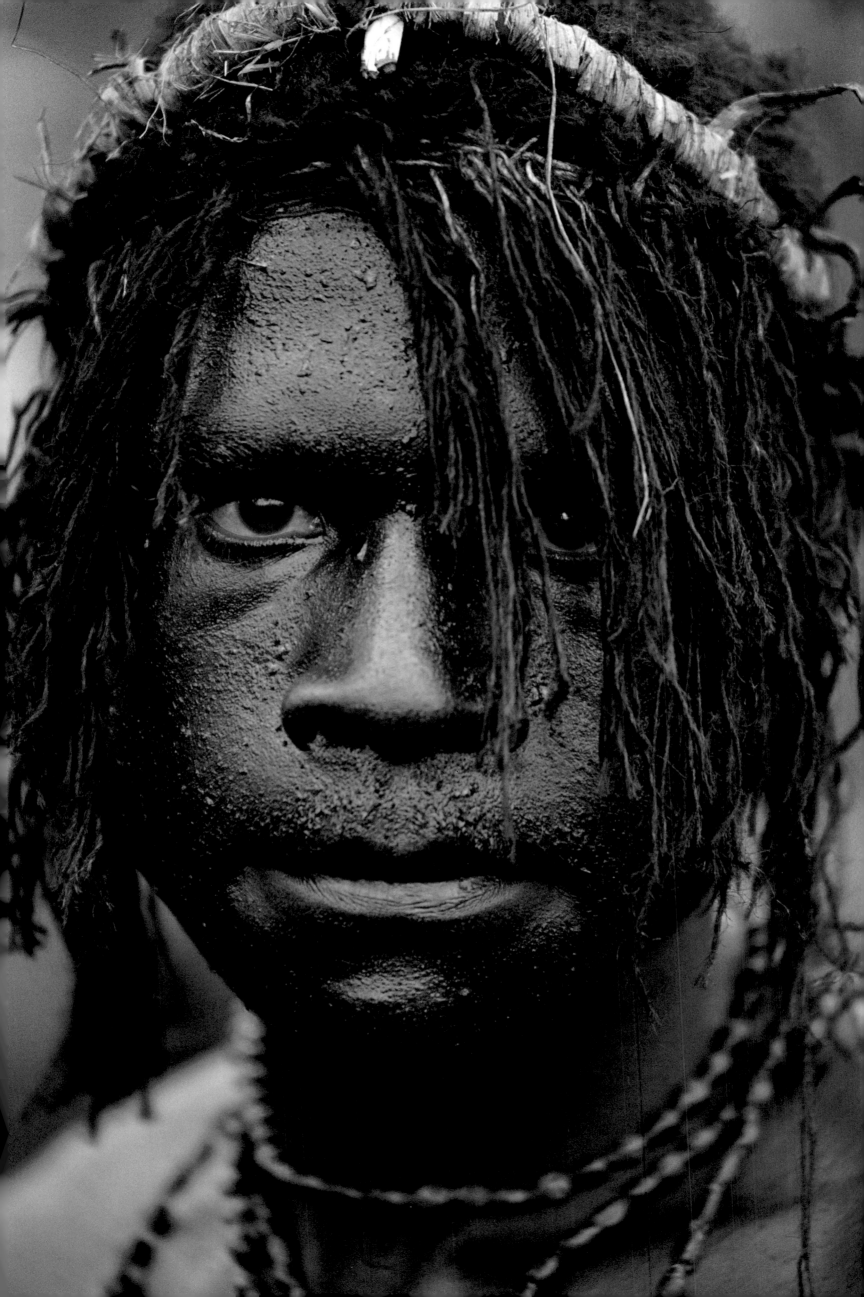

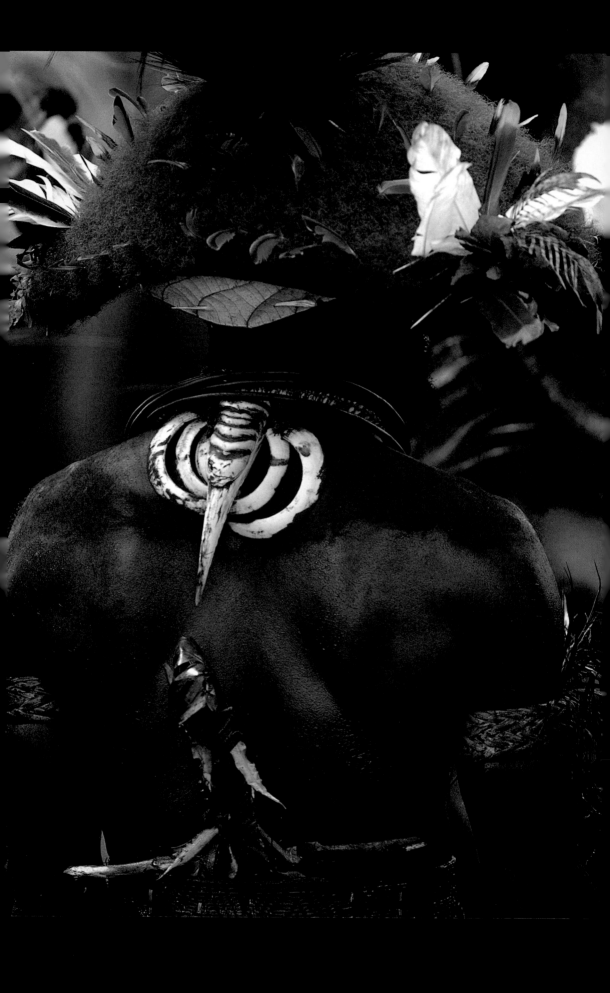

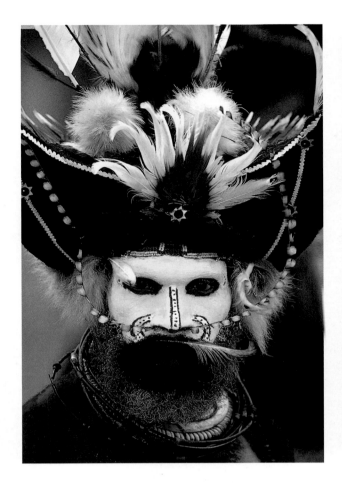

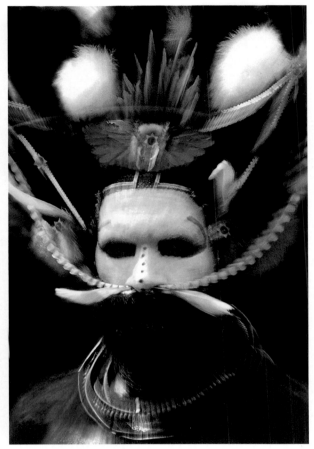

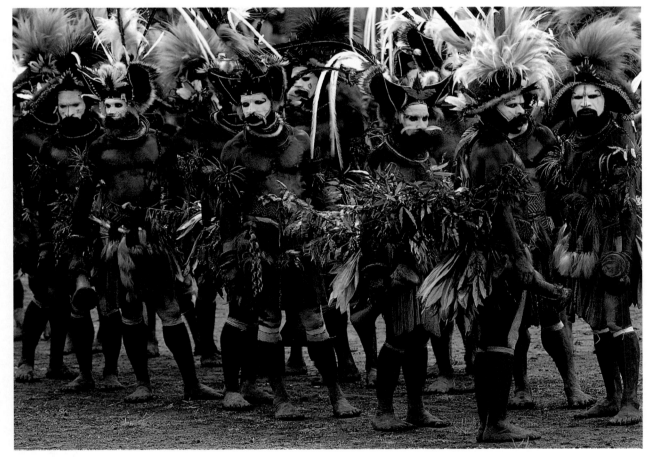

(opposite, above, and previous pages) HULI MEN

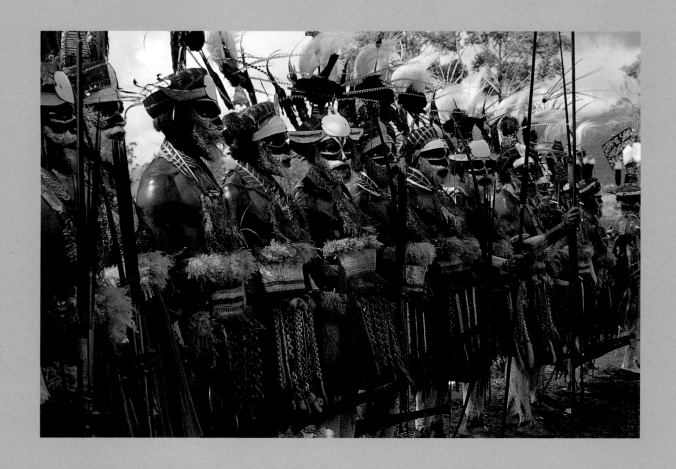

MENDI MEN

(*opposite*) MENDI MAN

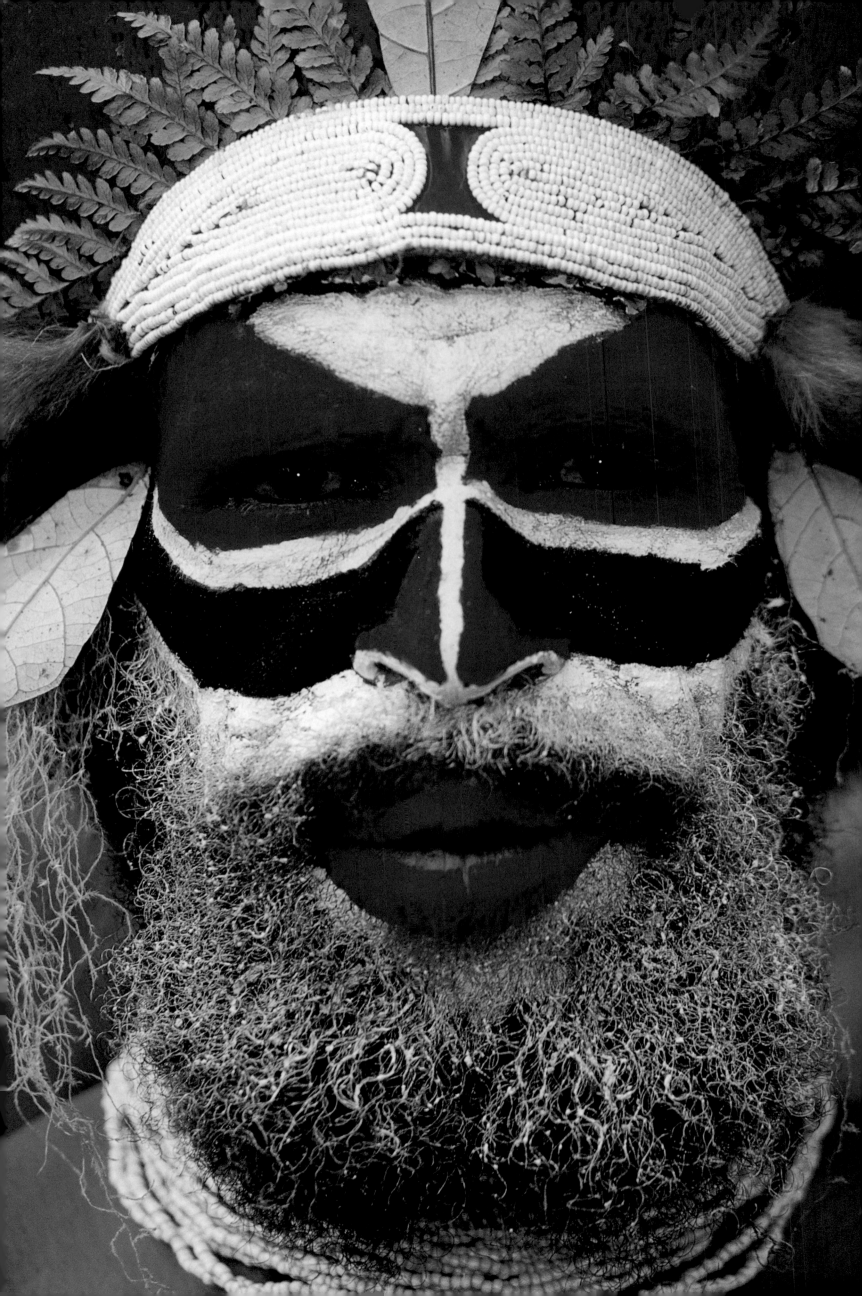

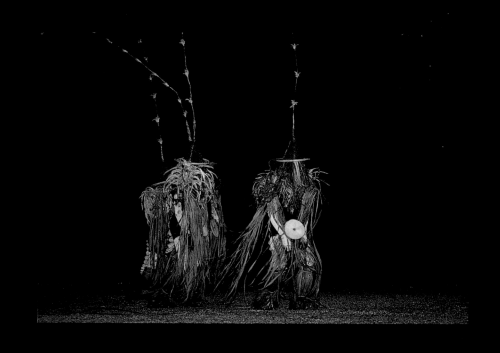

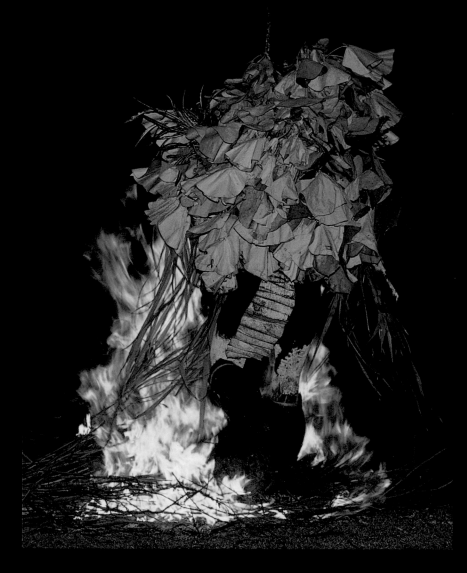

BAINING FIREWALKERS

(*opposite*) EAST NEW BRITAIN ISLAND BOY

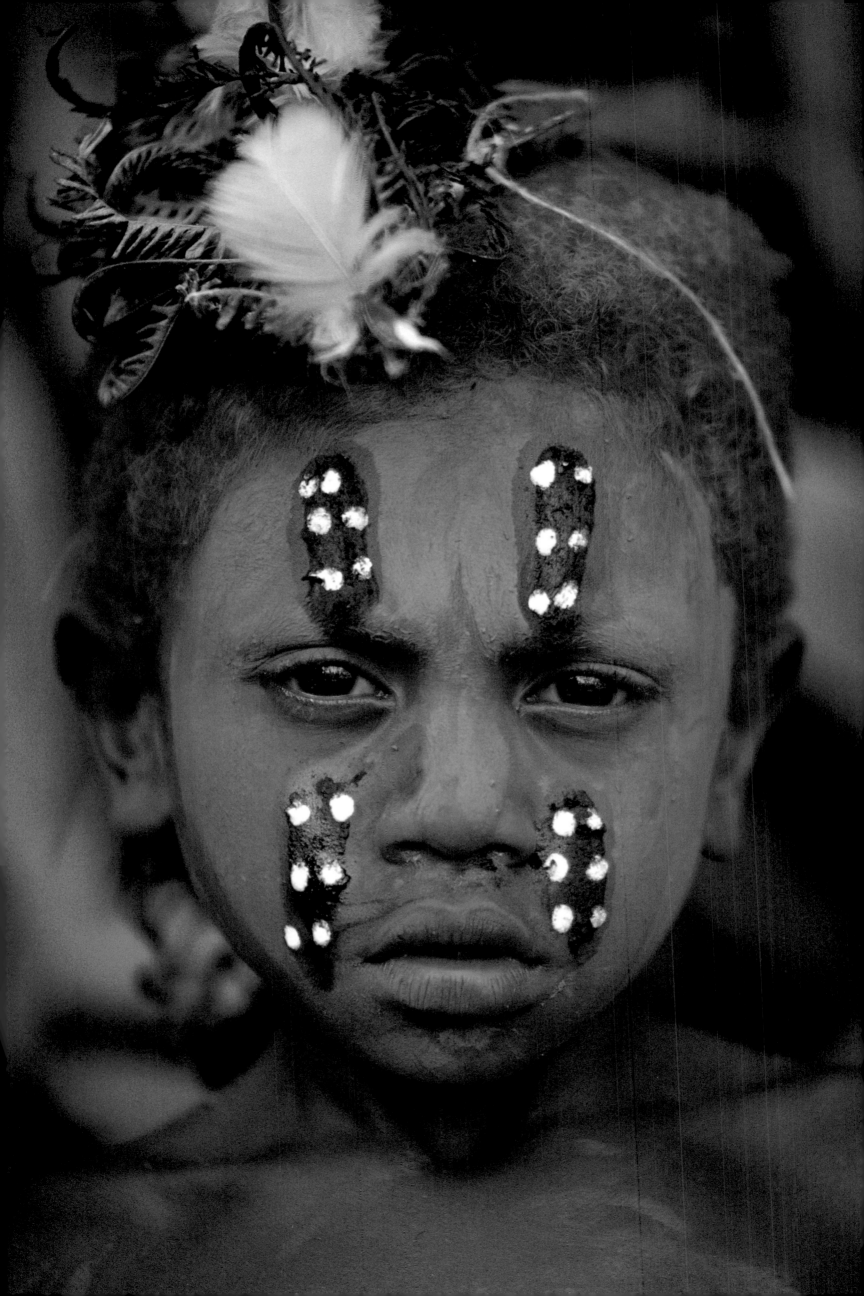

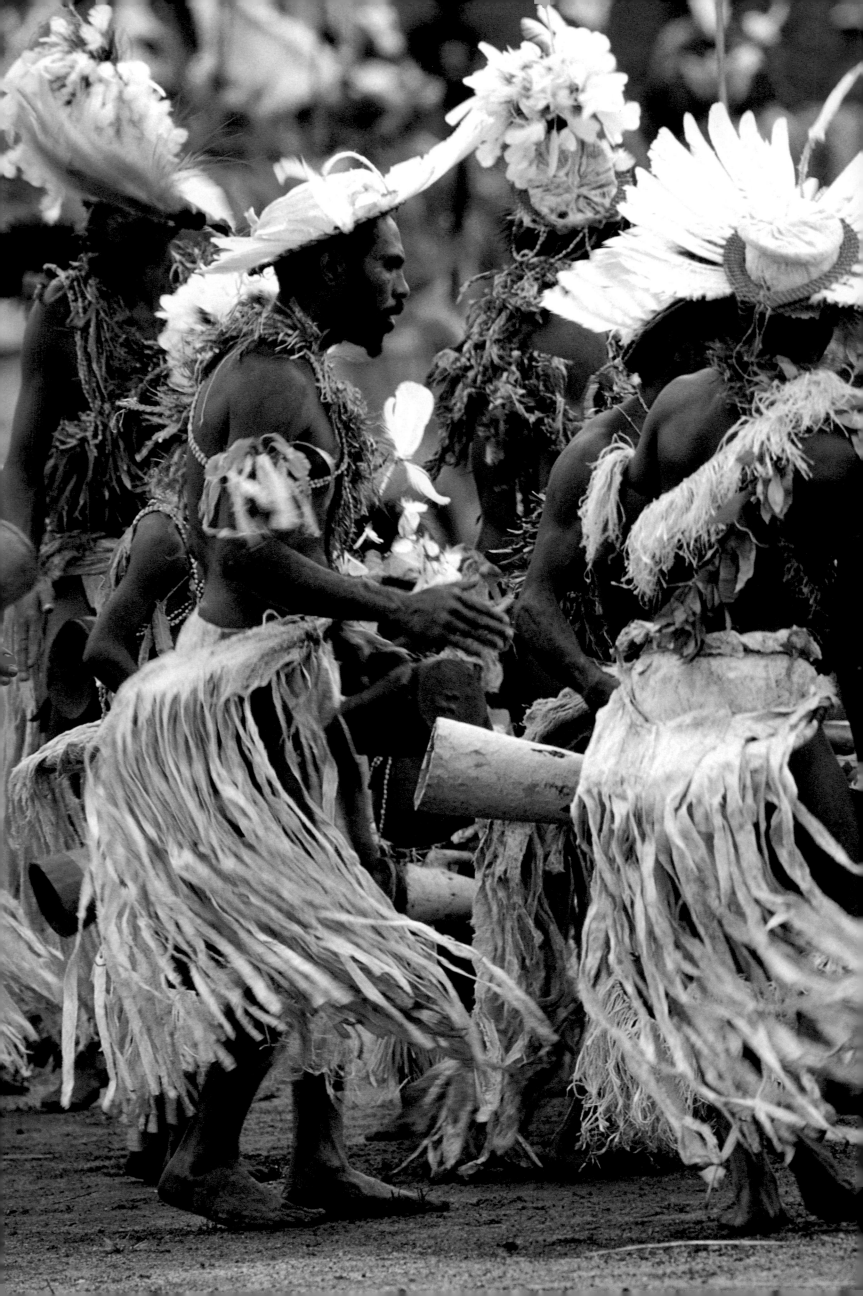

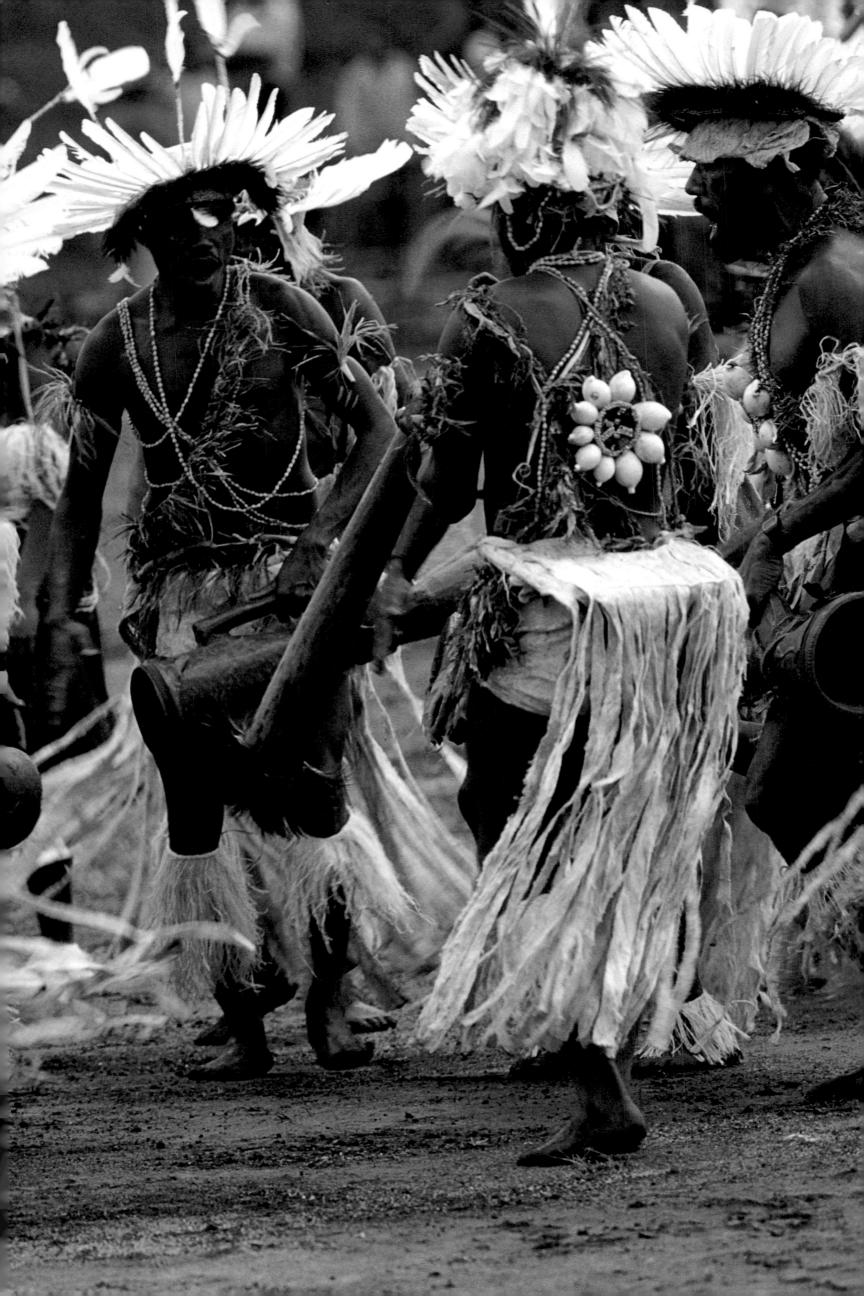

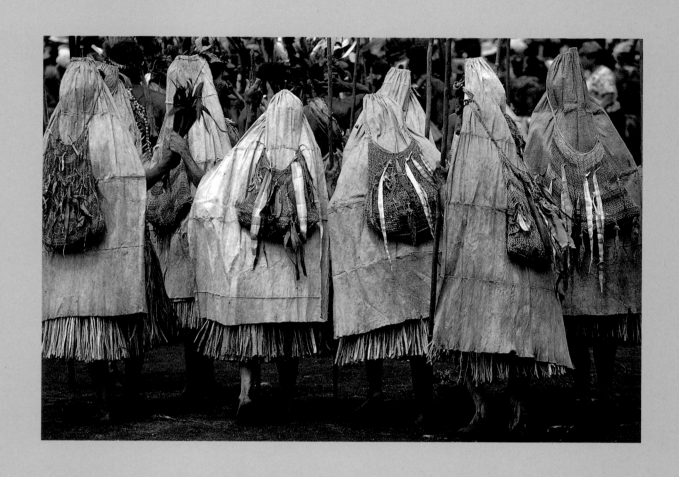

KAIMANGA WOMEN

(opposite) KAWELKA MAN

(previous pages) MOUNT HAGEN DANCERS

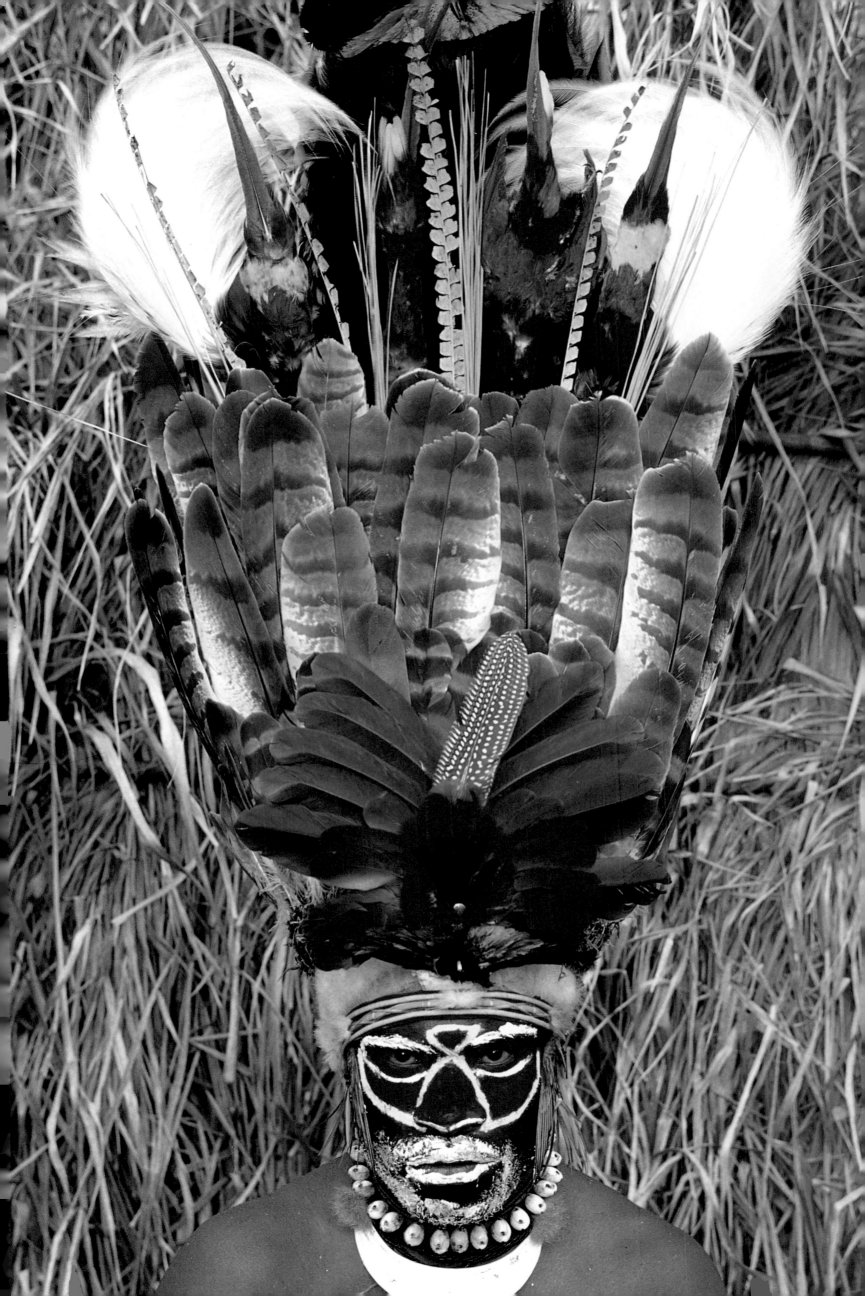

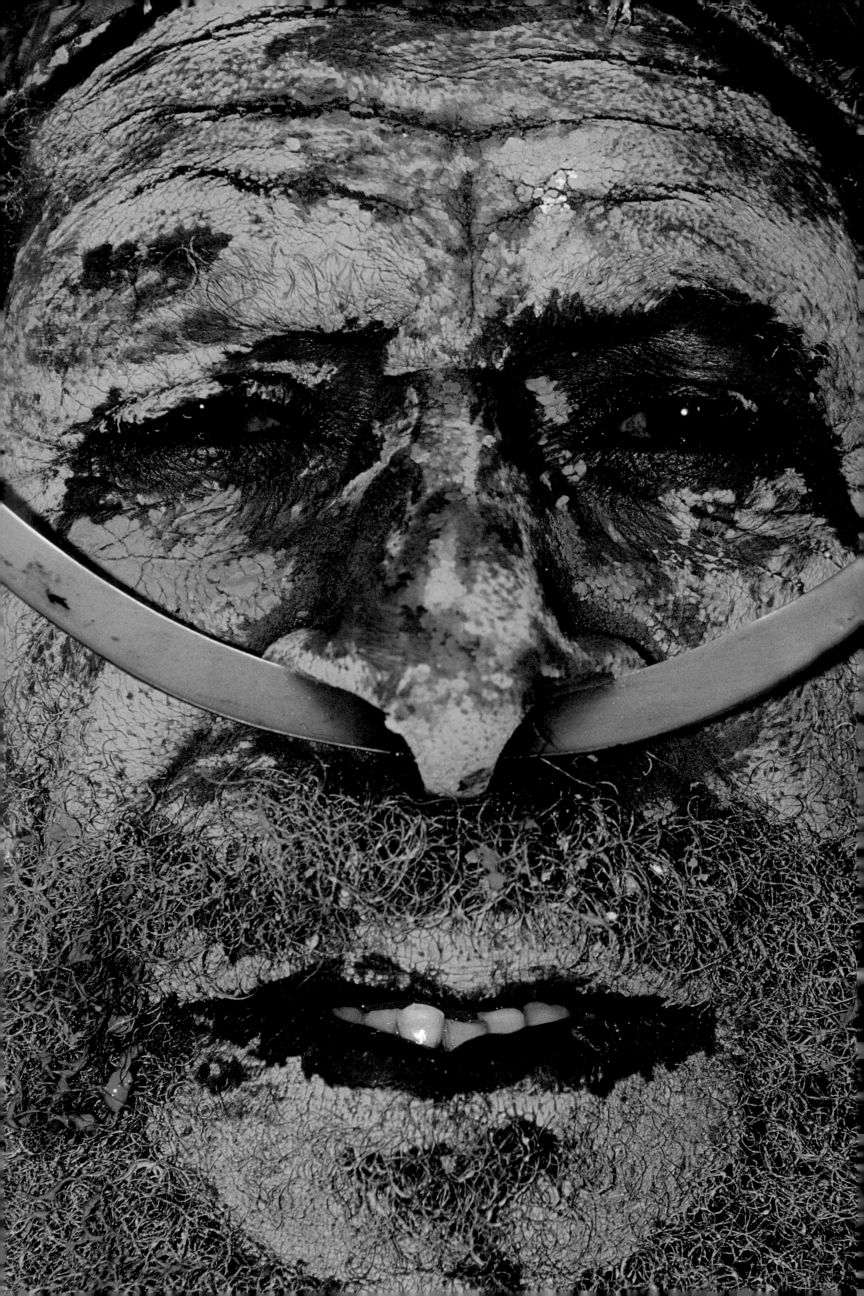

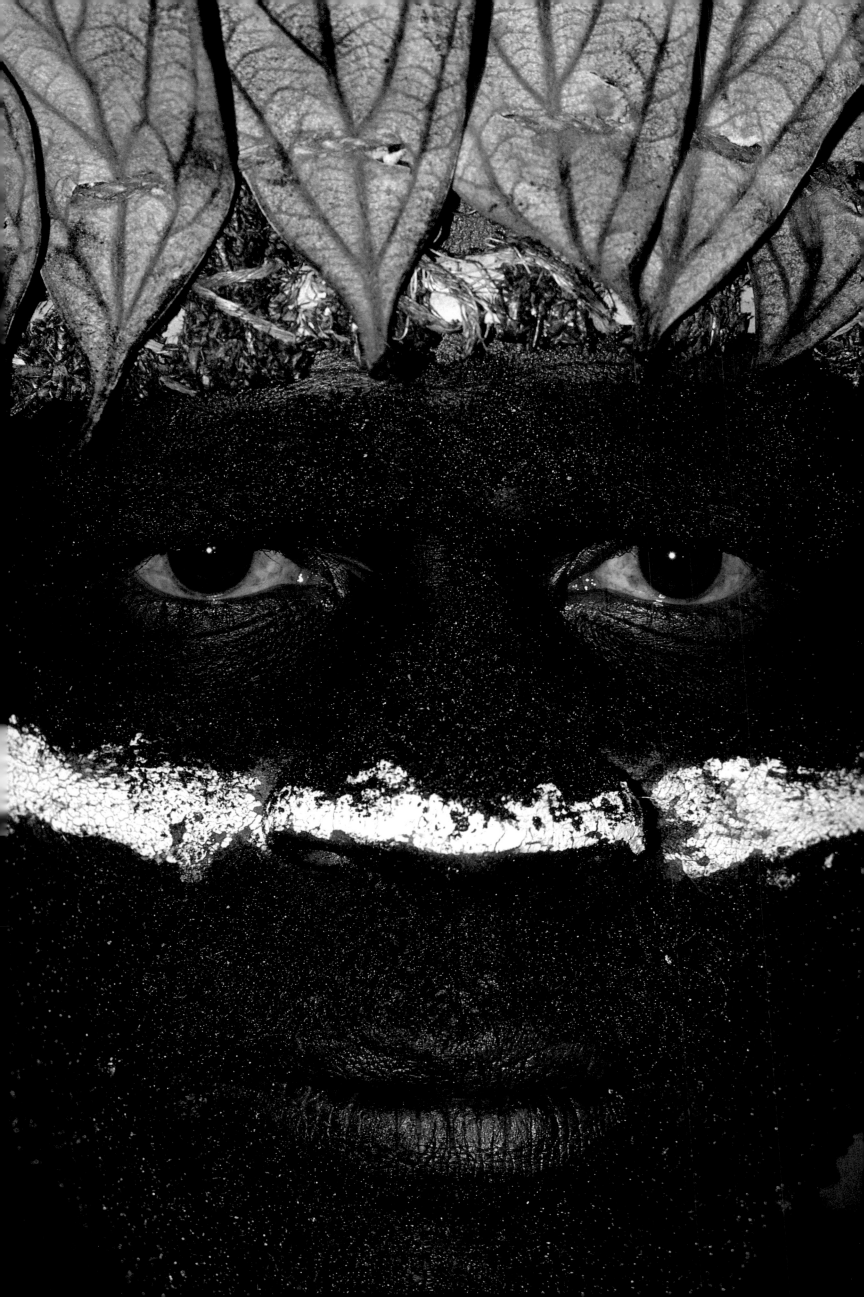

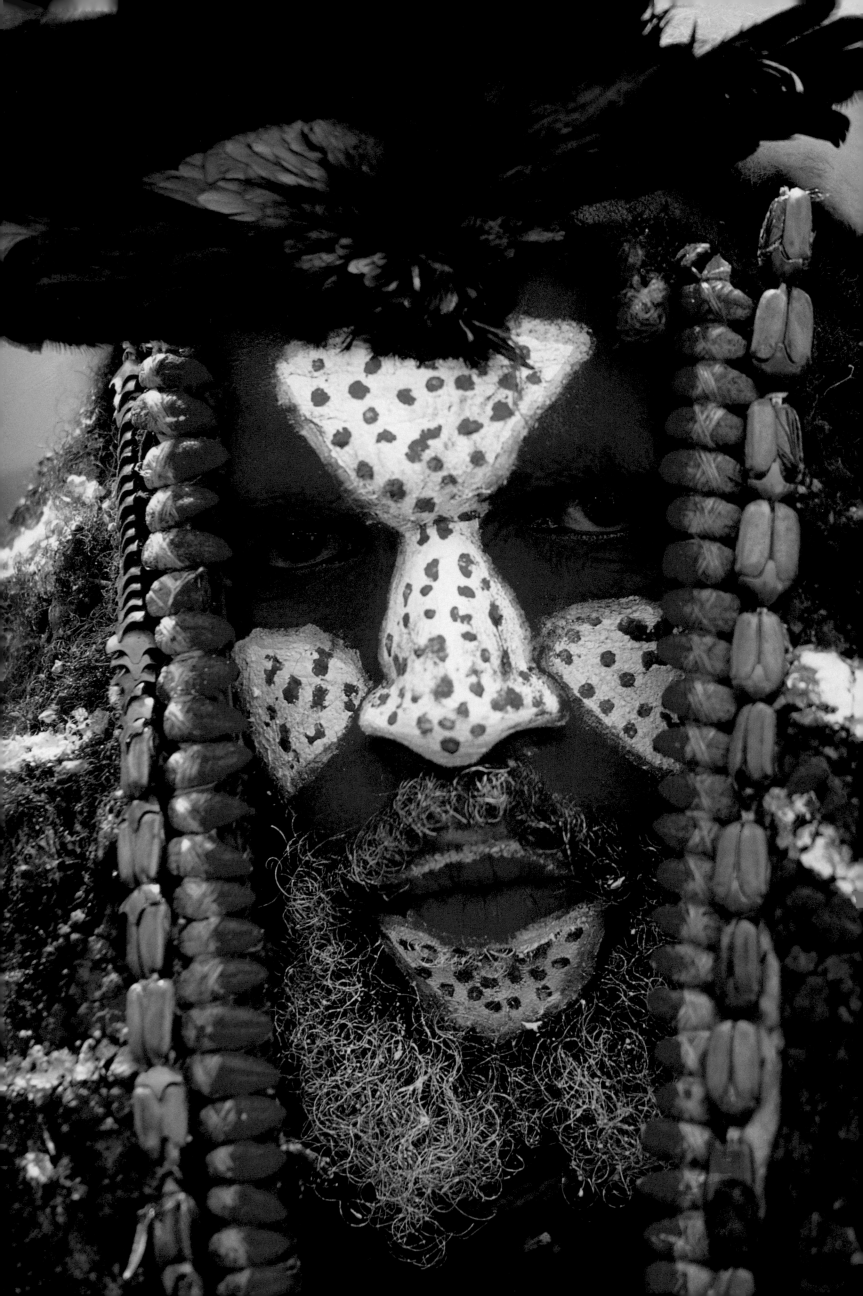

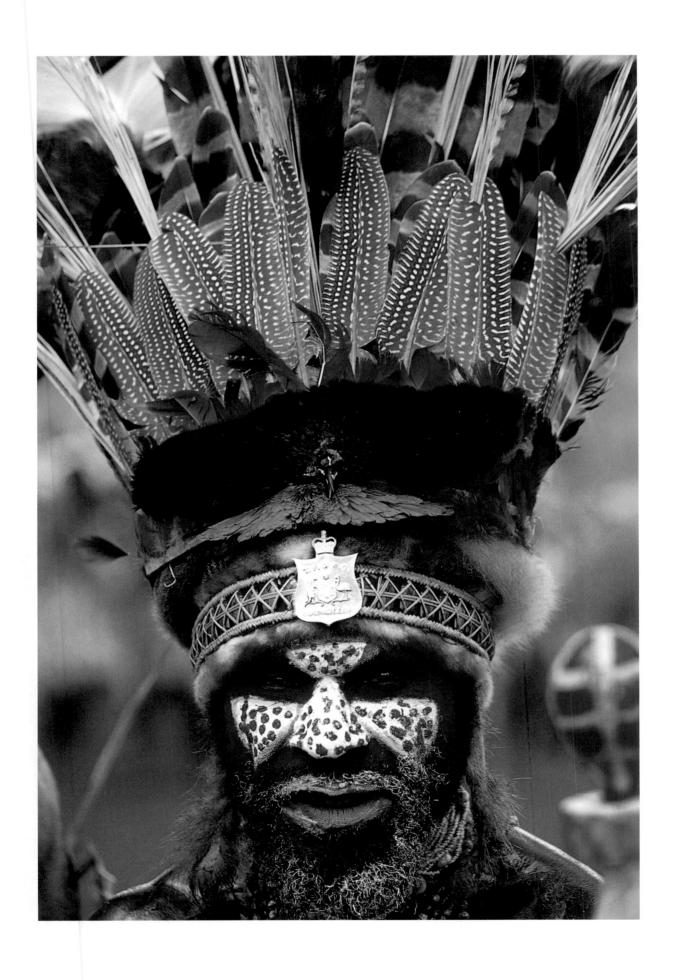

(opposite and above) PANGA MAN

(previous pages) MOUNT HAGEN MEN

THE MOST STUNNING of all tribal celebrations are the singsings of Papua New Guinea. In *tok pisin*, the national language, singsing signifies a festival that involves dancing, feasting, and singing. Singsings are held all over, but the one in Mount Hagen may be the largest. There were over seventy tribes participating when I was there, thousands of onlookers, and probably only a few hundred foreigners in attendance. The singsing is most definitely a tribal event, not one staged for tourists. Half a dozen judges circulate among the performers, taking notes and inspecting both the creativity of their adornment and the skill of their dancing. The top award is a cash prize, and it is coveted not just for the purse, but also for the honor. If the spectators consider the ornamentations and performance poor, the exhibiting group is shamed. The failure portends that someone in the group will soon die, so it is not surprising that Papuans work very hard on their decorations.

With rain in the afternoons and evenings, the morning was the only time available to photograph. For three hours on two mornings I rushed about the singsing like a madman, shooting nearly a hundred rolls of film in the process. To say the least, it was both an exhilarating and mind-numbing experience.

Asaro Mudmen

The mudmen, also called bush demons, are probably the most famous of all New Guinea tribal peoples. The whitish-gray body clay is the color of death and spirits, and the pointed bamboo "fingers" are nightmarishly sharp. The Asaro wear masks to reenact an occasion when their ancestors, near defeat in battle, were able to scare off the enemy by emerging from the river so disguised.

Bomai Warriors

Black is a male color, strong and forbidding in its effect. The overcast light that day smoothly reflected off the oily texture of the charcoal-and-oil-pigmented skin. Further augmenting the warriors' ferocity was the fact that they chew betel nuts, which turn their teeth and gums a bloody red. White chicken feathers and strings of blackened Job's tears seeds added ornamentation to the otherwise spare costumes.

The Huli

Not surprisingly the Huli wigmen usually walk away with the top honors at the Mount Hagen singsing. The overcast lighting made the crimson- and saffron-colored ochres glow with a violent intensity. The Huli wear heirloom human hair wigs, which they have turned up so as to resemble a pirate's tricorn, or turned down like an umbrella. A mark of manhood as well as being home to ancestral ghosts, the wigs are decorated with the wings and tails of innumerable birds of paradise species—it is a wonder there are any birds left in the forests. At the napes of their necks, the Huli suspend arcing boar's tusks and hornbill beaks. They also wear necklaces of smooth black cassowary quills and cowries. Bustles of fresh leaves cover their backsides while woven aprons with pig's tail tassels cover them in front.

Some of the Huli dances imitate the courtship display of the bird of paradise; the birds are symbols of sexual attraction and reproduction. They also "breed true," that is, transmit dominant markings consistently. When the Huli imitate these birds, they flex their knees and swish their aprons, giving attention to every aspect of their decoration.

The Mendi

The overcast day could not have been more perfect for portraiture. In combination with a fill-flash, the light allowed the brilliant reds and stellar yellows of the Mendi tribesmen to "pop." A man's face becomes divided into fields of color: charcoal and crimson and gold. This living canvas is framed by a headband of white beads and a beard full of white chalk.

Highland leaders are self-made men; they excel in persuasive oratory and political organizing. Their ambition for prestige motivates them, and they gain this prestige through elaborate gift exchange ceremonies. Gift exchange links thousands of people in the highland valleys, crossing both tribal and language barriers. It is a simple concept of giving, receiving, and the resultant obligation that can become wildly complicated and politically charged. Within the many societies of the highlands, however, gift exchange maintains the balance of power.

The Tribes of Mount Hagen

The older dancers charcoal themselves so heavily that their faces become more like landscapes with eyes. Some still hold to the idea that a dancer should not be recognizable so he will garner more praise, but I think youth is vain and likes to be recognized. A few participants simply paint their faces and wear only black cassowary feathers and tree-kangaroo headbands.

In a pageant full of statuesque headdresses, that of a Kawelka tribesman impressed me the most. I took him aside and photographed him against one of the grass dwellings where the performers were staying. Included in the headdress are whole, "spitted" lorikeets; the wispy, lemony plumage of at least two lesser birds of paradise; the luminous turquoise ruffs of superb birds of paradise; an eagle's worth of eagle feathers; a single guinea fowl feather for accent; and many other plumes.

The ingenuity with which these tribes adorn themselves is staggering. Out of charcoal, clay, moss, and leaves they are able to create a look at once organic and supernatural.

The Panga

The Panga are exceptional in their face painting, using both natural vegetable dyes and artificial pigments. The elders show off the brilliant younger women in dance, standing behind them like shepherds. Iridescent scarab beetles shimmer from headbands, and the turquoise breasts of superb birds of paradise fan out at the base of elaborate headdresses. One man included a government councillor's badge on his headband. Another had fashioned dreadlocks from beetles and seed pods.

Simbu Warriors

The Simbu men were almost a mirage when I first saw them. They paint themselves with black charcoal and white clay, and despite the language barrier, understood exactly what to do when I motioned for them to line up. The black and white paints were so clean and compelling that in deliberate staging they became less human beings than a study in form and color. Even in dancing, the primary color scheme of the Simbu worked in perfect unison.

Tribeswomen of the Highlands

While the Kaimanga dancers from the Eastern Highlands added their distinctive dress of bark-cloth capes, other women adorned themselves in typical mourning attire. When Highland women are in mourning for a close friend or relation, they plaster themselves with mud. Some paint themselves in corresponding bands of color, while others employ a dour monochromatic style. Woven bags are worn over their heads in a shroudlike manner, as well as Job's tears necklaces and headbands.

The role of women in Papuan tribal societies is hardly relegated to mourning for lost kin. While their daily lives are somewhat segregated from men in their tribes—they have separate responsibilities, obligations, and living quarters—women are quite powerful and rich on their own accords. Women have been known to divorce their husbands over the killing of a prize hog without permission.

Baining Firewalkers— East New Britain Province

New Britain Island is known for its luxuriant forests, productive plantations, and volcanoes. The main city, Rabaul, is surrounded by a scenic, volatile ring of fire.

Invisible under bundles of leaves, huge masks, and headdresses made from bamboo, grasses, and paint, the Baining perform their spectacular fire dances. In the darkness with only the hot blaze of the fire, they are barely recognizable as human, seeming like otherworldly beings wildly exorcising evil before fleeing back into the forested mountains. Indeed, many of the tribes that once inhabited the Rabaul area have fled into the hills, driven there by the combative Tolai tribes, which invaded from neighboring New Ireland.

Just weeks after I returned from Papua New Guinea, I read of a volcanic eruption on the Gazelle Peninsula of New Britain Island. The lush rainforest where I had been able to photograph tribesmen clad in nothing but red ochre and green paint was now covered in a thick layer gray ash. Like many all over the world living in the shadow of volcanoes, the inhabitants of New Britain have experienced this calamity before, and they have survived it, enduring hardship but rising once again from the ashes.

Aboriginals

AUSTRALIA

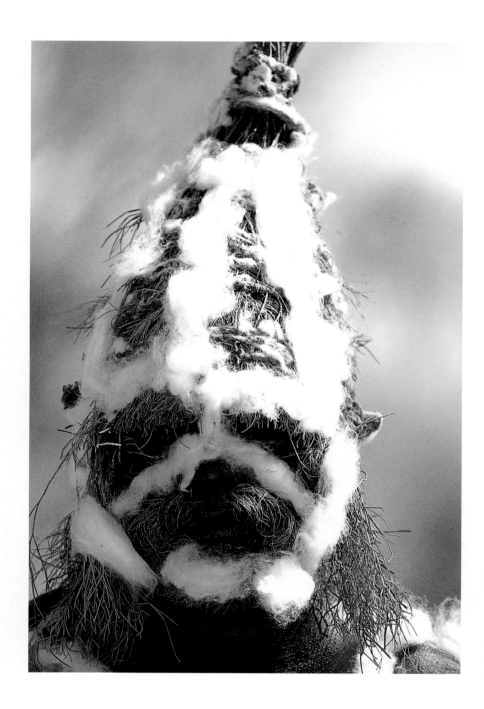

ABORIGINAL ELDER IN DREAMTIME RAIMENT

(opposite) ABORIGINAL DANCER

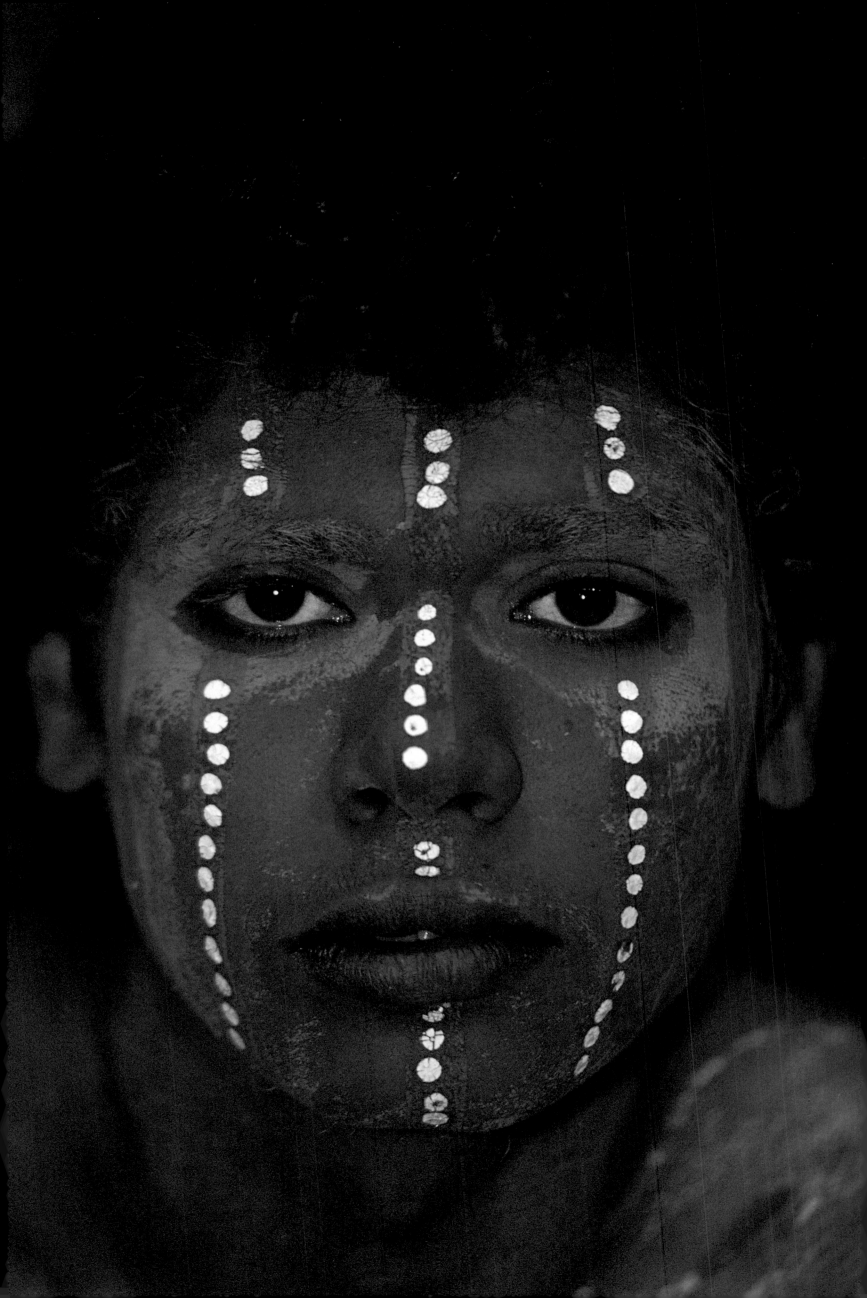

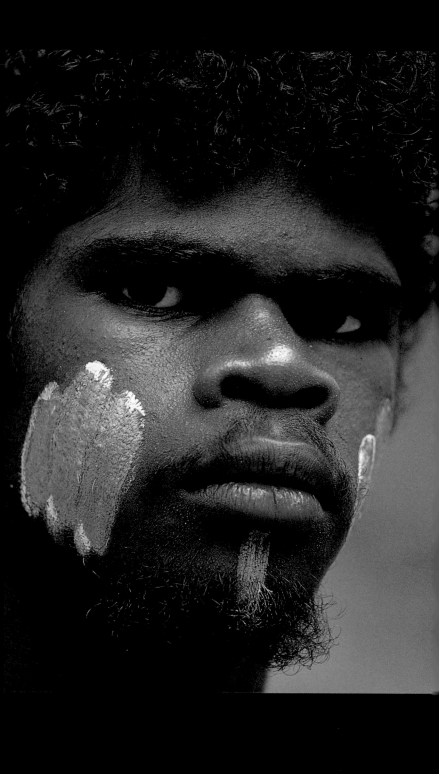

AT ONE TIME nearly five hundred Aboriginal tribes existed, each speaking a different language or dialect. These semi-nomadic hunter-gatherers were restricted to their own territories by strict self-enforced taboos, but they joined with adjacent nations along well-established routes called song-lines for *corroborees*, or religious ceremonies, and for trade.

Of two different groups I photographed one was a rainforest tribe near Cairns in Queensland, and the other was a tribe living near Australia's arid center. Many Aboriginals have a well-founded suspicion of outsiders. As with Native Americans in the United States, they have experienced many of the same persecutions, atrocities, and humiliations, such as wholesale extermination, removal from tribal land, and alcoholism. Despite their initial reticence, both groups came to understand my project and permitted me to photograph them.

Two young men who are members of a popular, internationally known dance troupe decorated themselves in red ochre and white clay for their performance. The audience was a mixture of the native and the exotic; Aboriginals, Europeans, and Japanese sat together witnessing a performance the essence of which had changed little in a thousand years. In stark contrast to the sophisticated corporeal adornment of the dancers, a tribal elder performed a dream dance under the hot desert sun nearly a thousand miles to the southwest. Swathed in outback plants, his human identity blurred and faded into the iron red earth and vivid blue sky.

Songs and dances are integral to the Aboriginal way of life. As Westerners often seek to define everything in our world, the Aboriginal "Dreamtime" escapes compartmentalization since it is based on the ideas of the subconscious. Traditional Aboriginals spend a lifetime absorbing the knowledge and following the teachings of Dreamtime. Songs and stories are layered with meaning, celebrating and renewing the sacred landscape.

It is indeed an error to describe Dreamtime as only being the time when earth was created and gods walked the land, singing it into wakefulness. Dreamtime is not only the past, but runs parallel to the present. Reality is multidimensional, and Dreamtime is merely a deeper level. According to the Aboriginal belief system, the cosmic scheme of which everything is a part needs both constant maintenance and renewal. Corroborees aid in this renewal, as does the walking of song-lines, which are the paths of the gods.

Since each Aboriginal has a totem in the physical world, such as a waterfall, kangaroo, or tree, they are bound steadfastly to the land. When they were removed from it by the Europeans, life for many became groundless and baseless. The Homeland Movement, aided by a landmark Australian Supreme Court ruling in 1992, is slowly allowing Aboriginals to return to their tribal lands so they can live in a more traditional manner. Many Australians think this is what the Aboriginals should do. But one can never go back in the true sense of the word. Most Aboriginals no longer have the requisite knowledge or the desire to return; like many other tribes in the industrialized nations, Aboriginals simply want to preserve their culture as part of their modern lives.

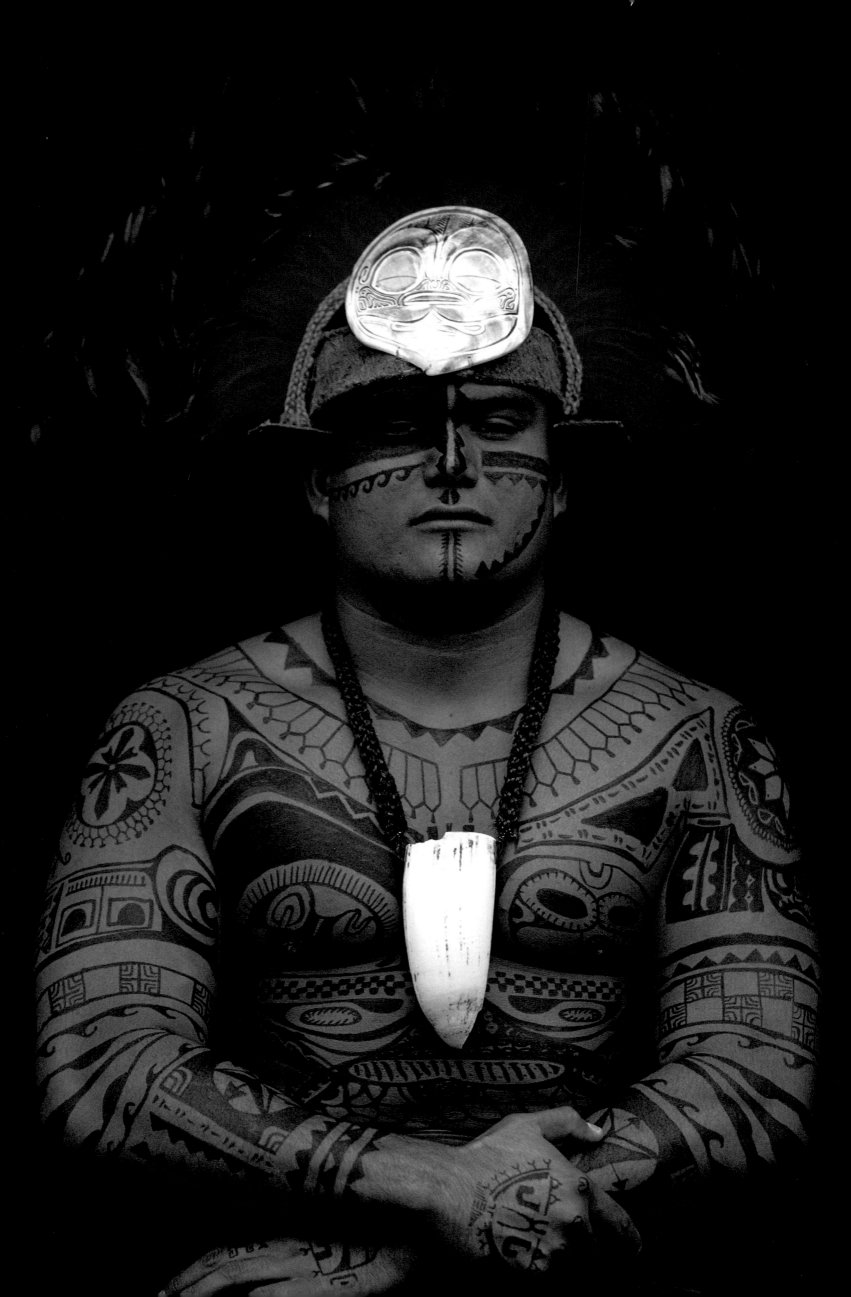

Polynesian Tattoo

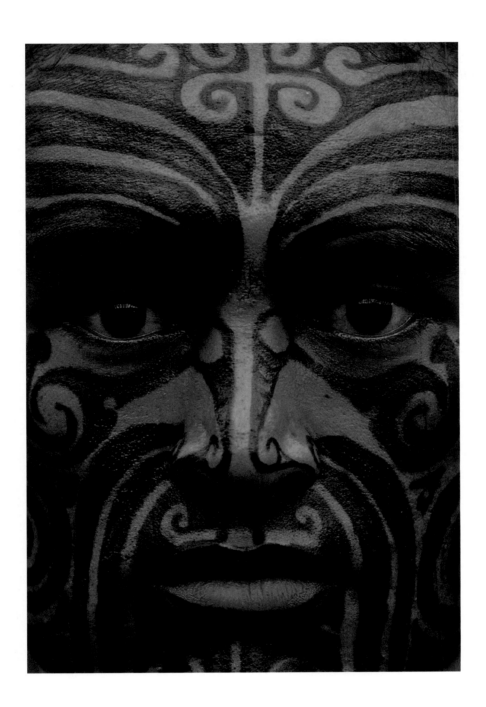

MAORI MAN

(*opposite*) MARQUESAN MAN

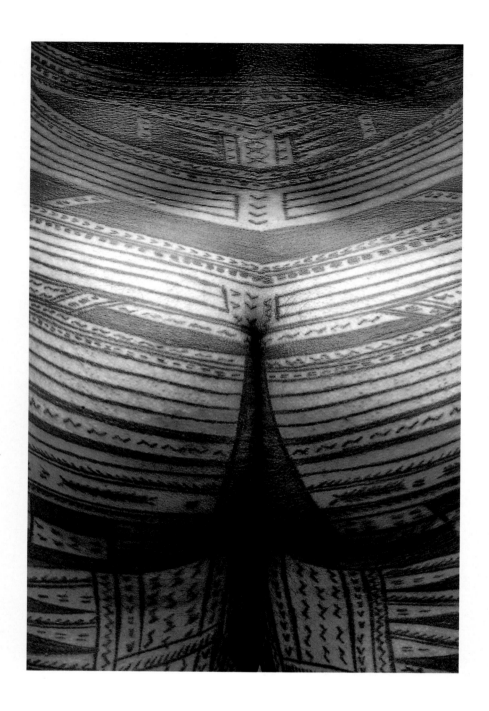

SAMOAN BODY TATAU

(*opposite*) MAORI MAN

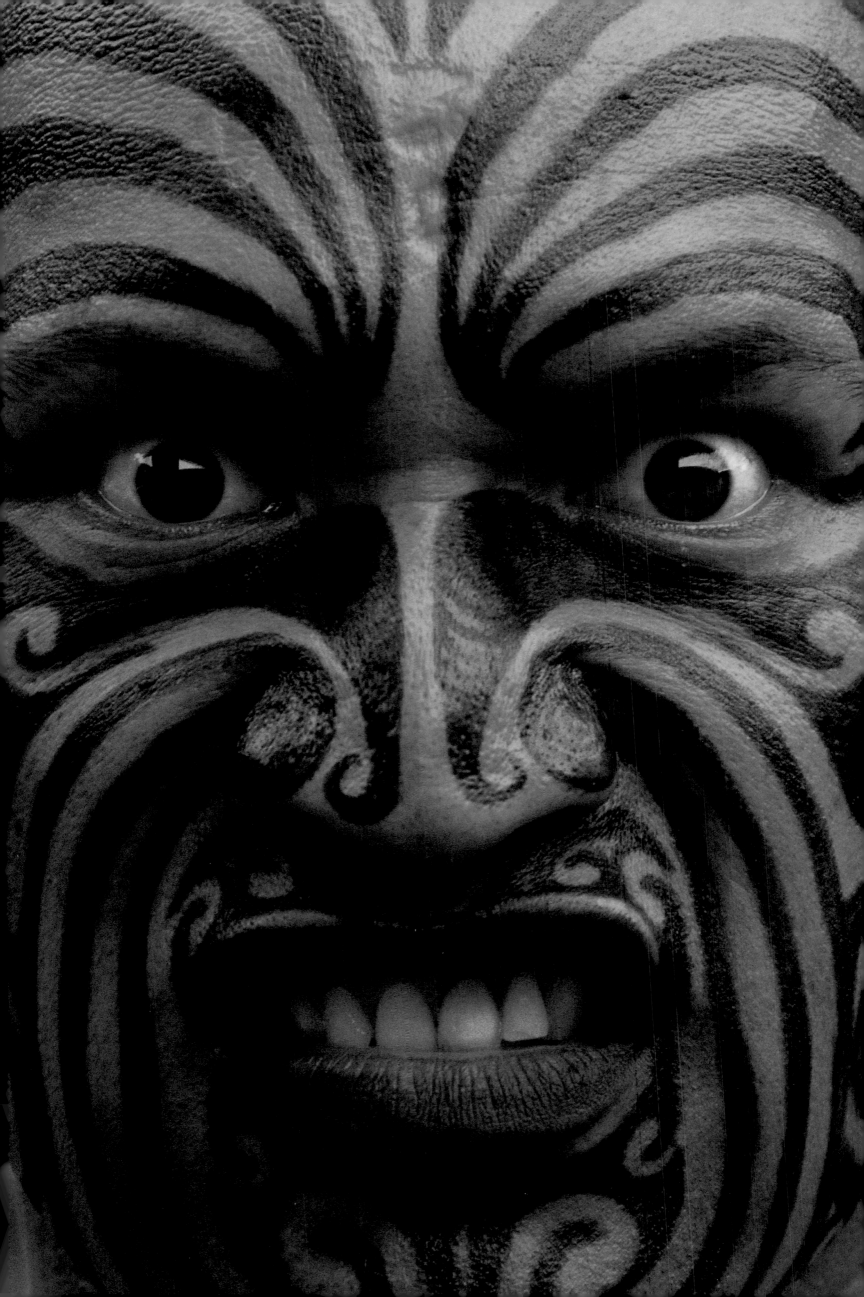

TATTOO IS THE TAPESTRY of Polynesian culture. In traditional times it defined a person, his or her rank, ancestry, profession, and beliefs. With the coming of the European explorers, missionaries, and settlers, a once omnipresent form of cultural expression declined precipitously.

Tattooing is an age-old art, practiced by ancient Egyptians and Romans alike. It is widespread, found in tribes from Asia to Africa to the Americas. A related art, scarification, is practiced by numerous African tribes, such as those found in the Omo River valley, and by Australian Aboriginals.

Polynesian tattooing is done with a broad comb, up to two inches wide, dipped in pigment then placed on the skin and struck with a wooden mallet. Finer details are done with narrower combs. But tattooing is more than the decorative art form that most Westerners believe it is. In Polynesia it is an integral aspect of religious, economic, and social tradition, and is practiced by the younger men of the societies who are intent on preserving their cultural identity.

While *tatau* is still practiced in Samoa, the full body tattoos of the Marquesans and the facial *moko* of the Maori are a thing of the past. For festivals and ceremonies the Maori paint their faces in the traditional design. Before I photographed them, the young Marquesan and Maori men spent hours having tattoos painstakingly drawn on them with felt pens—a modern adaptation of an ancient art.

One Samoan man with a traditional body tattoo commented to me on the curiosity and aversion he aroused in people unfamiliar with it. At first, he said, they would approach him and ask how he could do such a thing to himself. "I would explain what it means to me, to Samoans as a whole, and they would walk away much more appreciative and much less judgmental of it as a form of social expression."

Maori Moko

The Tahitian *tatau* was unknown to the Maori, whose moko was singular among the Polynesians.

In moko, the skin was actually carved with a chisel to "clear" or groove the skin for the introduction of pigment. Ancient moko was performed with bone chisels tapped with a mallet, but after European contact these were replaced with metal.

Male moko was a badge, a designation of member-

ship to a particular clan and social standing. The face was divided into four fields: left and right forehead to the eyes, and the left and right lower face. Within these major areas secondary design fields fell along the jaw, ears, and central forehead. The right side of the face was devoted to the father's rank, tribal affiliation, and position, while the left was devoted to the mother's. Needless to say, Maori society was a highly structured one.

Despite this structure, moko was not confined to ranking families or indeed to men. Rank and status could be earned by outstanding achievement. Women who outranked men by virtue of their genealogy were usually regarded as men and possessed the rights and privileges of chiefs, including the traditional masculine moko.

In 1845 a Maori woodcarver carved a madonna for an altar of a Catholic church. The Virgin was tattooed completely as a male, which indicated her purity to the Maori worshipers. Not surprisingly, the statue was rejected by the priest; later it was obtained by an art collector.

As male moko declined in the nineteenth century, reviving in brief nationalistic spurts after wars with Europeans in the 1840s and 1860s, female moko began to develop. Until the 1940s, *tohunga*, or tattooers, were in demand for female moko. Women took up the ancient ways to emphasize the social importance of maintaining a link with the past and to demonstrate tribal pride.

A traditional prayer sung to calm those under the chisel beckons over the ages:

> *Man with no ornament,*
> *Stretch out here.*
> *Be struck with the mallet.*
>
> Te Rangikaheke, ca. 1853

Marquesan Tattoo

Las Marquesas de Mendoca are comprised of six major islands in eastern Polynesia. Unprotected by atolls, they are at the mercy of the pounding seas. When the Marquesas were annexed by France in 1842, the indigenous political system quickly fractured. This was succeeded by an appalling decline in the population, and by the 1920s it hovered at around 2,000. The Marquesas became yet another testimonial to the brutality of colonialism.

The full-body Marquesan tattoo was an instant

(opposite) SAMOAN FIREDANCER

curiosity to Europeans; many Europeans themselves went under the comb for their own financial gain, finding employment as curiosities in traveling shows. However, a tattoo done without understanding is merely decorated skin, and the owner will not benefit spiritually.

Traditional Marquesan tattooing was perhaps the most complex of all Polynesian styles. Just the fact that it covered the body literally from head to toe in geometric designs, rectangular spirals, and parallel zigzags set it apart visually. As a denoter of wealth, endurance, status, and strength, men and women who were tattooed were far more desirable for marriage.

Anyone could rise to the position of *tahuna*, or tattooer in the Marquesan language. If a boy demonstrated artistic talent and potential, he would be apprenticed to a tahuna. Like modern-day beauty schools, cut-rate tattooing was offered by the apprentices. Since the poor were most affected by the exorbitant price of tattooing, this was the only way they could get them.

Like the Samoan tatau, the Marquesan ritual marked the coming of age for a young man, and it was done at puberty. A special house would be built for the process, which would often take six weeks or more. A strict taboo was placed on the tahuna and his subject; they were not to be approached, especially by women, who were thought to be unclean. After a ritual cleansing, including fasting and sexual abstinence, the *opou*, or eldest son, would go under the tahuna's comb. During the protracted period the opou's siblings would receive lesser tattoos while he was resting between the hours-long sessions. After the tattoo was complete the young man would be celebrated with feasts by the village. The raw tattoo would be rubbed with bright yellow turmeric to enhance and draw attention to the spectacular designs covering his body. A modern tattoo, drawn on with pens, is rubbed with talc to give it added luster, as in the photograph on page 104.

Tattooing of women was casual by comparison. No special ceremonies accompanied the female tattoo. The tahuna would perform his trade in the woman's dwelling; the wealthier the woman, the more extensive and elaborate the tattoo. While it was obligatory for the opou, for women it was merely a status symbol.

As a coveted aspect of Marquesan life, a tattoo was believed to be unacceptable in the afterworld, or *Havai'i*. In some areas of the islands, tattooed skin was removed before burial. It was believed that the supreme goddess Oupo, who ruled over a lovely, Eden-like region of Havai'i, excluded those with even a trace of tattooing. Her domain was situated around a freshwater lake surrounded by abundant forests. Only those with many pigs and servants could reside there, and of course, the wealthy were always those most decorated. The reason for this anomaly is unclear—perhaps Oupo did not want the tattoos, accompanied by all their social connotations, to bring discord to Havai'i.

Samoan Tatau

Once there were two sisters who swam from Fiji to Samoa. All the while on their journey they sang songs of the art of tatau and how it beautified women. They carried with them the tools—the various bone combs and the requisite knowledge. When they neared Samoa they espied an oyster in the depths of the turquoise water and together they dove for it. When they rose to the surface, their songs had become confused: instead of tatau beautifying women, it beautified men. And so male tatau came to pass.

Samoan legend

Traditionally, tatau is for sons of chiefs, but in the modern era, money is the main determinant. However, a wad of dollars cannot buy understanding and respect for the culture tatau represents. Once the tatau was the mark of success in Samoan society. Without it a man could not participate in government or be influential with the local *matai*, or chief.

No longer does tatau have such powerful connotations; but, neither is it a painful exercise in futility. It requires a tremendous amount of courage and tenacity. Not everyone can afford a tatau and most certainly not everyone can bear it. An unfinished tatau is a major disgrace to both the individual and his family. The prestige of a full tatau from the torso to the knees is not to be underestimated.

The young man who posed for me explained that at first he was reticent to go through with the tatau, especially since he was only half-Samoan and did not speak the language. But his father persuaded him, telling him to get the tatau and the rest would follow; in fact, it would seem easy by comparison.

Over a two-week period with daily sessions of several hours apiece, the *tufuga* taps in the black dye. The young man is held down by friends who sing songs to

soothe him. The pain is acute, and it is necessary to bring it into perspective:

> *The woman must bear children,*
> *The man must be tattooed.*

Most songs are uplifting, offering encouragement throughout the ordeal, exhorting the young man to show courage and predicting his joy when the tatau is complete. Nothing is allowed to discourage the young man from finishing the tatau, and his friends never leave his side. They say prayers for him every day, as many have died during the process. At the end, the young man's skin is completely raw, and simple movements such as walking and bending are impossible to do alone. Many hours are spent in the sea, because the saltwater inhibits infection. A year will pass before the tatau and underlying muscle layer are healed.

Now the young man is a full member of the *aumaga*, a group of men who serve the chief. It is a group not unlike the Samburu and Maasai moran. By demonstrating uncommon determination and responsibility, he is held above most men as an example and an inspiration.

Tatau Detail

Even though every tatau is unique, they all have similar elements. One of them is the *aoao*, located in the small of the back. A sort of "antenna to the gods," the aoao is the center of the Samoan tatau. This one is buttressed by the sharp tines of a comb, in honor of the two women of legend who brought tatau from Fiji to Samoa.

AOAO, SAMOAN TATAU DETAIL

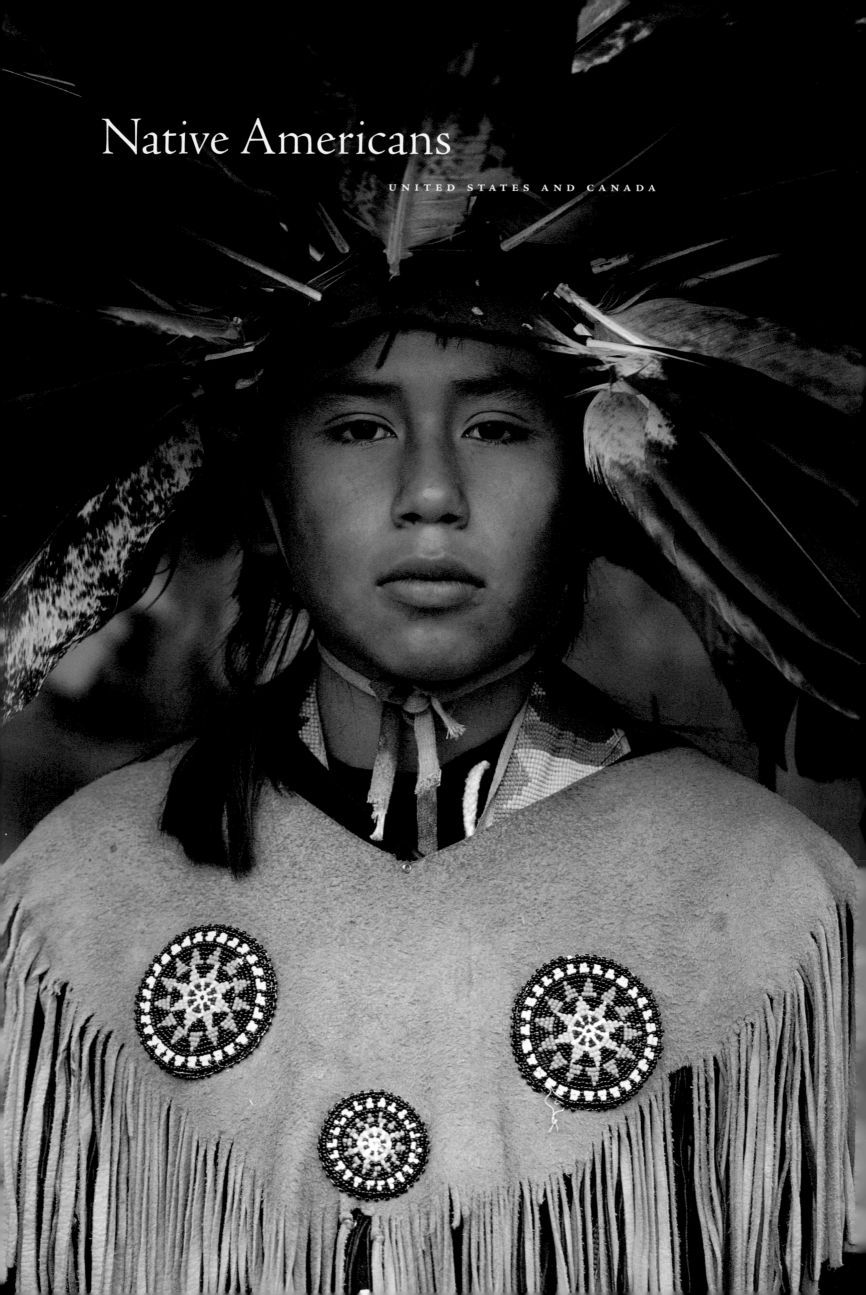

Native Americans

UNITED STATES AND CANADA

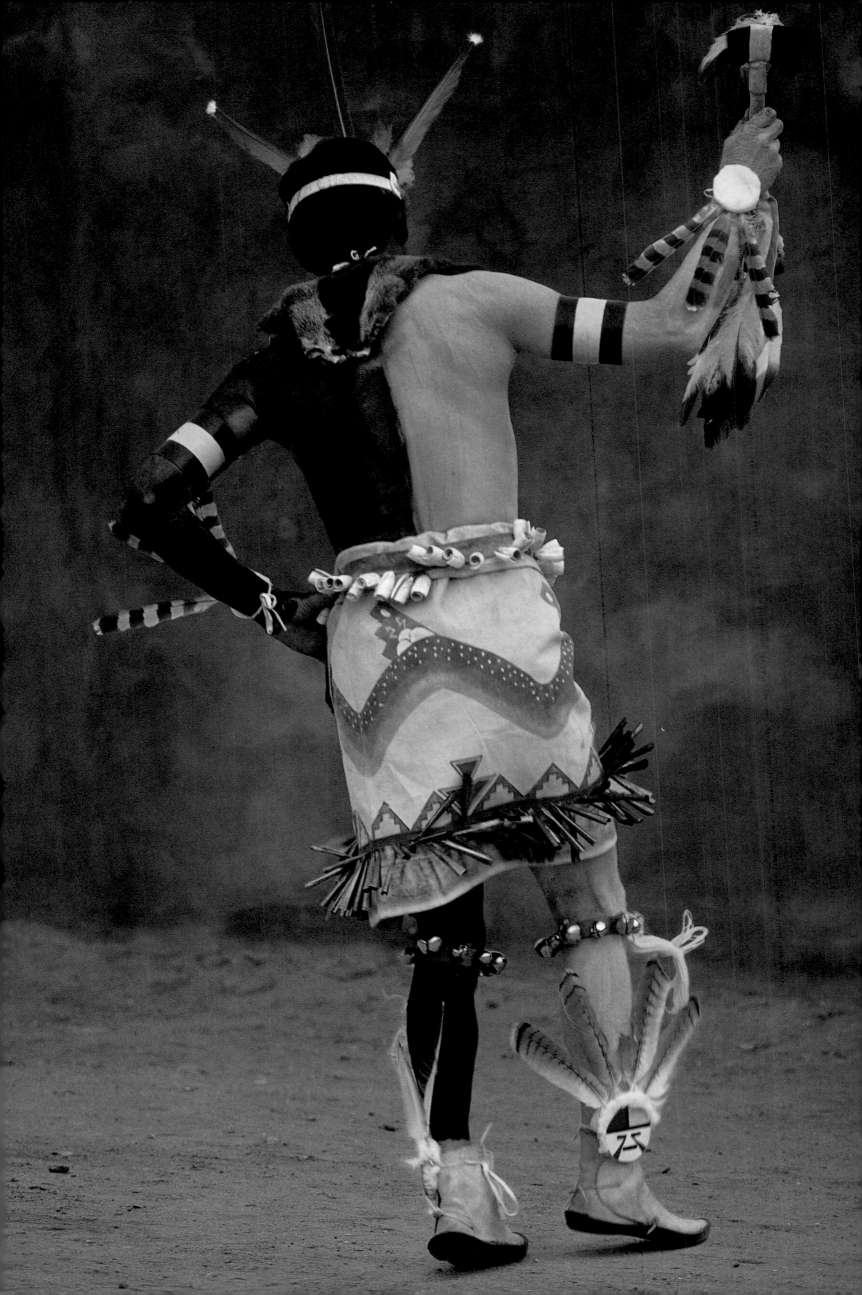

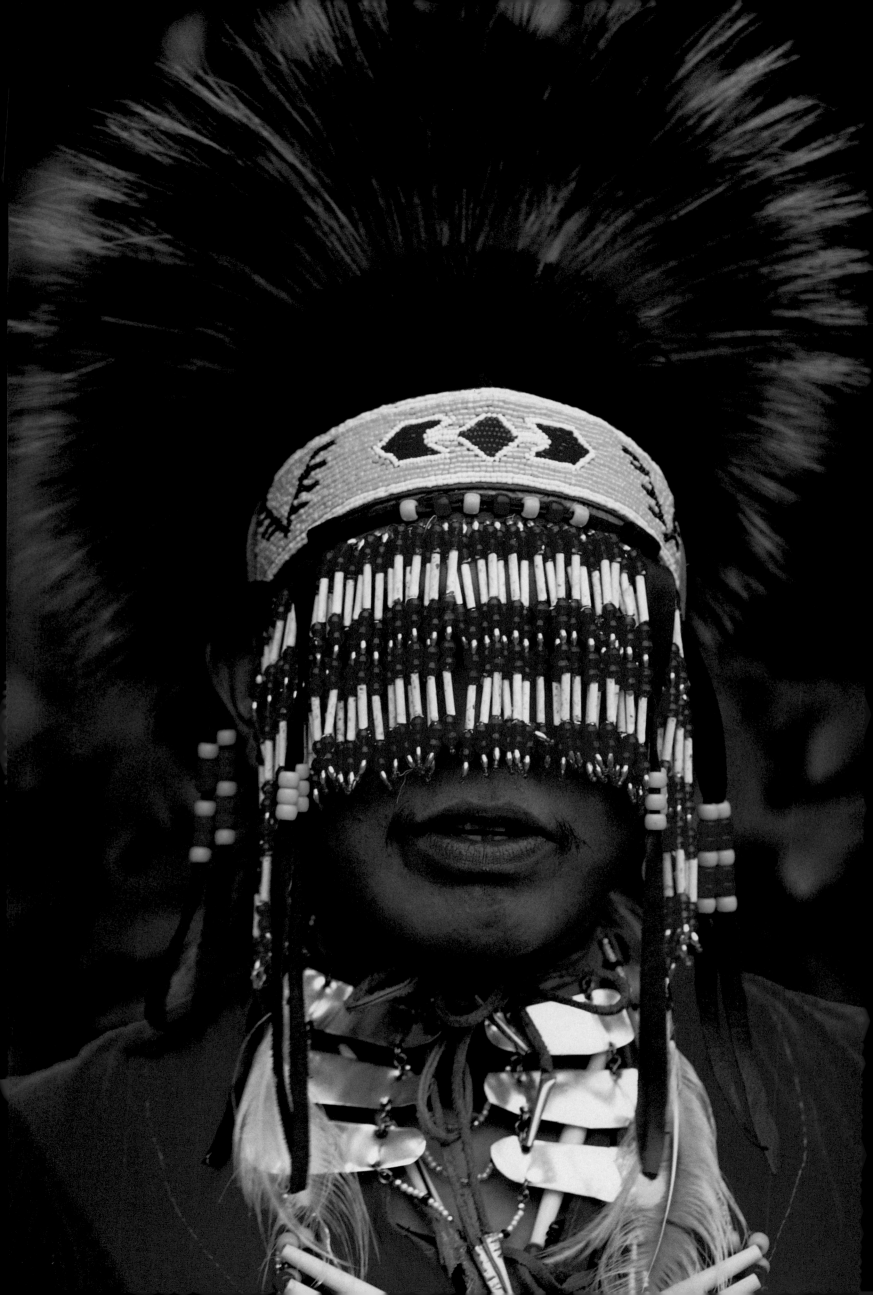

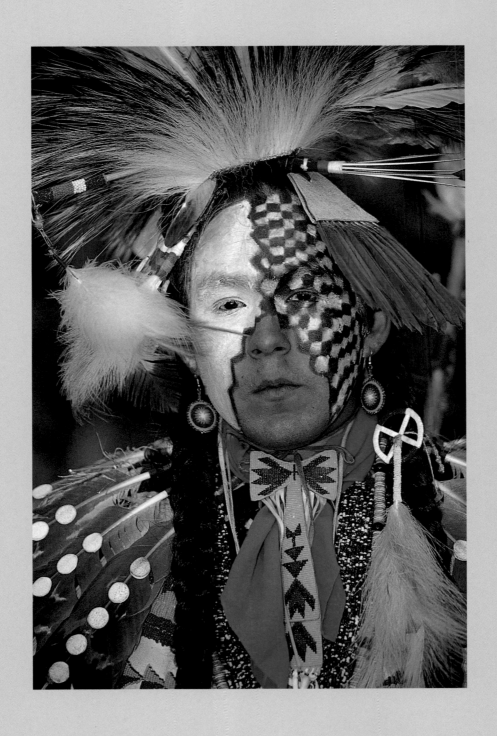

(opposite and above) POWWOW PERFORMER

(page 112) YAKAMA YOUTH

(page 113) TEWA DANCER

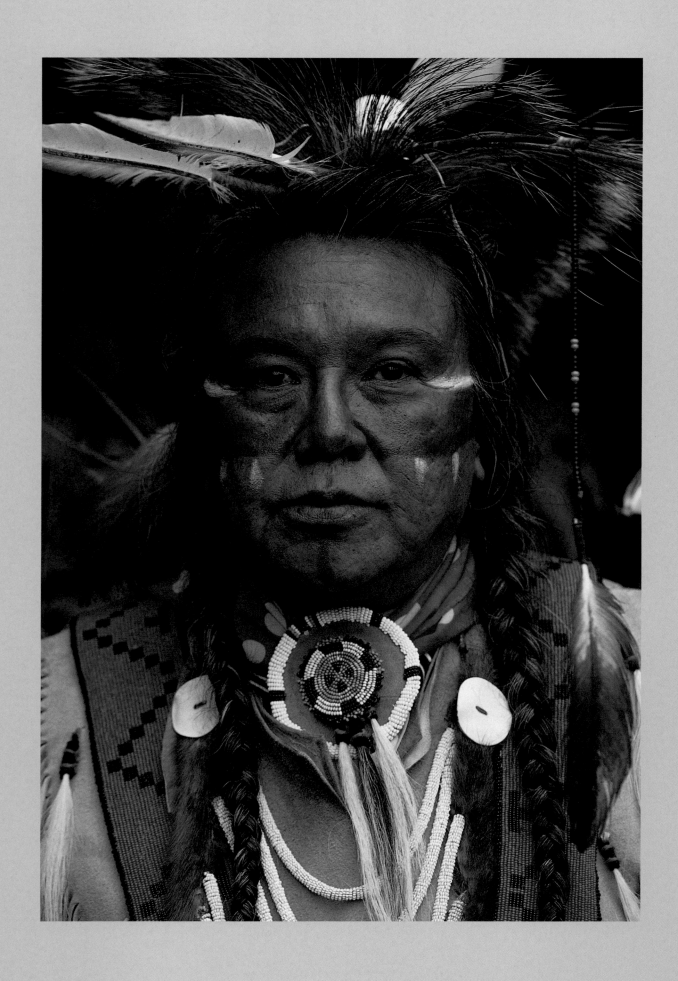

KALISPEL MAN

(*opposite*) ASSINIBOINE MAN

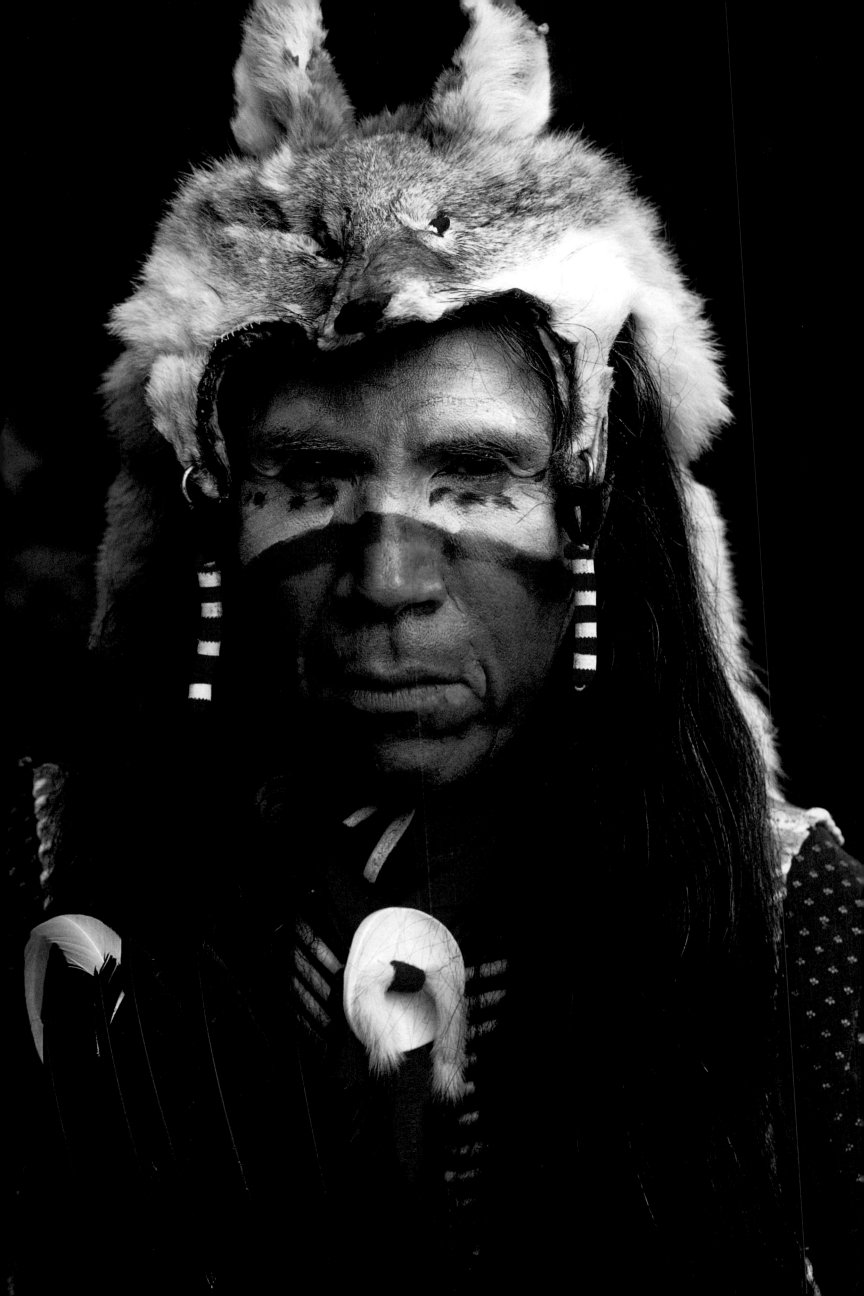

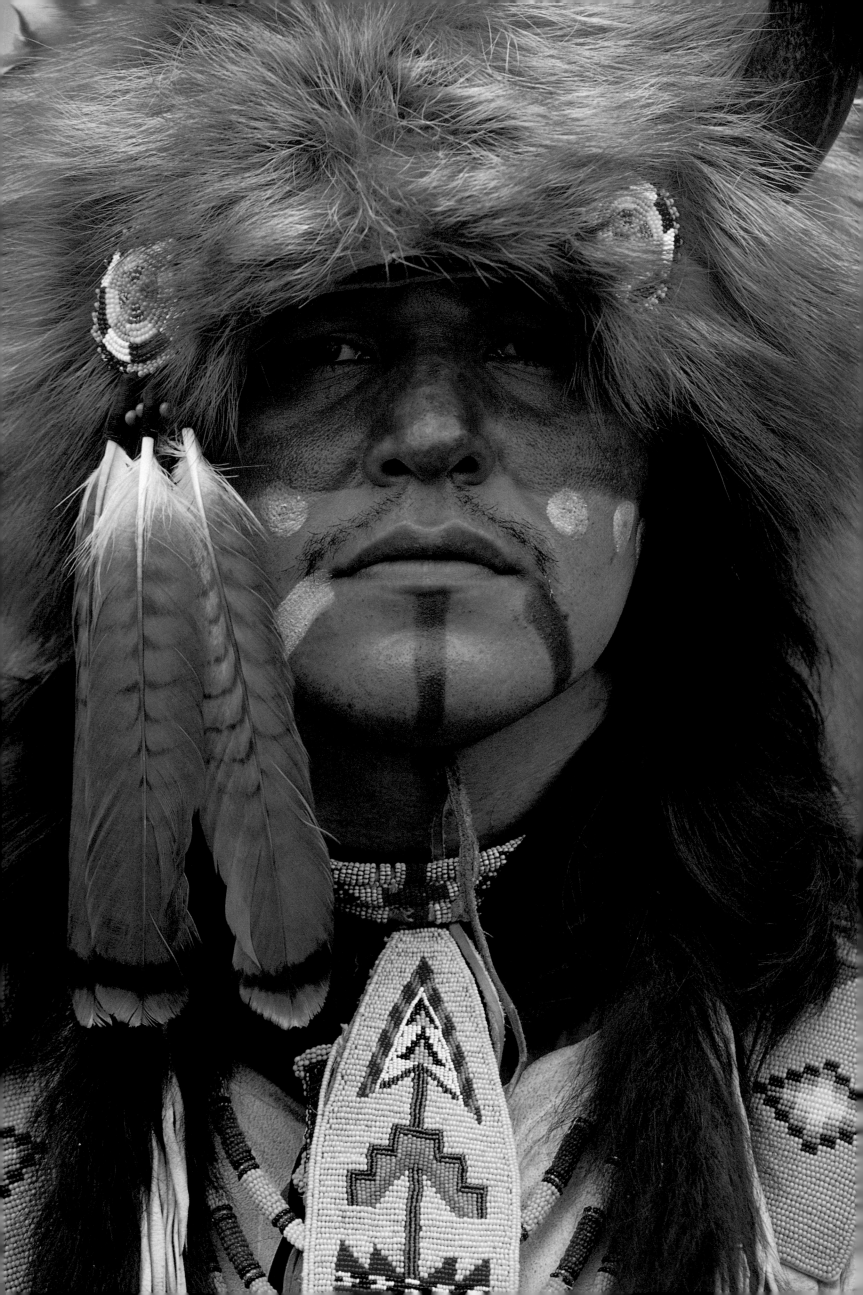

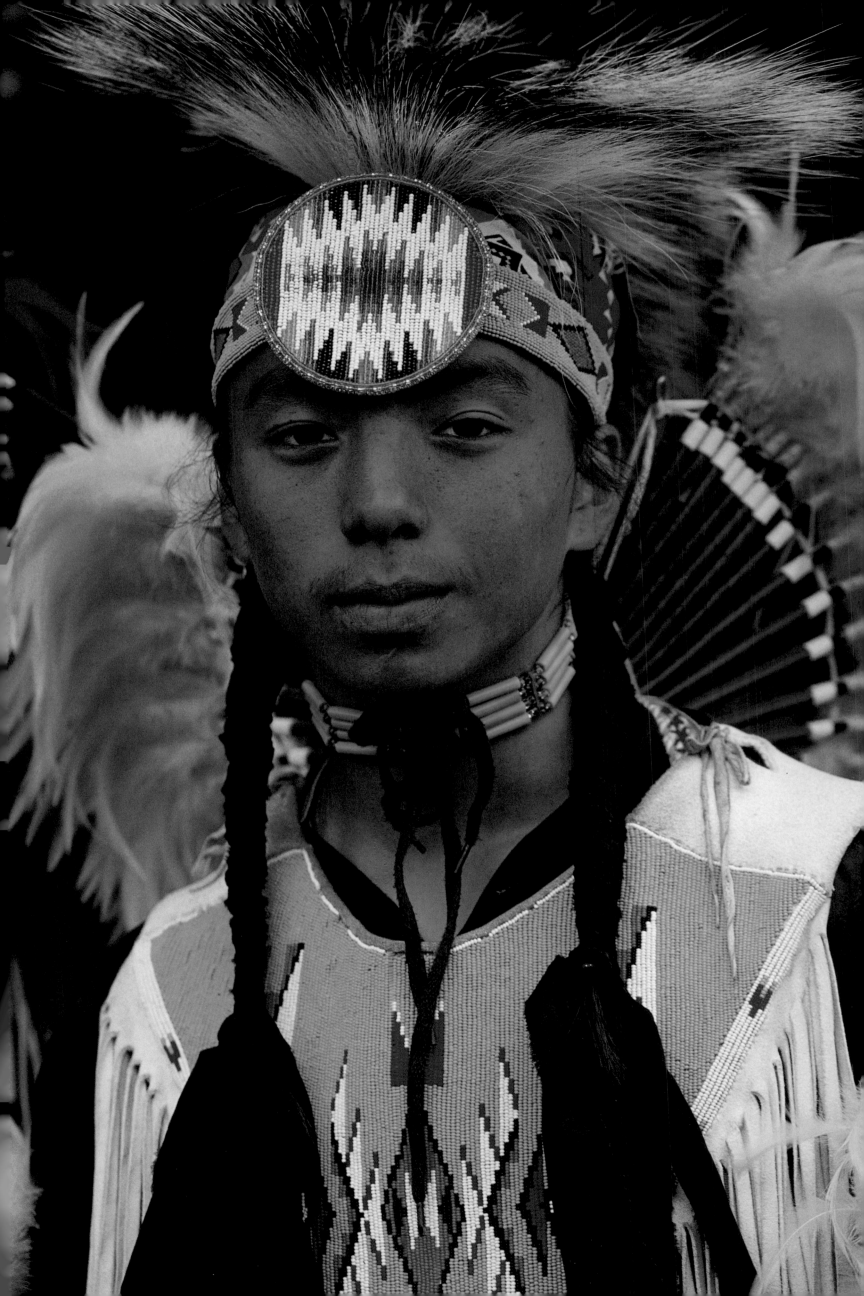

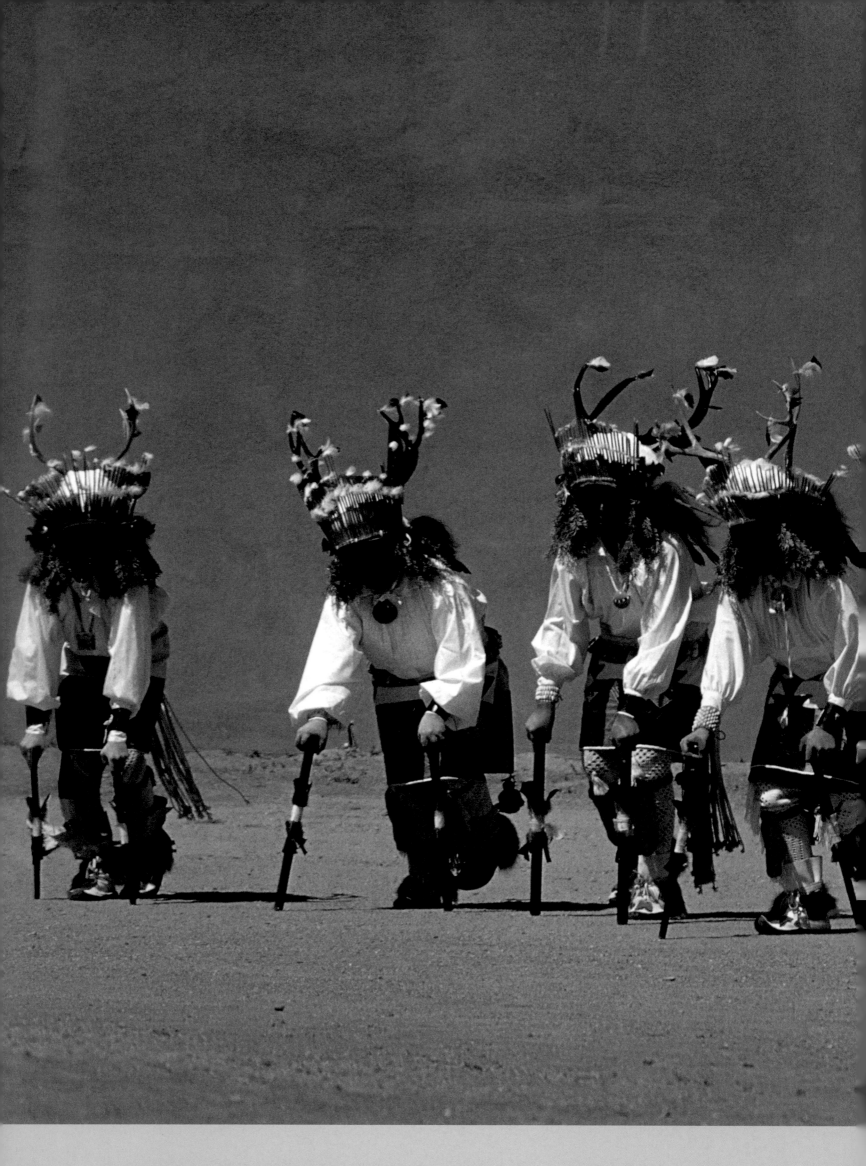

(page 118) COLVILLE MAN; (page 119) YAKAMA YOUTH

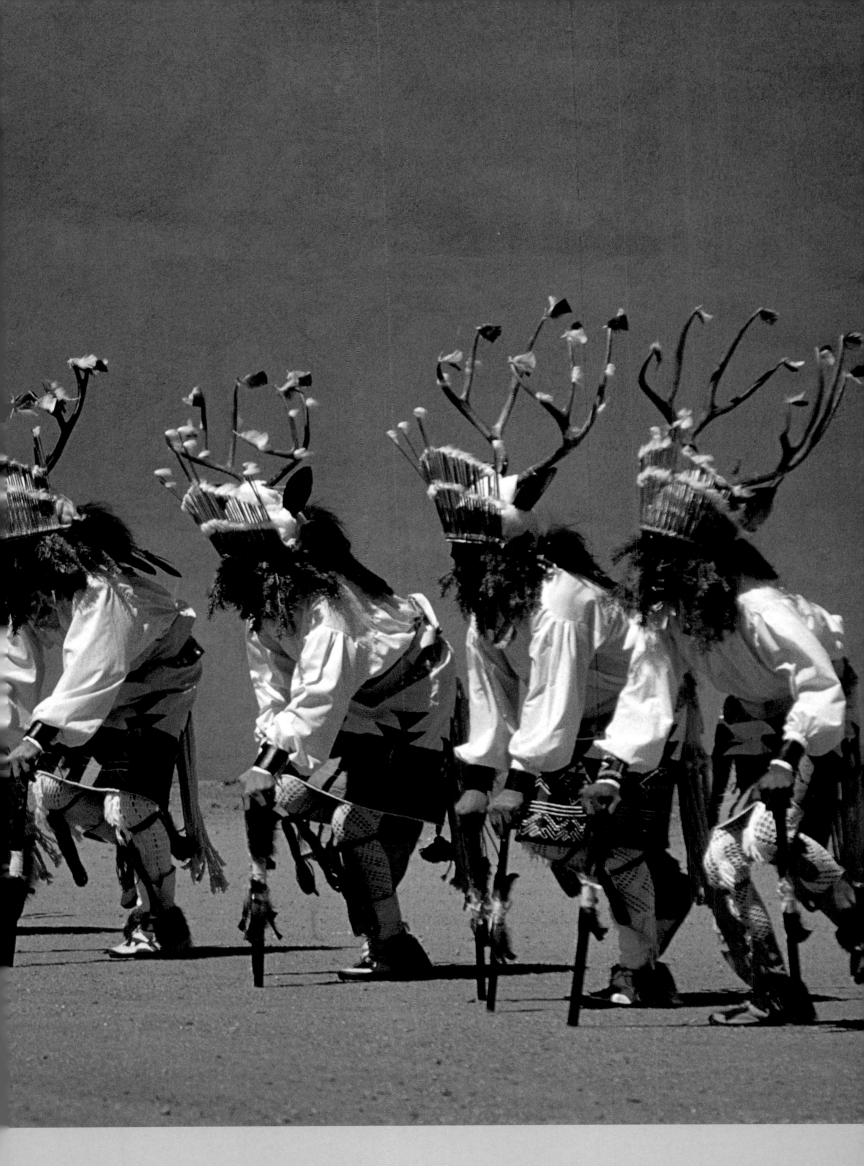

TEWA DEER DANCERS

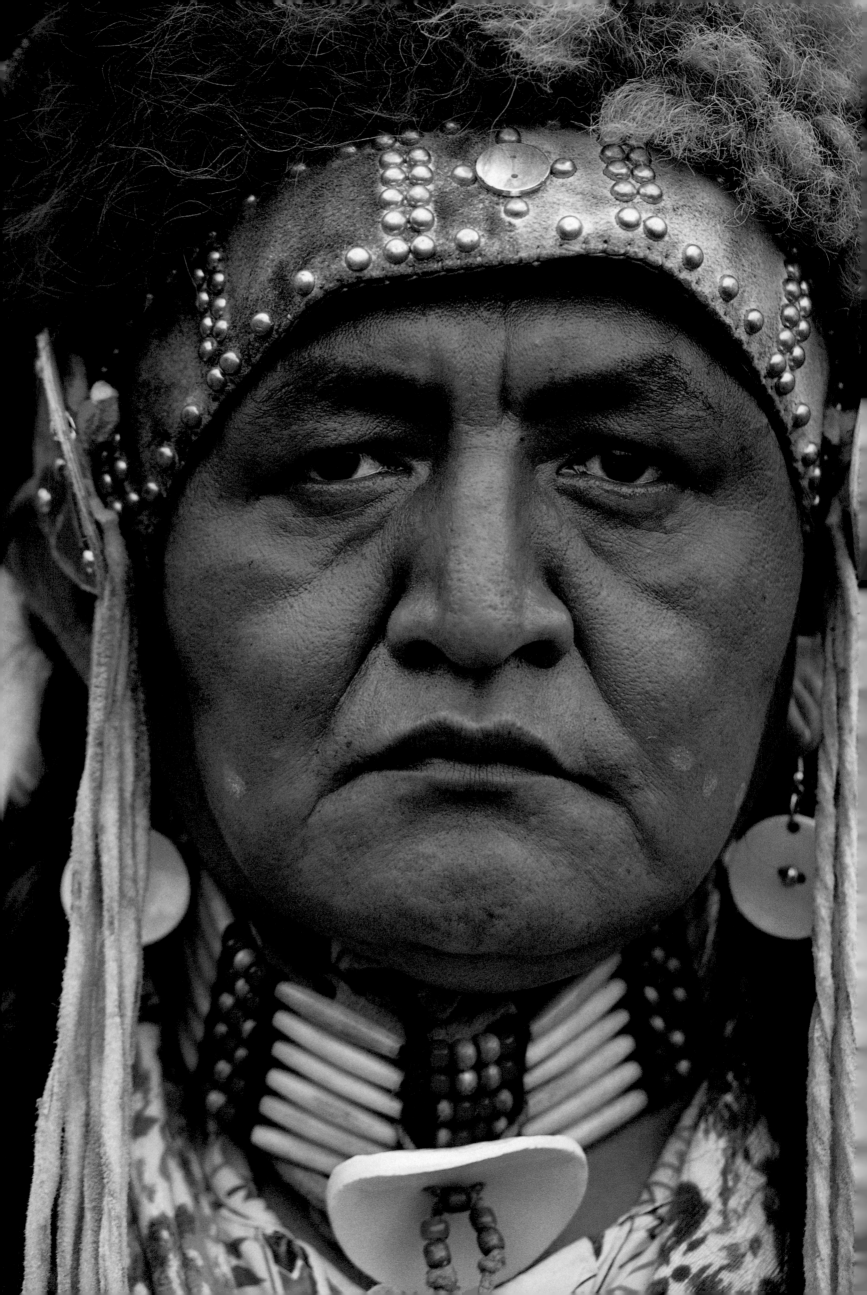

NATIVE AMERICANS today face dual pressures, those of surviving in a modern society and retaining cultural identity in the process. They straddle two worlds, those of isolated reservations and those of clamorous cities. One way of expressing their uniqueness and importance to the contemporary American culture is the powwow, a word taken from the Narragansett language meaning "shaman," and now denoting an intertribal gathering. Since the 1970s powwows have become the fastest-growing cultural activity within the Native American community, and are popular with other visitors as well. Many outsiders overdo their appreciation and participation in the ceremony—whether it is lingering guilt or romantic delusion, people want to be Native American, not Euro-American. Nevertheless, powwows have become as frequent as Kikuyu ingomas and as elaborate as Papuan singsings.

Powwows serve as a time of intertribal exchange, an expression of pride, and an exuberant exhibition; powwows are not merely dance- and costume-driven; indeed, "costume" is a pejorative term because the accoutrements of different dances have been handed down for hundreds of years. Powwows are held to celebrate when children are given Native American names; to remember the deceased; to honor graduates and veterans; and to mark the first dance of a child. Cultural awareness is a large factor. Many Native Americans have been victims of crushing poverty and alcoholism, not unlike the Australian Aboriginals, and while these problems ravage the collective psyche, it is impressive to see many tribal nations and individuals come forth and assert the glorious ritual that is their heritage.

Before the arrival of the Europeans, Native Americans used all their ingenuity to adapt to environmental change. To meet the challenges of the last five hundred years, they have needed every bit of that ingenuity and creativity to retain their religion, art, and language. The Native American goal is to adapt to technological changes without losing identity. Native American culture as a whole is in a vital, creative, and politically involved stage. While society at large is stubbornly indifferent to subgroups, Native Americans are putting forth their individuality in a renaissance of fine art, including sculpture, painting, jewelry, and performance.

Powwow participants are wary of photographers,

but I came well prepared to the powwows I attended in Seattle and New Mexico. As one of the last shoots I did for this book I had assembled a large portfolio of laser copies to introduce myself as a serious photographer and demonstrate my technique as well as intentions. Those participants I was able to photograph were quite taken with the diversity of the peoples and pleased to be included in such a celebratory body of work.

Tewa Dancers— San Ildefonso Pueblo, New Mexico

Descendants of the ancient Anasazi and Mogollon, the Tewa are the heirs to a southwest culture steeped in rich tradition and elaborate ritual. The tribal peoples of this region have proven incredibly resilient to European influence. After over four hundred years of contact with whites, 75 percent of the original tribes remain in name, though not in the same numbers. They have been able to reserve a core culture to themselves, effectively warding off influences that might have disrupted their tightly integrated way of life. While adapting to new languages, Spanish and English, and a new religion, Catholicism, they have managed to preserve a sense of cultural identity. This they express in poetry, song, art, and, in particular, dance.

Today the pueblos of the Rio Grande valley are some of the best places in the United States to get a sense of traditional indigenous Southwest life. While most Tewa are wage-earners, working in towns and cities throughout the Southwest, they ardently preserve ornate ritual in their lives; many return home frequently for important ceremonies. Pueblo ceremony follows the annual cycle of solstices and equinoxes. Since the Spaniards introduced Catholicism in the sixteenth century, the seasonal rhythms also flow with the feast day schedule of the Church. Some dances are performed to bring rain, others to ensure the healthy growth of crops, livestock, and children, and still others to remedy illness. Unlike European dance, which frequently emphasizes individual creative expression, pueblo dances focus on group harmony and community spirit.

Over the Easter holiday in 1994, I traveled to New Mexico in hopes of witnessing at least one of the spectacular dances of the Tewa. While some dances

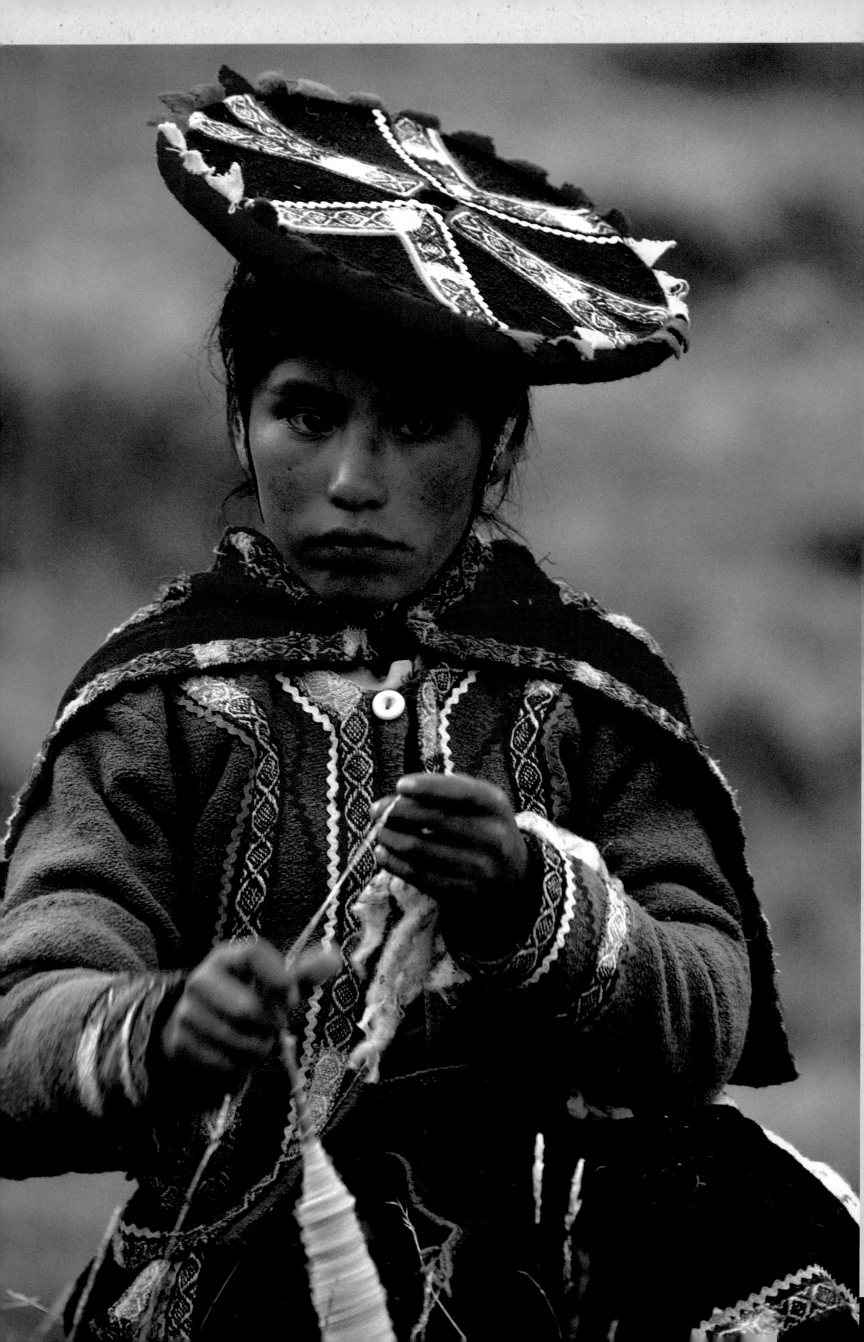

From the
Amazon to the Andes

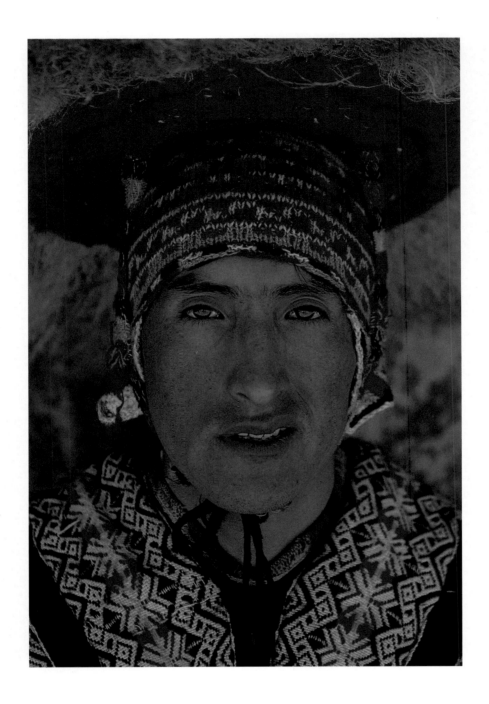

QUECHUA MAN

(opposite) QUECHUA GIRL

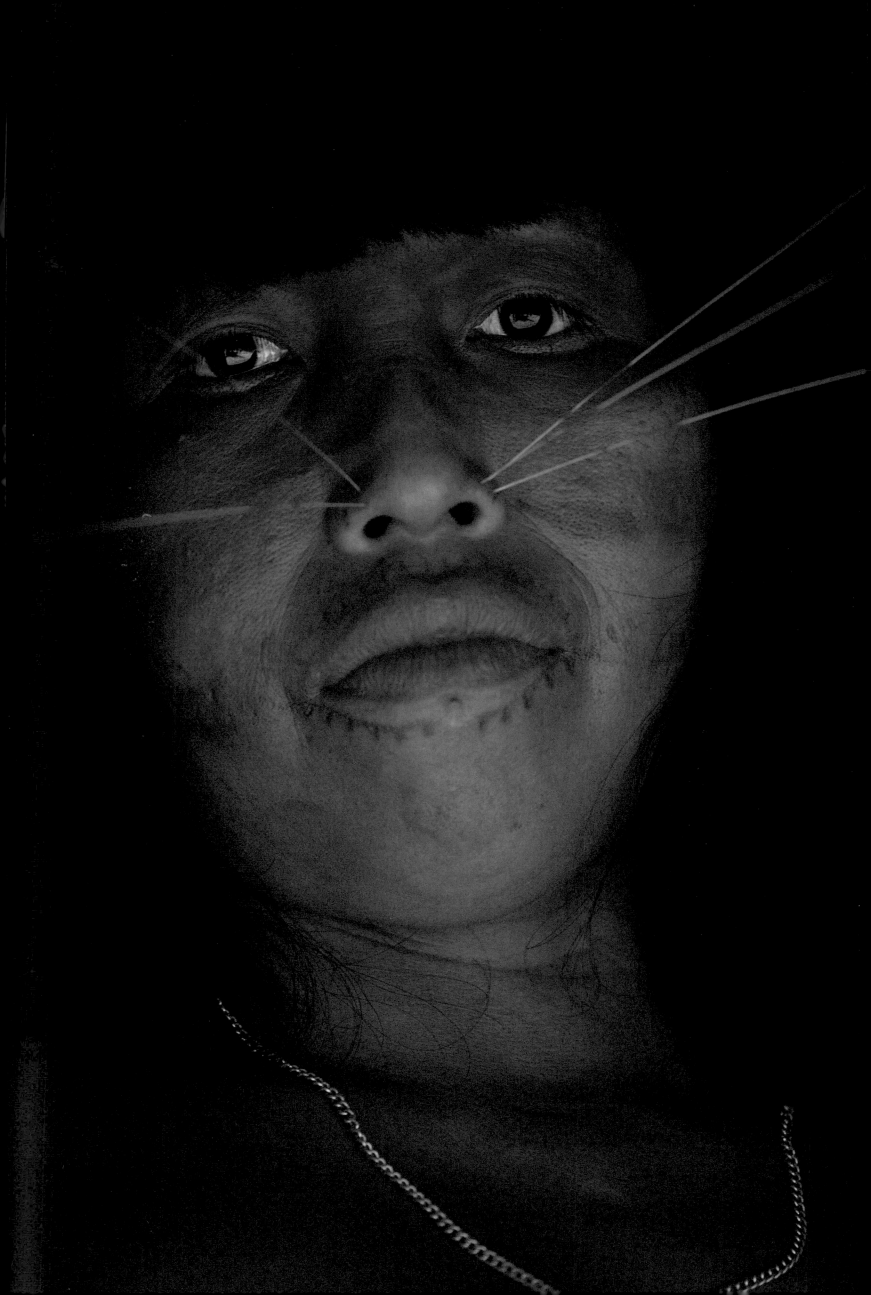

A Mayoruna Woman— Rio Javari

Photographing the Mayoruna was a rather trying time for me. Throughout the trip I had been suffering technical difficulties with my cameras. The Mayoruna village was located on an oxbow lake about two hours from Iquitos, the main city of the Peruvian Amazon. I traveled upriver with a guide in a dugout canoe equipped with an outboard motor. The boatman was exceedingly skilled, threading us through a maze of channels. It was flood season, so some waterways looked like major rivers even though they were dead-ends, and the Rio Javari we were on appeared secondary. Finally we reached the village. Upon disembarking I noticed instantly the exotic pets kept by the Indians—monkeys and parrots chattered at us from the dwellings. Later, after we had departed, my guide casually informed me there were two rare red-faced uakaris (golden-haired monkeys with bright red faces) kept there as well, which I had missed the chance to photograph.

I did photograph a Mayoruna matriarch, who was extremely patient with me, and her infant son. What was so striking about her were the 'whiskers' of palm spines she had sticking from her nose. The puma is a symbol of strength to the Mayoruna, and she wore the whiskers to give her strength when she needed it most as a new mother. She also wore red achiote dye in a thick stripe over her eyes and a bluish tattoo around her lips.

After that session, I hauled my gear down to a small lake to photograph landscapes. I was followed by a group of children who ran into the water and began to play in a dugout. I set up my tripod in the soft lake-shore earth, rolled off several frames and accidentally tipped the camera into the muddy water. The Amazon, in a less than subtle way, was telling me to go home.

The Quechua—Andes

Wearing traditional clothing made from llama and sheep wool, two dancers pose in front of the great stones of Sacsahuaman, an ancient Incan fortress outside Cuzco. The vivid hues and ornate embroidery of their dress were mesmerizing, and the young man had a compelling imperious look, with his aquiline nose and liquid dark eyes. He reminded me of men portrayed in ancient Incan drawings.

The Quechua have quietly lived through centuries of imperial domination. First came the Incas, followed by the Spaniards. During Incan times, the Quechua language became the preferred tongue of the empire, before yielding to Spanish. Employing "dress legislation," the Spanish viceroy prohibited the wearing of native dress in 1572, attempting to eradicate memories of former Incan rulers. In some areas today, locals are obliged to wear native costume to boost the economy by supporting local industries. Today most Quechua lead isolated lives as marginal farmers in the high Andes, though many have dispersed to urban centers. Those lingering in the mountains have been subjected to numerous studies focusing on their physiological adaptation to high altitude living.

While life in the mountains is difficult, the burden is shared by all in Quechua society. All men, women, and children spin wool or knit while they tend their herds of cattle, llamas, alpacas, and sheep. All men and women weave—the women still utilizing the pre-Columbian Inca loom. Everyone shares in the daily chores of home repair, meal preparation, and livestock tending.

As with the Lisu of Thailand, it is difficult to tell when the Quechua are dressing for tourists and when they are dressing for themselves. It is most likely that a young girl I photographed as she spun wool and watched her small herd of llamas outside a small village dressed in the traditional manner at all times.

(opposite) MAYORUNA WOMAN

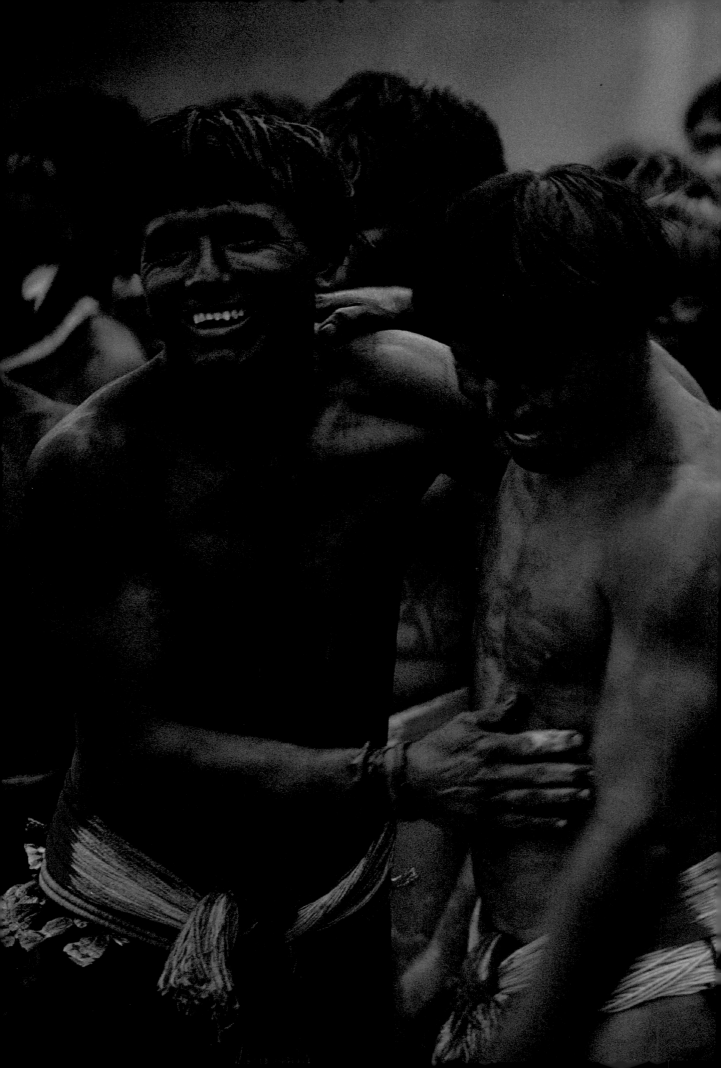

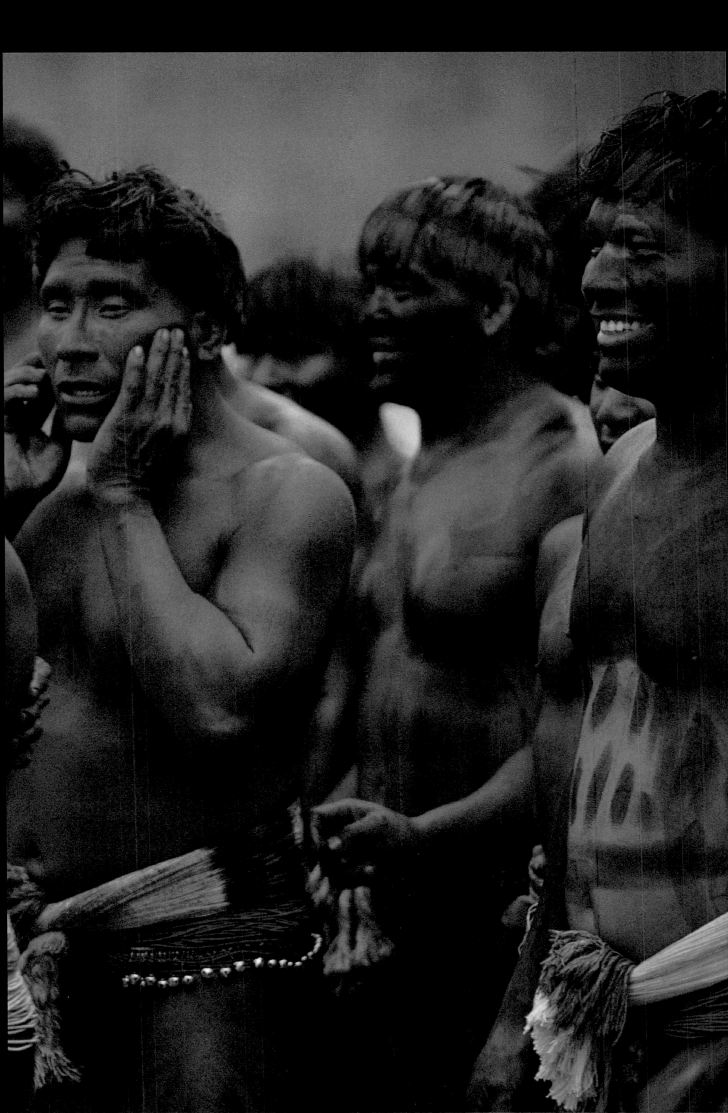

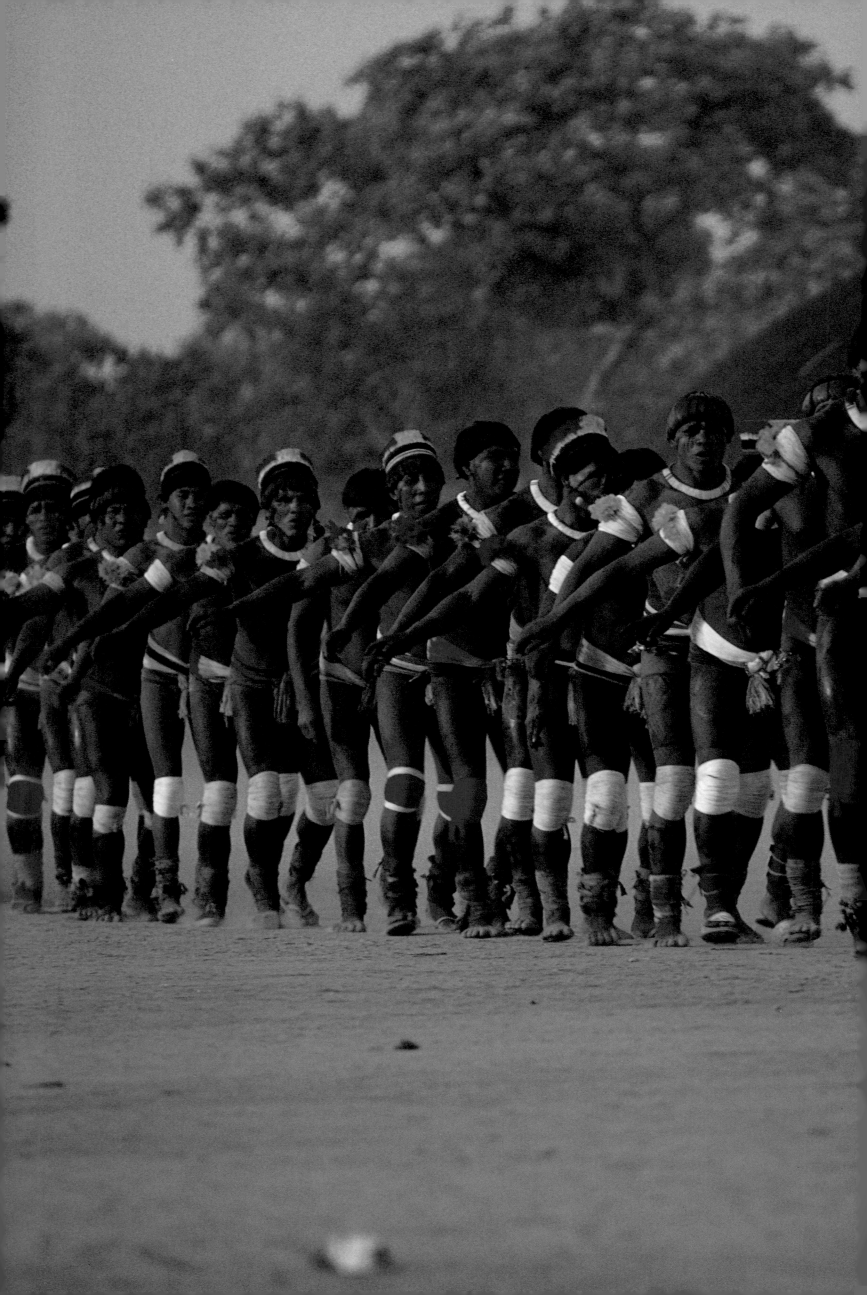

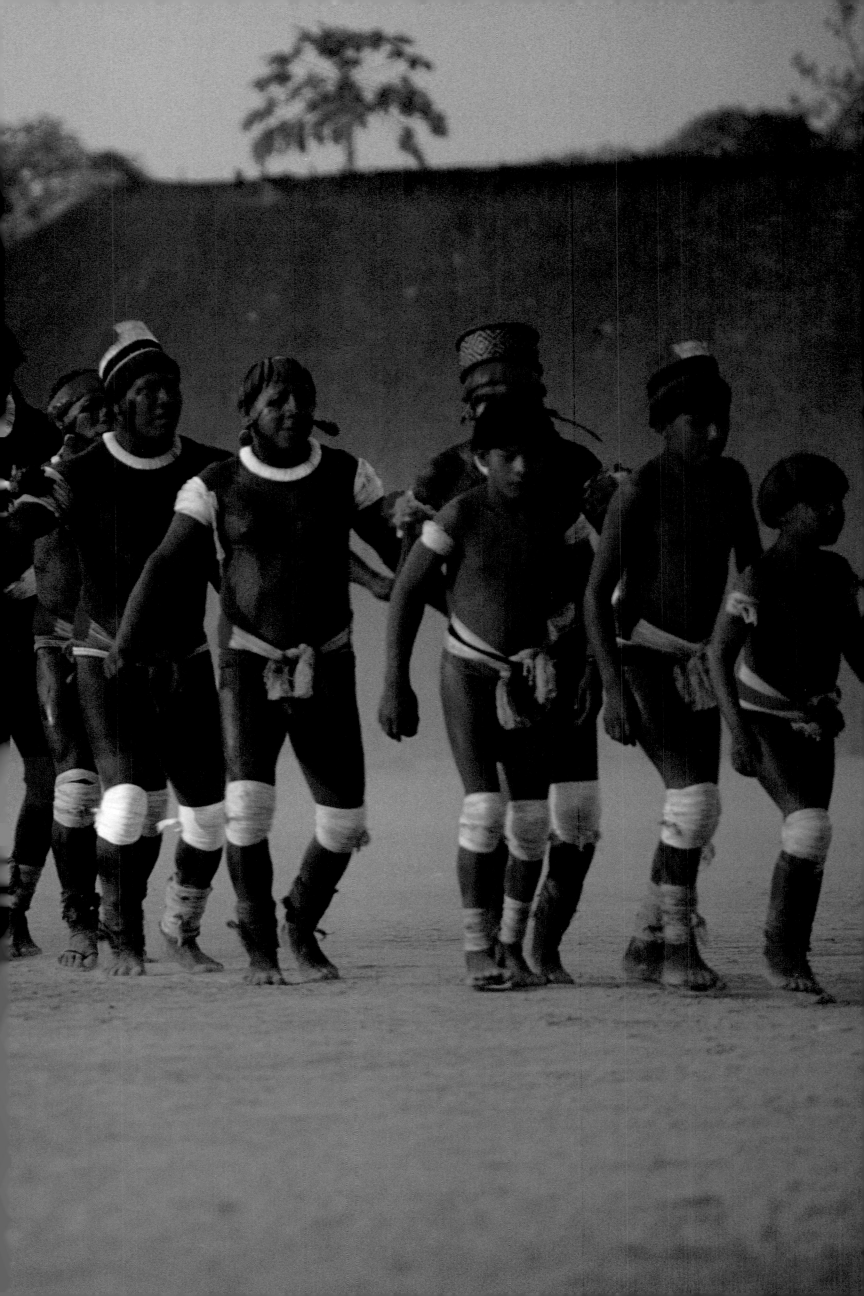

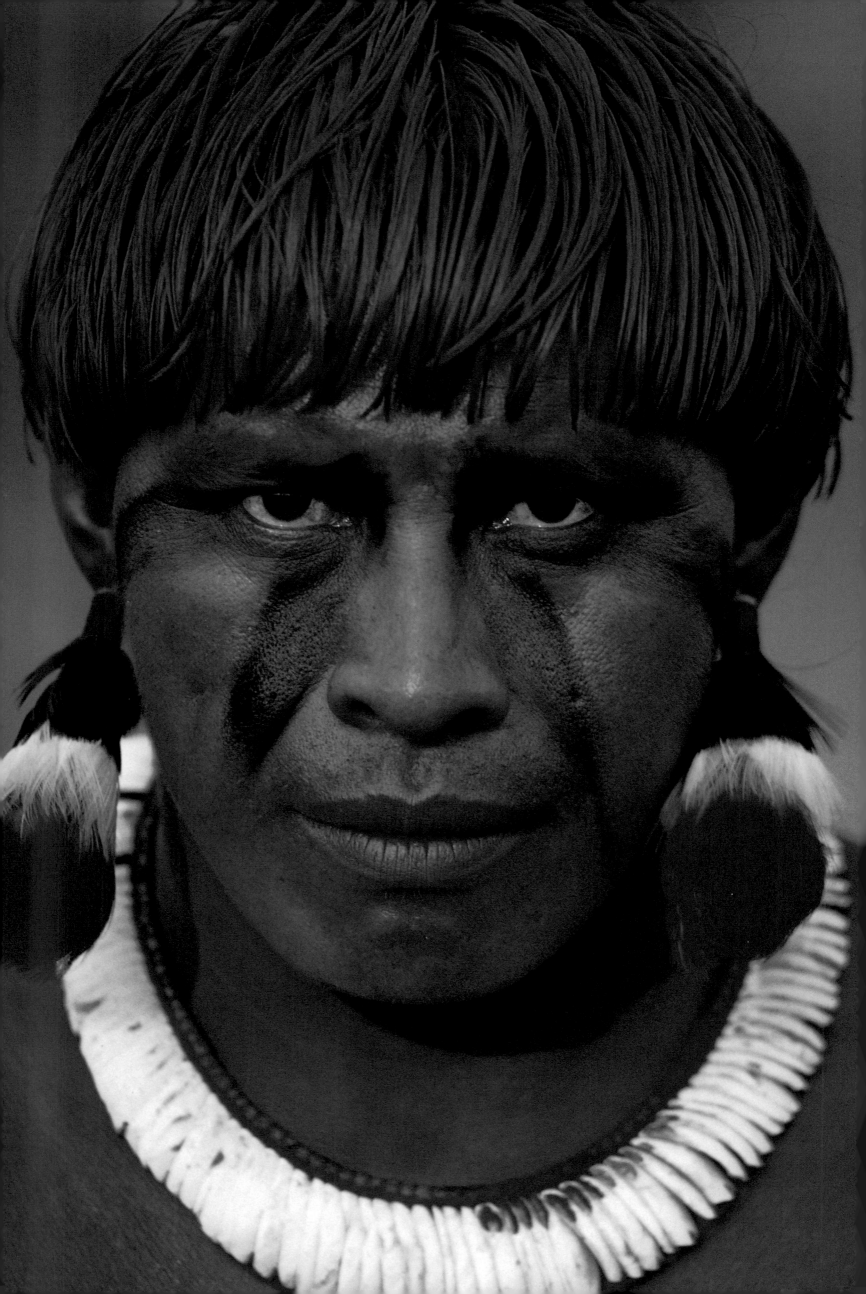

Mavutsinim, a legendary ancestor of the Kamayura, wanted his dead people to come back to life. So he went into the forest, cut three pieces of kwarup wood, brought them back to the village, and decorated them with macaw feathers and necklaces. The kwarups were set up in the center of the village, and two toads and two agoutis were ordered to sing near them, to plead them into life. When Mavutsinim informed the villagers that the kwarups were going to turn into people, they wanted to weep for the kwarups, who represented their dead. But Mavutsinim would have none of this; the kwarups were going to turn into people so there was nothing to cry about. On the morning of the second day, he forbade the villagers to even look at the kwarups. By dawn on the third morning the kwarups were already taking human form from the waist up, as the agoutis and toads sang. Reminding his people not to look, Mavutsinim finally ordered all dwelling entrances to be covered up. When the transformation was nearly complete, he ordered the villagers outside to spread joy and laughter near the kwarups. However, those who had had sex the night before had to stay inside. Only one couple had, but the young man could not contain himself and came out to look. The kwarups instantly turned back into wood, and Mavutsinim was furious, declaring: "I wanted to make the dead live again every time a kwarup was made, but from now on, the dead will never come back to life. From now on, it will only be a festival."

KAMAYURA LEGEND

WHEN I GOT A CALL from a Brazilian anthropologist asking me to accompany her to a tribal ceremony deep in the Amazon Basin, I jumped at the chance. Called a Kwarup ceremony, or Feast of the Dead, these observances are made one year after someone of chieftain lineage has died. It is a time of both mourning and celebration. Many different tribes of the region, including the Yawalapiti, Kuikuro, and Kamayura, were going to participate in the sacred festival in memory of several villagers.

Excluding their unrelated languages, the tribes of the Alto Xingu are remarkable in that they share common customs, celebrations, and ways of life, while maintaining a distinct separateness from one another. Xingu Indians paint themselves with semi-permanent blue-black genipapo dye, obtained from the juice of the genipapo fruit and crimson bixin dye, called *urucu* in Brazil and used by tribes throughout South America, made from annatto seeds. Urucu is mixed with *piqui* oil to give it a high gloss.

When they saw me, the young Kamayura men saw a chance for artistic amusement; I am sure had I allowed them to paint me, the genipapo would have remained with me for months, even though it usually only lasts for weeks. Unfortunately, I was forced to decline their smiling offers because I had business meetings in New York right after the shoot. Sometimes the prudent thing to do is not always what one wants to do.

After a brilliant procession, where all the participants danced in a long line before the Kwarup posts and hosts, the tribesmen formed pairs and began to wrestle. Well painted with urucu, genipapo, and dust, they were fiercely competitive. This spirit of competition is instilled at a young age. Like their elders, boys engage in wrestling matches, building strength and gaining confidence in their young lives.

(opposite) KUIKURO MAN

(previous pages) KWARUP PROCESSIONAL

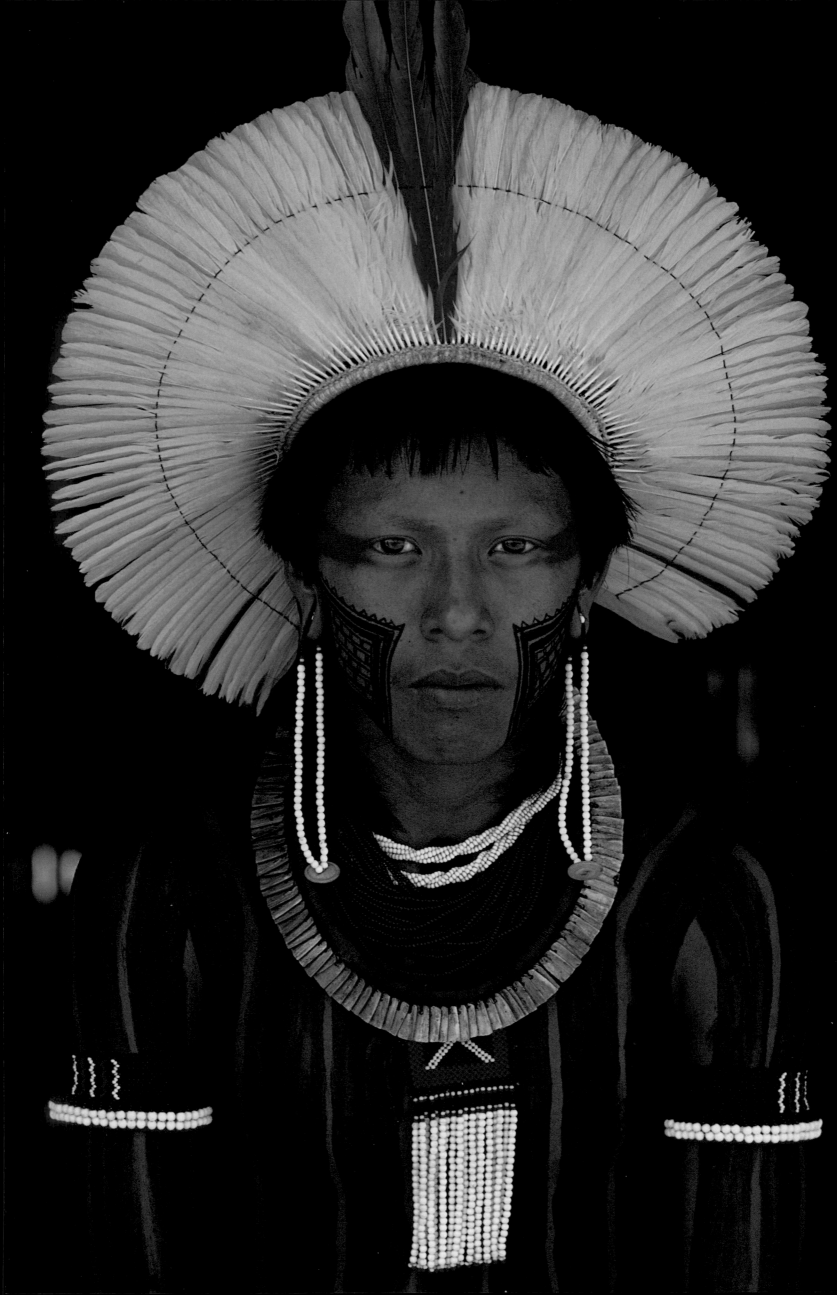

^eKayapo of Kapcto Village

PARA, BRAZIL

(opposite) KAYAPO MENÔRÔNY-RE

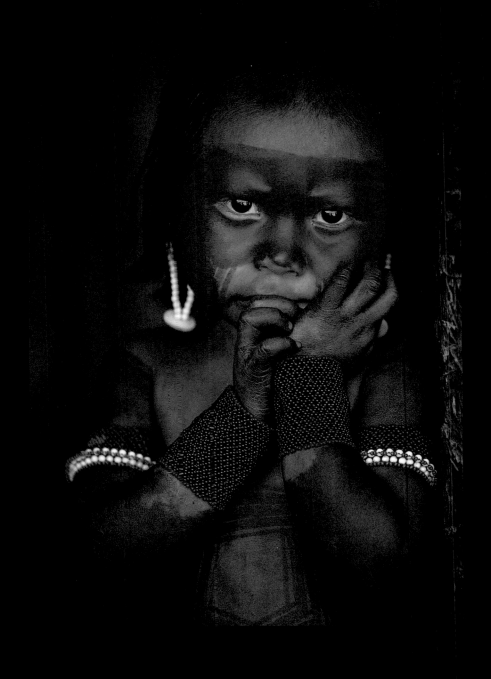

KAYAPO GIRL

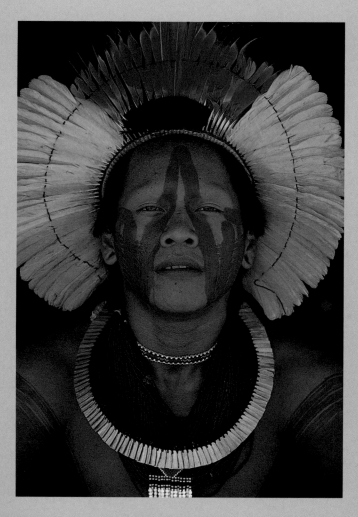

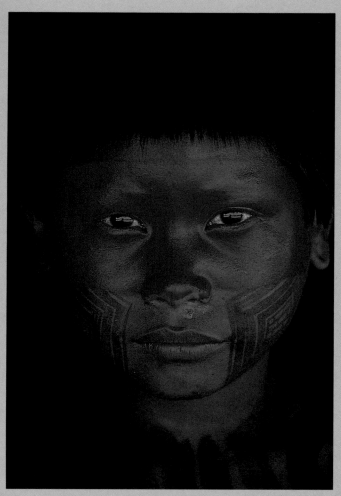

(*top*) KAYAPO MENÔRÔNY-RE; (*bottom*) KAYAPO BOY

(*opposite*) KAYAPO MEKRAKRAMTÎ

138

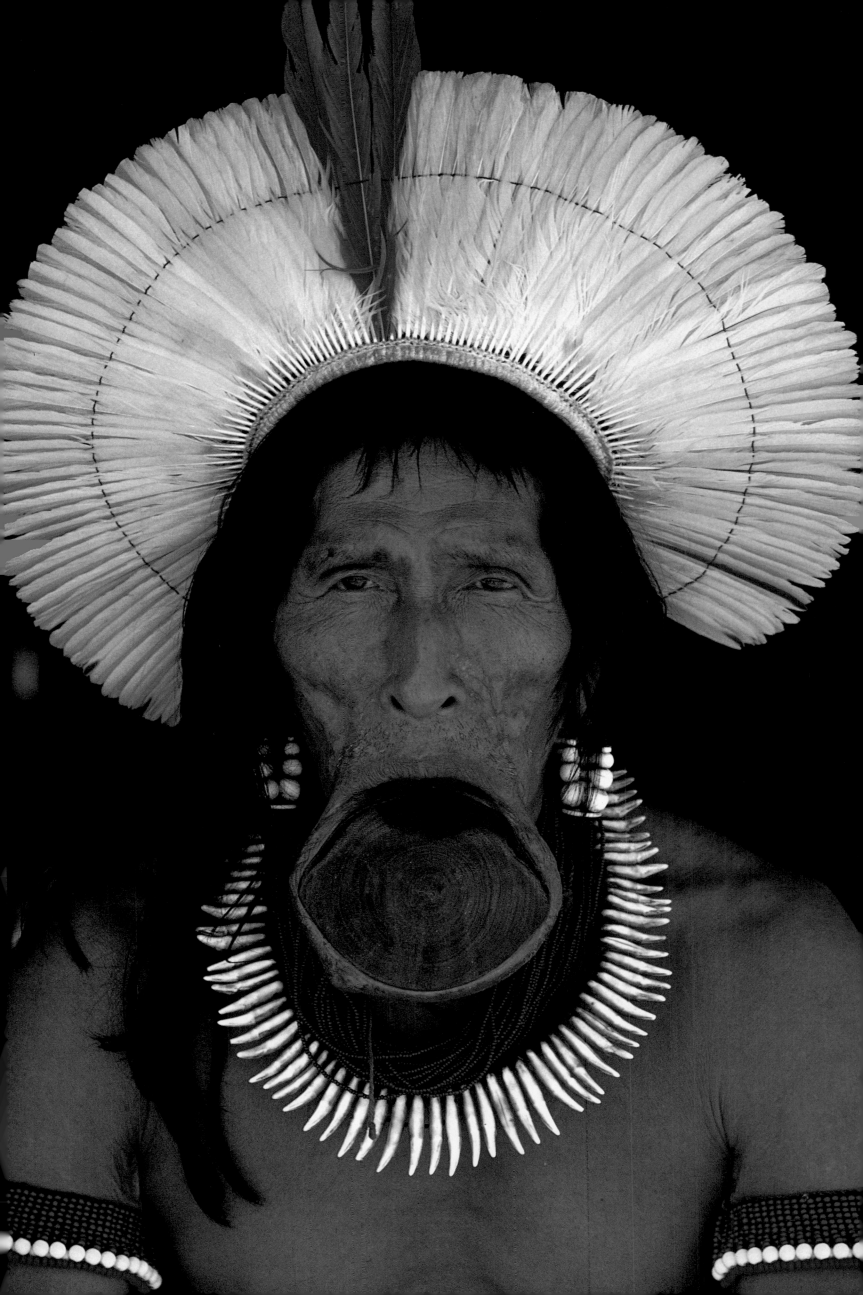

As OFTEN HAPPENS, the Kayapo were named by others, not themselves. Neighboring tribes who witnessed a specific ritual during which Kayapo men performed dances while wearing ape masks, dubbed them Kayapo, meaning "resembling monkeys," but the Kayapo call themselves *Mebêngôkre*, or "people of the watering place."

The Kayapo are flamboyant in their self-adornment, and I was filled with admiration and appreciation for their art. The combination of red and black dyes traced over the body in geometric patterns is stunning in its intricacy, and their use of psychedelic parrot feathers and other jewelry of the rainforest has become a rarefied art. In the Kayapo and Xingu villages I visited, including the small village of Kapoto, many "domesticated" macaws wandered about, terrorizing children and chasing dogs. Parrots, parakeets, toucans, and eagles are also raised, as their feathers are extremely valuable in both trade and social leverage. Their feathers are plucked regularly to prevent them from flying away, and because of their value the birds are rarely killed.

Body painting is more than ornamentation for the Kayapo; like Polynesian tattoo, it is a medium of visual communication, reflecting the status of the individual. Painting is applied for both specific ritual and daily living, becoming a second "social" skin for the individual. Like the Xingu Indians, the Kayapo use genipapo; it is mixed with ashes and water and lasts up to a fortnight. Charcoal and water is used more often for ceremonial purposes, while genipapo is applied for everyday or what the Kayapo term "beautiful painting." Genipapo is considered dangerous because of its vital coloring, so it is only applied to those considered strong and healthy. There are two methods of decoration: a broad application with the hands and fine drawing with the thin rib of a palm frond. The latter method is almost exclusively used for children, who are decorated by their mothers.

The Kayapo are famous for their generous use of brilliant carmine urucu. Urucu is water soluble and must be reapplied daily. For the Kayapo, as in many cultures, the color red symbolizes health, energy, and vitality, fostering growth and strength. Red is applied to peripheral parts of the body, such as the face and feet, while black is applied to the biological core of the person, the torso, upper arms, and face. On the face, the black is covered over with a layer of red, energizing the intelligence of the individual.

Kayapo Children

As I was photographing the adults of the village, I noticed a flash of movement out of the corner of my eye; a tiny, little girl stared from her family dwelling, transfixed by the foreigner in her midst. She had a compelling, intriguing glance for one so young.

Mothers, grandmothers, or other kinswomen decorate their children and each other in time-consuming linear fashion. Children are the passive recipients of the art, often falling asleep under the caress of the palm frond. At around the age of eight boys go through a painting ritual that marks the end of childhood. From this time forward they will rarely spend time with their mothers and sisters, and they will be painted only by men. They will learn to paint each other in broad strokes with their hands. The girls will learn the elaborate art from their mothers, the supreme painters in the village.

Two Menõrõny-re

Like all tribal societies, the Kayapo are eased through the cycles of life through age-grading. Age-grades differ from the age-sets of the Maasai and the Samburu in that graduations from grade to grade occur on a yearly basis; in East Africa, the ceremonies are a rare occurrence, often many years apart. From infancy to old age, the six age-grades are ritually distinct, having their own set of behavioral rules, and requiring specific ornamentation. At pubescence Kayapo boys begin to wear a *mydjê* or penis sheath, reflecting their sexual maturity; it is humiliating for a man to show his penis in public, much as it is for the Dani of Irian Jaya.

There is a warrior age-grade, similar to the moran of the Samburu and Maasai tribes, called the *menõrõny-re*, literally meaning "those who sleep in a new way." The young men now are allowed to move from the homes of their birth to the men's house. The menõrõny-re share a constant togetherness and solidarity that leads to strong lifelong bonds between individuals. The Kayapo word *inhikjê*, meaning "my

other half," expresses the constant state of togetherness and mutual friendship that connect the menôrôny-re. All their activities are performed en masse: they paint each other, dance and sing together, hunt together, and eat together. They are free spirits, able to come and go as they please, sometimes disappearing on long treks for months at a time. The most energetic and enthusiastic participants in communal activities, menôrôny-re gain the high esteem of married women, often taking them as lovers.

Mekrakramtî with an Akàkakô

This village elder is one of the last to wear a lip-plug, or akàkakô. It appeared to me that no one younger than fifty wore the akàkakô. Adorned in a headdress of macaw feathers and a necklace of monkey teeth, this mekrakramtî, or "father of many children," has reached the most senior age-grade.

Flamboyant oratory is a major activity of Kayapo men, and in past generations the akàkakô was a symbol of self-assertiveness and mature masculinity. The Kayapo radiate a self-confidence that other rainforest peoples have begun to adopt.

Brazilian Indians have much less political control than their North American counterparts. Until recently they have had to rely heavily upon pro-indigenous organizations, run by non-natives and foreigners, for support. It used to be Amazonian tribespeople tried to imitate Brazilians as much as possible when they ventured outside their own communities, but now they remain in full tribal adornment whenever visiting nearby towns and cities. In their struggle for survival, the Kayapo in particular have learned to deal effectively with the government and the press, and in so doing, they have become the foremost spokesmen of the embattled indigenous peoples of Brazil. Several tribal spokesmen have traveled overseas to plead their concerns about deforestation, mining, water pollution, and other large-scale developments proposed for their lands. The apogee of the indigenous movement came in 1989 when the Kayapo effectively protested the building of hydroelectric dams along the Xingu River.

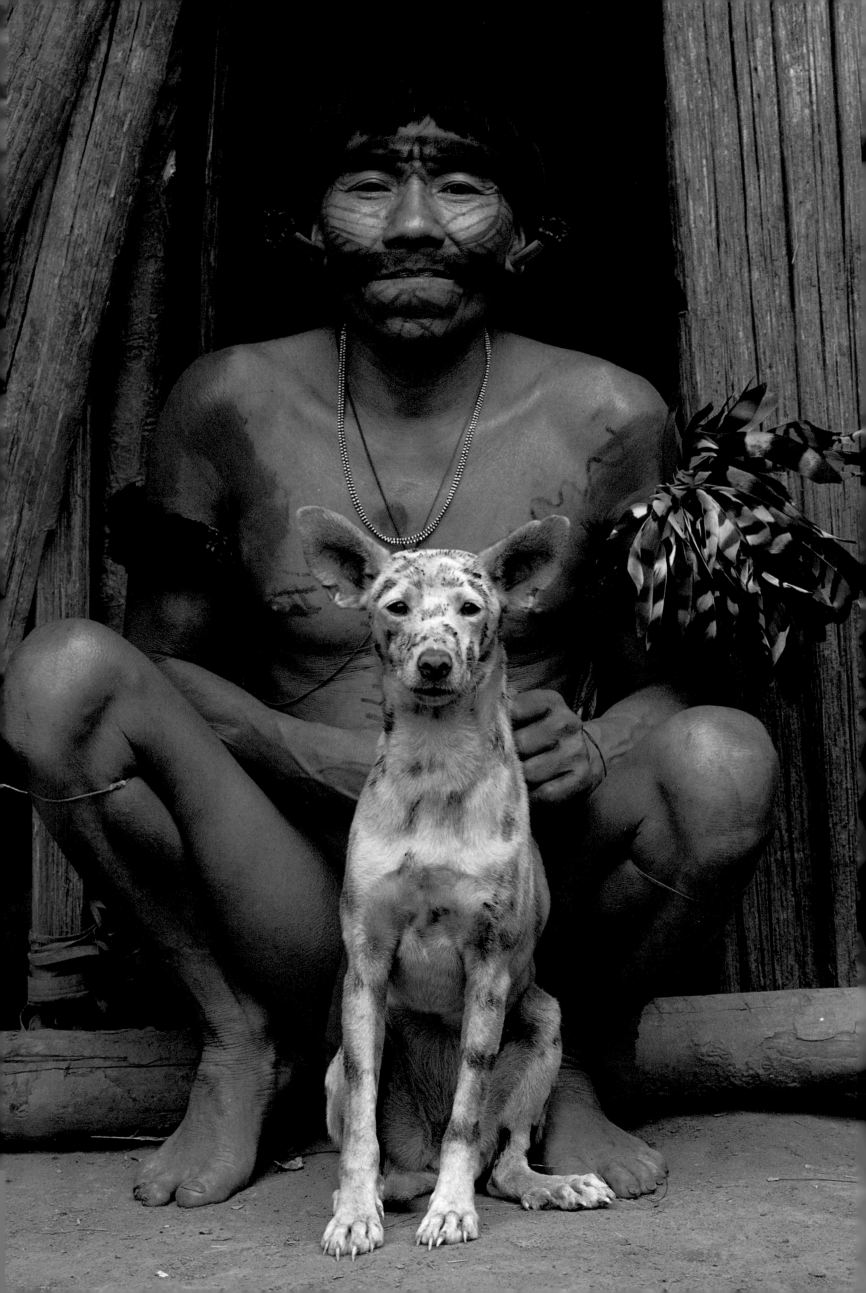

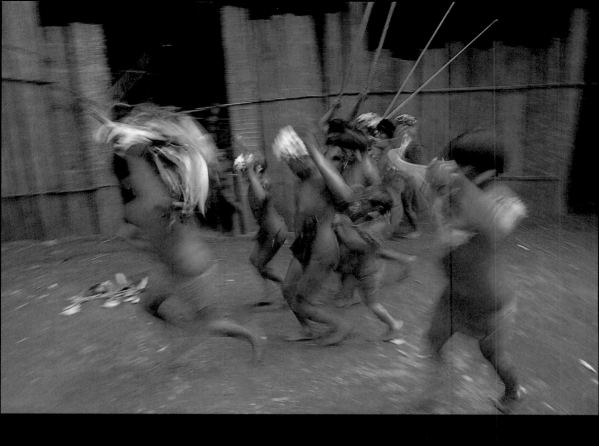

YĄNOMAMÖ WEDDING DANCE

(opposite) YĄNOMAMÖ MAN AND HUNTIG DOG

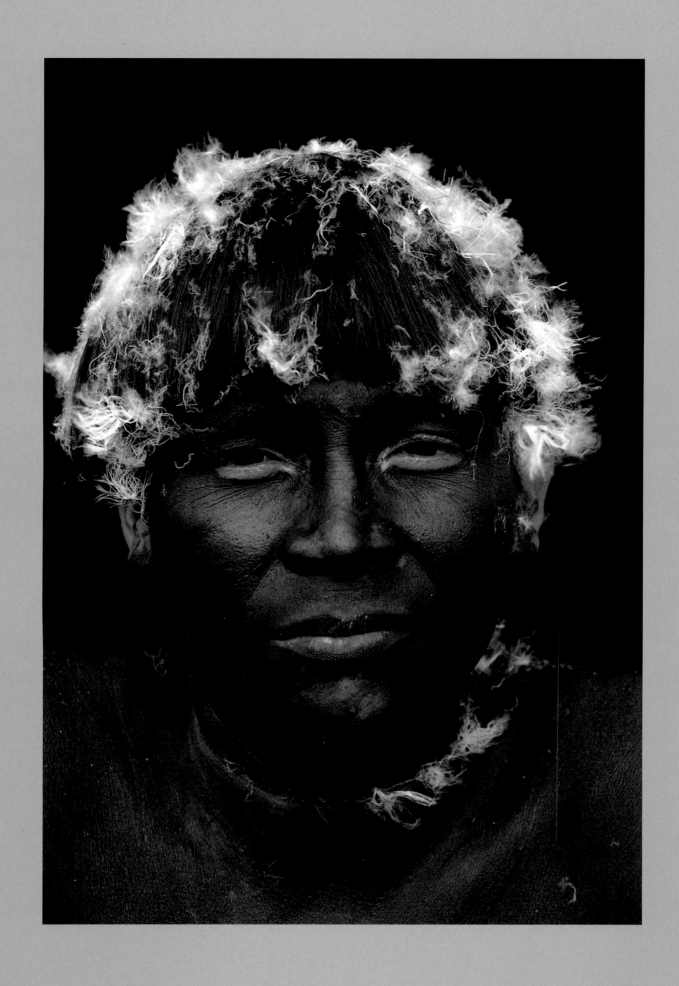

YĄNOMAMÖ MAN

(*opposite*) YĄNOMAMÖ BOY

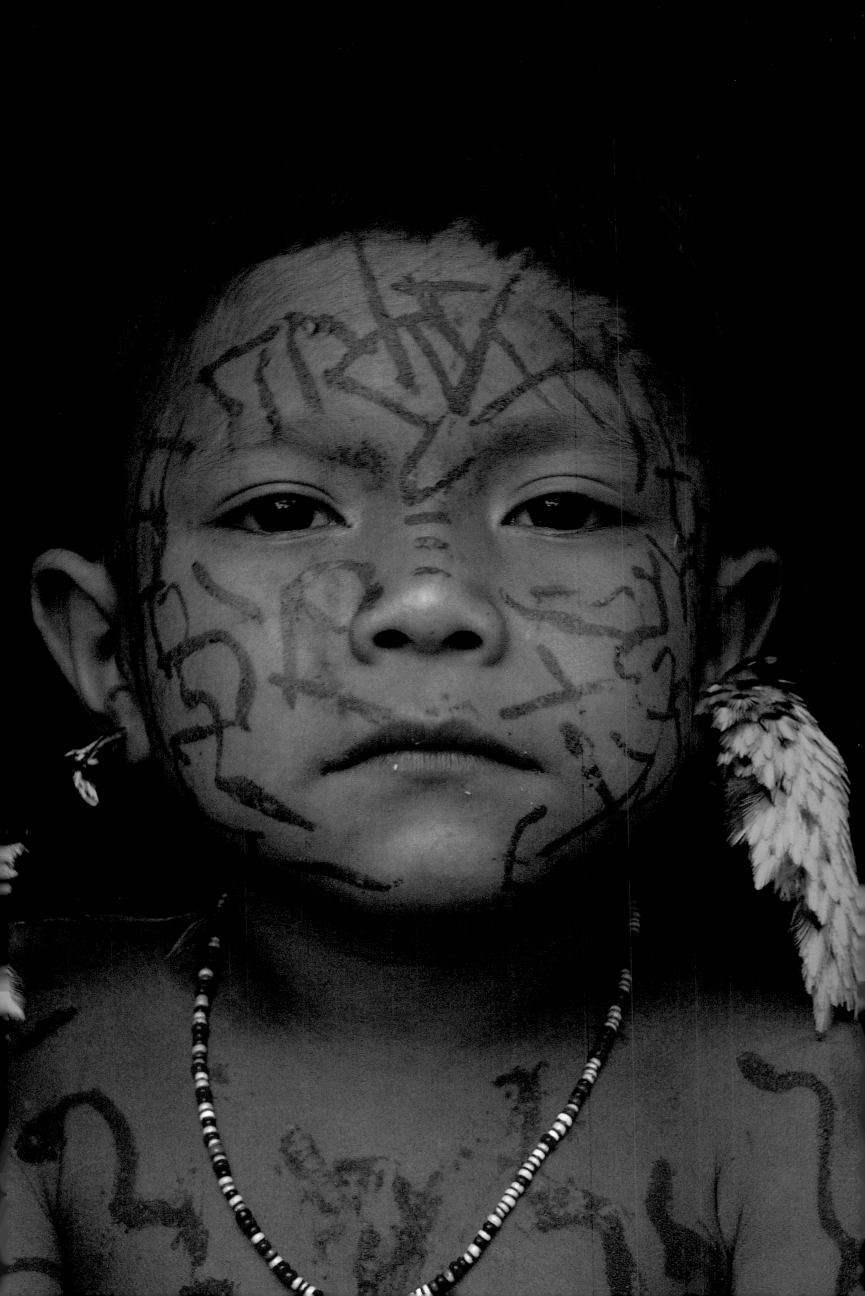

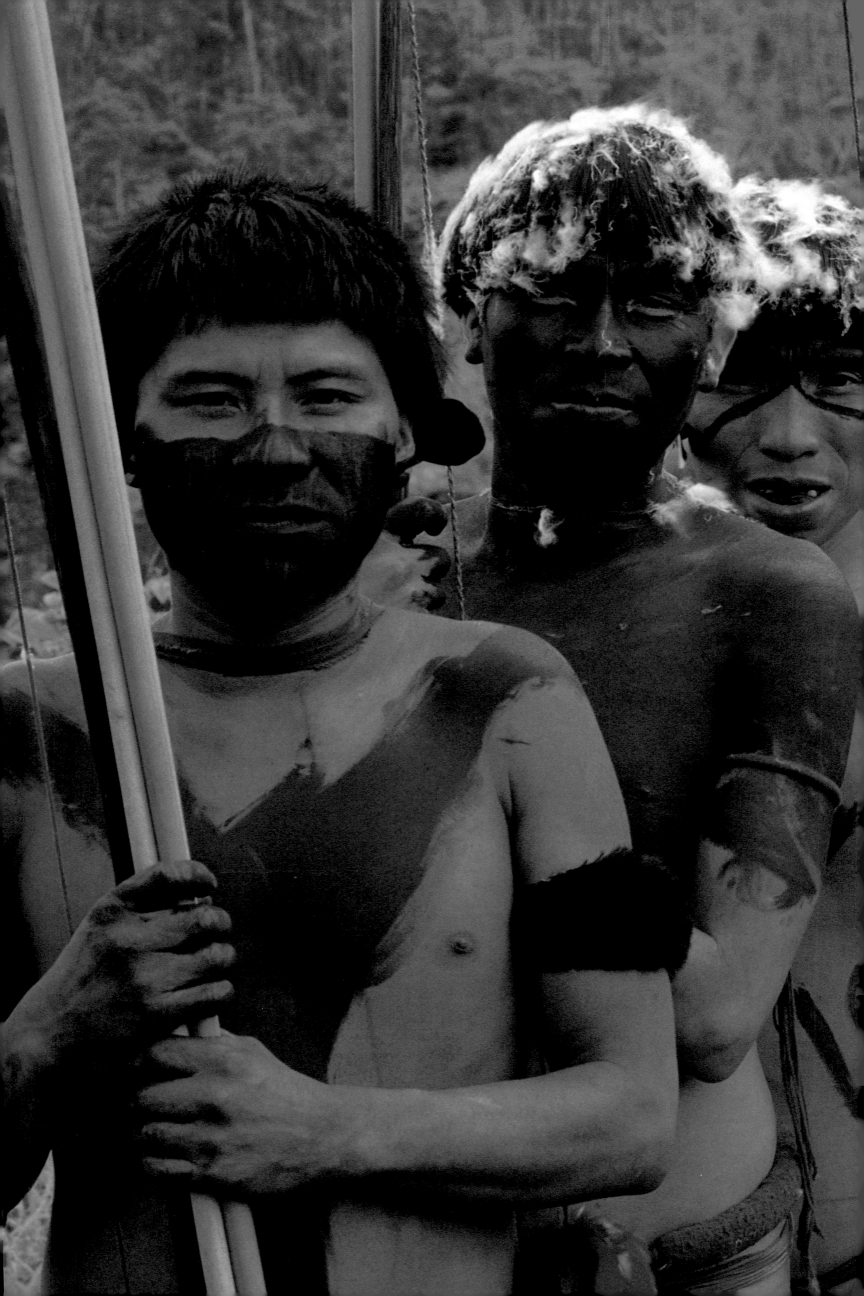

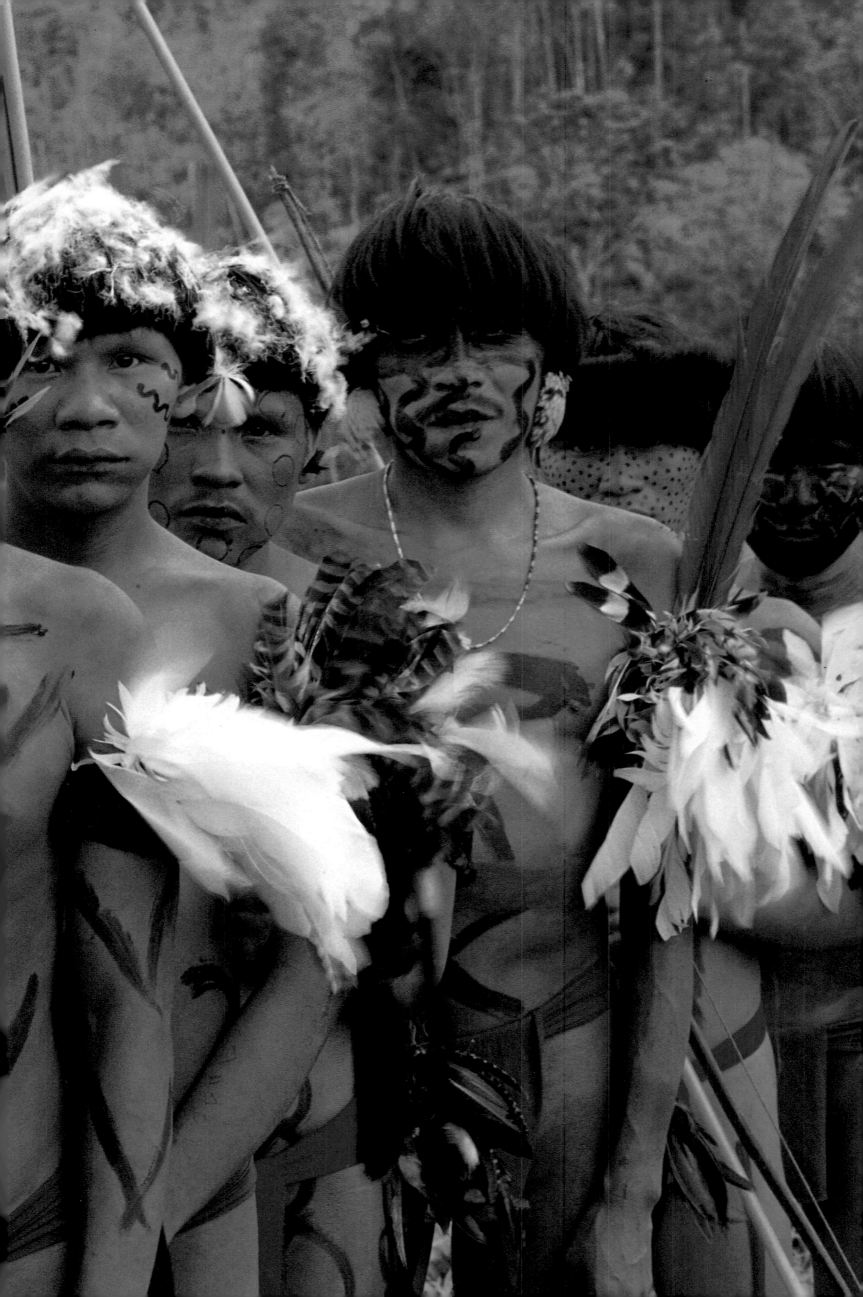

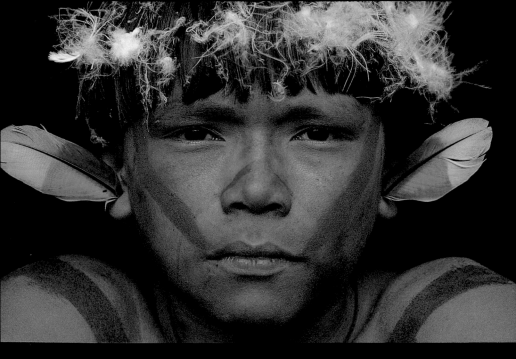

(top) YĄNOMAMÖ YOUTH

(bottom) ADORNMENTS AND TALISMANS

(opposite) YĄNOMAMÖ GIRL AND BLUE-HEADED PARROT

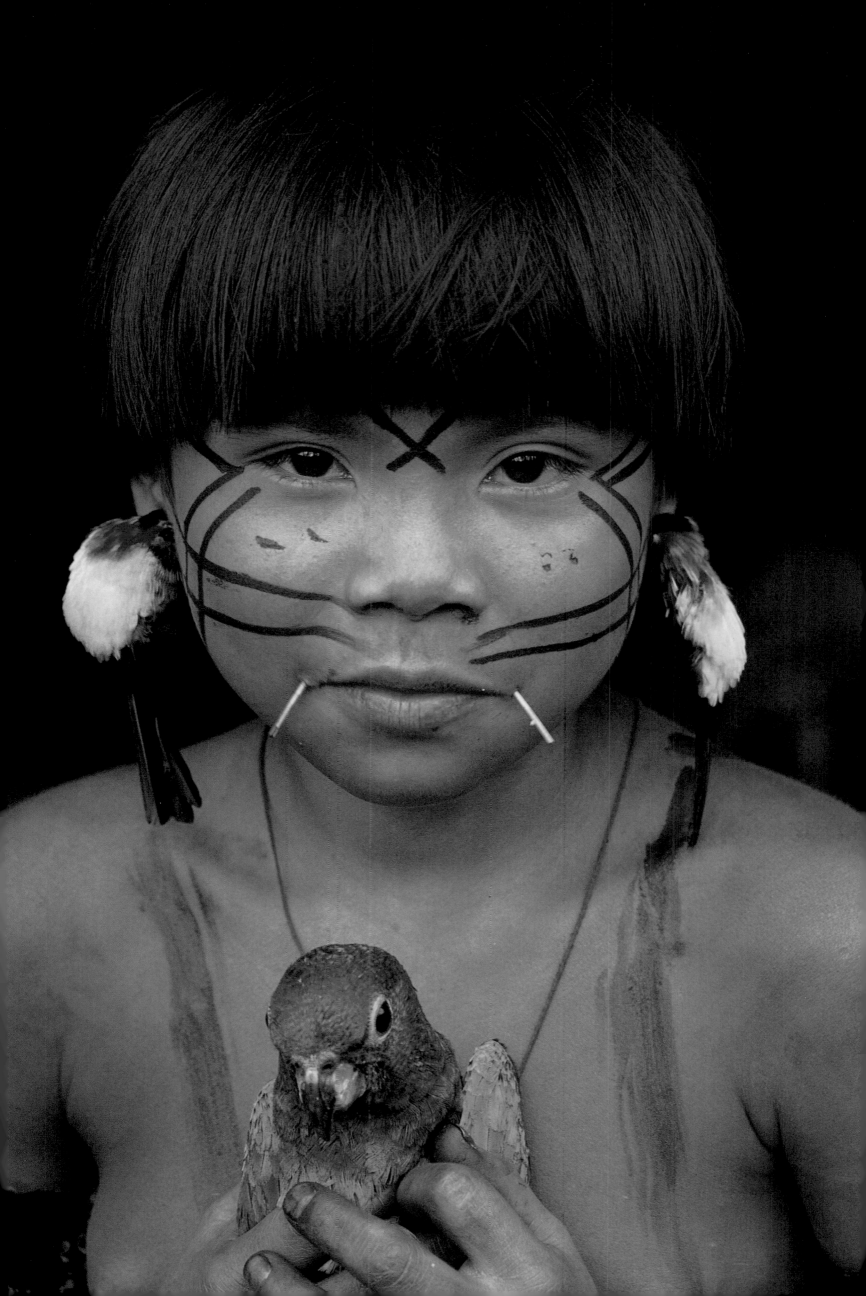

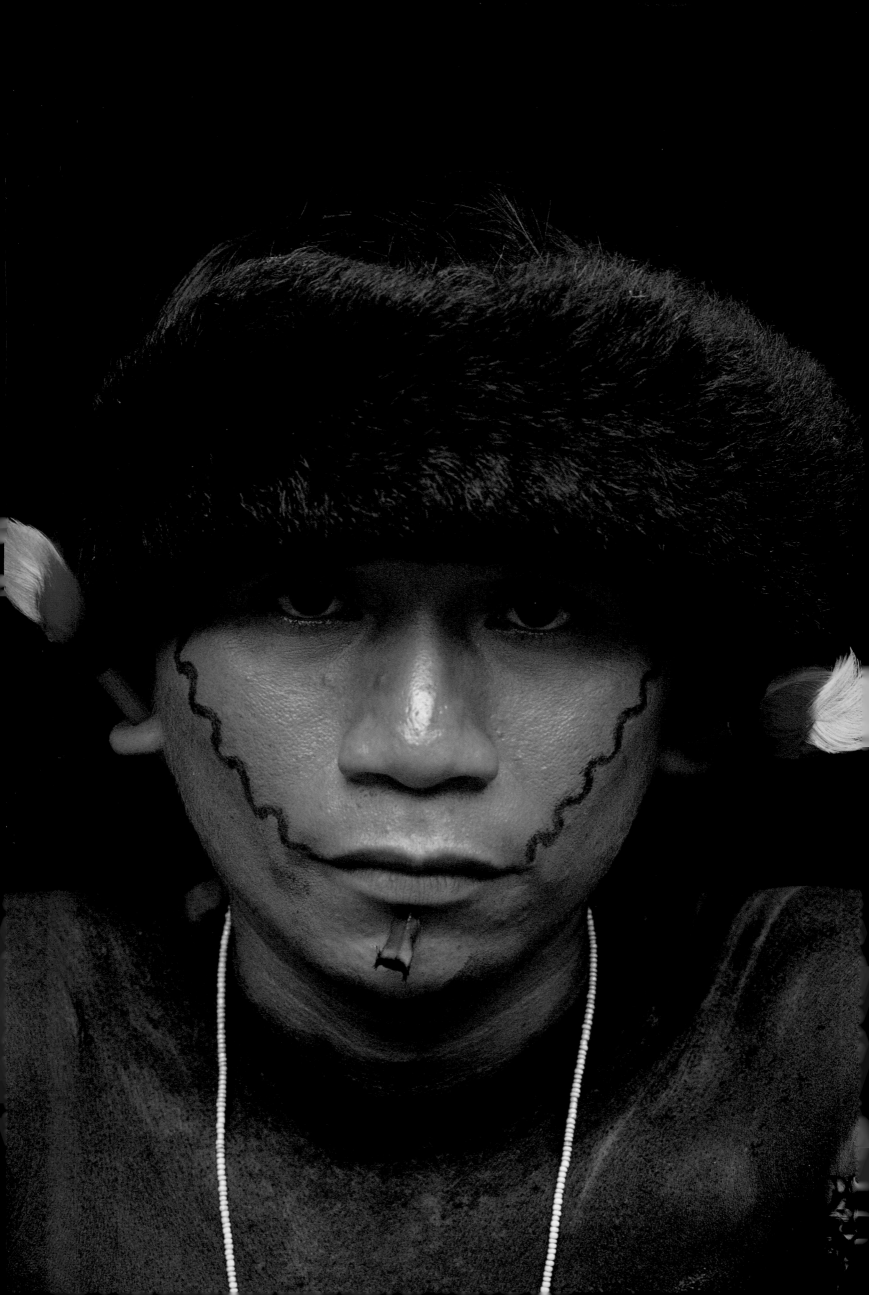

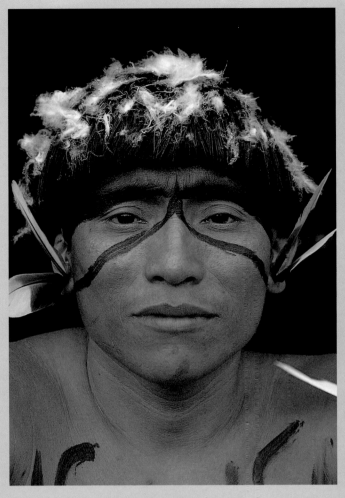
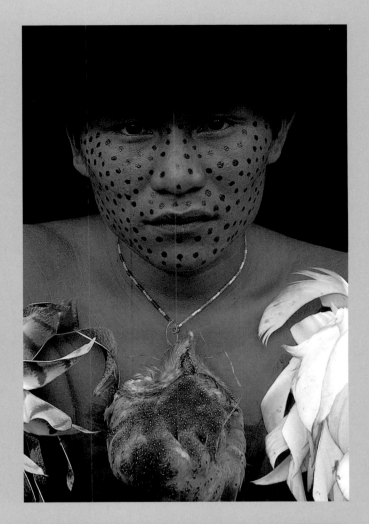
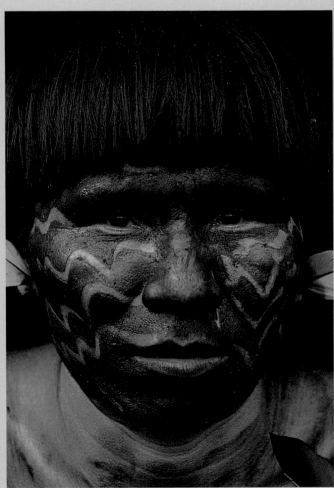
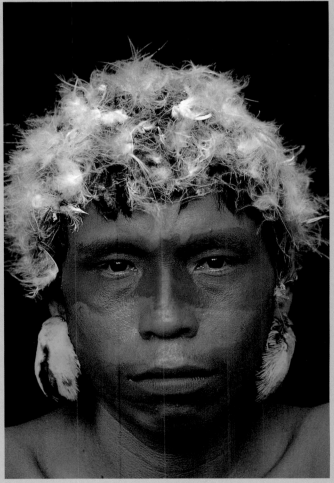

(opposite and above) YĄNOMAMÖ MEN

YĄNOMAMÖ HUNTER WEARING A TORA

(opposite) YĄNOMAMÖ WOMAN

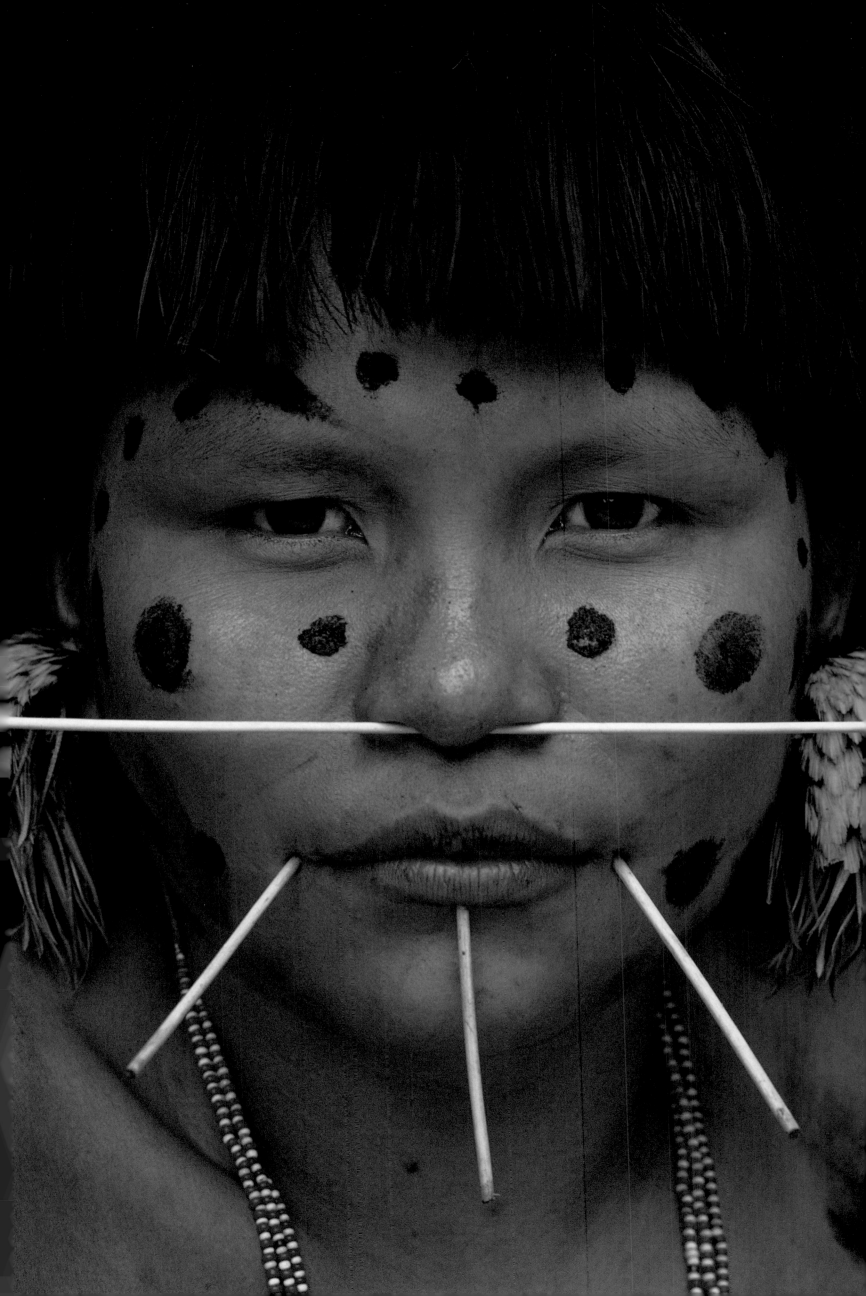

RIVERS blocked by cataracts and rapids, mountainous terrain blanketed by impermeable forests, the Sierra Parima proved to be an impenetrable wilderness until the advent of the small, single-engine aircraft. Straddling the border of Brazil and Venezuela, mesalike *tepuy* formations bulge from the forest cover and waterfalls cascade a thousand feet down their rough sandstone faces. This landscape has protected the Yąnomamö who live there, and they are among the last great unacculturated Indian tribes of Amazonia.

I have experienced many wild plane rides in my years of travel, but this one into the Parima highlands was truly terrifying. Not only was it a year soaked by record rainfall, but the pilot seemed to have a death wish. We bumped through dark, mean clouds pelting us with rain, and suddenly burst into clear sky. I had no idea how low we were flying until we sliced through one of these storm banks and were jetting straight into a sheer cliff; I was breathless with terror, but the pilot casually banked the plane and we rose over the mountaintop. For the remainder of the flight, I was under my seat.

We landed on a narrow airstrip traversing a small savanna, and after loading up our gear and gifts for the Yąnomamö, we hiked into the forest. It was a trek littered with the evidence that people had been there, but we saw no one until the forest opened into a clearing of cultivated plantains, manioc, yams, maize, and tobacco. Before us rose an impressive *shabono*, the great, circular building peculiar to the Yąnomamö. The shabono is built of many self-contained homes which are covered by a single, high, distinctively sloped, palm thatched roof.

The Yąnomamö have gained a reputation as the fierce denizens of the forest. This ferocity has been somewhat overstated, and the Yąnomamö both as individuals and as a population behave much as other societies do, with a modicum of wit, happiness, humor, and satisfaction with their lives. Nevertheless, they have a warrior tradition, believing one should never withdraw from conflict, and skirmishes are common between less-than-friendly villages. However, even this ferocity has not been able to protect them from Brazilian *garimpeiros*, hungrily seeking gold. The Venezuelan Yąnomamö have faired better, protected to a degree within the Parima-Tapirapecó National Park. I had to go through an extensive per-

missions process with the Venezuelan government, and my fellow traveler and I were accompanied by an anthropologist who indicated when and where we could photograph.

The Yąnomamö are a sylvan people in the strictest sense. Except for the tribes in the lower areas, they do not engage in any boating or river trade. They are perfectly adapted to their environment, being lithe and strong of build. The tallest man stood little over five feet.

The Yąnomamö material culture is simple and functional. Many items, such as elaborate basketry, are used in gift exchanges to solidify social ties between villages. They subsist on simple agriculture and hunting and gathering in the surrounding forests, staying in one place for around five years and moving on. Life in the shabono is close; hammocks slung around a smoky fire delineates a family space within the greater sphere, and these areas are always buzzing with activity. Adults play with children, chatting, decorating one another, and spinning, while men catch up on sleep lost while on a grueling hunt.

Impromptu celebrations may erupt at any time, but the Yąnomamö also take extreme care when preparing an elaborate feast for an allied village. Distances between tribes can be lengthy, so it is important for the rare gatherings to be properly attended to. These are political events and they are a rare chance for the host village to show generosity and hospitality in the maintenance of critical alliances. There is much feasting, dancing, and chanting.

Yąnomamö Tribesmen

The life of a Yąnomamö male is a harsh one. Intervillage warfare still occurs and a good percentage of all adults meet a violent end. Violence is not random and there are culturally important graded forms of aggression from verbal exchanges and chest-pounding to out-and-out shooting to kill. Some men are tonsured to show the scars from club fights of which they are very proud.

To lead a village in this rancorous environment, headmen are chosen by their wisdom, charisma, and most important, their kinship ties. Usually the head of the largest family in the shabono is so honored. The chief is not a tyrant, rather a greater among equals, and he must work like everyone else.

The Yąnomamö are incredibly skilled hunters, so skilled that the forest ringing the shabono was relatively silent. They are extremely accurate with their six-foot-long bows and equally long arrows tipped with curare poison. I was incredulous as I watched one man shoot a hummingbird at fifty feet. Their bows are made of dense, brittle palm wood and strung with bark twisted into thick cords. These cords are so strong that they double as hammock ropes in a pinch. The arrows are kept in a quiver, a *tora*, made from a section of bamboo. The hunter will carry in his tora arrow points, fibers, resin, and sometimes a magical charm.

The compact between man and beast is sacred; the Yąnomamö never kill more than they need for fear of the vengeful spirits of the dead animals. Every time they kill an animal or take produce from the forest, they believe they have incurred a debt which must be discharged. Also, a hunter will not eat what he himself has killed, as the spirit of the animal will avenge itself on him. He will eat only what other hunters have caught. The large animals of the rainforest are much prized. The taking of a fat tapir, peccary, deer, or giant anteater is cause for celebration, as is the finding of a cache of honey. If a hunter is slow to return to a village, it is often because he has found a hive and has had to go to great lengths to extract its sweet prize.

Hallucinogenic snuff called *ebene* allow the Yąnomamö shamans to invoke spirits, or *hekura*, to fulfill both benevolent and malevolent tasks. Hekura can be put to work curing an illness which has spread through the shabono or killing the children in an enemy village. Scraped from the inner bark of a tree, ebene is extremely potent; it is taken directly into a nostril, then blown by a companion through a cane tube. The initial sensation has been likened to having one's brains blown out; indeed, the pain is severe, causing many to double over and vomit. The recipient, however, is transported into the spirit-world for several hours, luring the hekura into his body so he can control them to do good and evil.

Though not in the same league as ebene, tobacco is a prized crop, and it will be the only section of the garden which will be fenced off. The faces of the Yąnomamö are forever transformed by a large, oblong wad of leaves rolled in their lower lip. Both men and women are addicted to it, and children have been documented as using it as well.

Yąnomamö Tribeswomen

It is a man's world among the Yąnomamö, and nowhere is this more evident than in the constant conflicts between men over women. Yąnomamö men take multiple wives so that, even if women marry earlier than men, they are always scarce and much disputed. Social dynamics are solidified by the giving and receiving of marriageable girls, and many girls have been promised long before they reach puberty.

A Yąnomamö woman's life is not an easy one. Her domestic chores are time-consuming and laborious, and she must readily cater to her husband. Wife-beating is not uncommon, and a woman must depend on her brothers for protection from a vicious husband. If a man is too severe with his wife, her family may take her away and give her to another man. To be married off to a distant village is a nightmare for a Yąnomamö girl, for she will not have the shield of her brothers. Women are hardly helpless, though. Some are closely related to and have the ear of influential men, while others band together to help protect each other. Mature wives and sisters have no fear of making their views clearly known. It is not the Yąnomamö way to back down.

As women age and their children grow into adulthood they gain respect; their children care for them and treat them well. Elderly Yąnomamö women are in the unique position of being immune from raiders and they can go from one village to another without fear for their lives. Because of this diplomatic immunity they are often employed as messengers and liaisons between villages.

Yąnomamö Children

Courage and confidence is taught to all ages and sexes, and nothing illustrates this better than the faces of these children. The little girl was exceedingly self-assured—an enigmatic smile decorating her face as she lightly held a blue-headed parrot to her breast. Displaying a hauteur reserved for the more mature, the young boy will be the chief of the village when he grows up, of this I am certain.

Children are much indulged and the shabono is their playground; they play at hunting, play at hearth-tending, and play with their pet monkeys and parrots. They scamper about, climbing the support poles and

rafters—good practice for later in life when they will go into the forest and hunt. At the age of five, boys will begin to accompany their fathers on the hunt, while the girls remain at the shabono to help their mothers cultivate the crops, weave, collect firewood, haul water, and care for their younger siblings. The children are hardly drudges, though; they are free much of the time to play in the river not far from the shabono.

Children are full-fledged biologists by the time they are twelve. They learn the Yąnomamö ways at the school of the rainforest, and they are able to recognize hundreds of plant and animal species, useful for food, medicine, drugs, poisons, dyes, and building and weaving materials, all things that allow them to survive in the rainforest.

The Yąnomamö hold that several spirits dwell within each child, chief of which comes from the father's sperm and lives in the child's chest, heart, and blood. A second spirit takes the form of an animal: harpy eagles for boys and weasels for girls. It is not surprising, therefore, that the hunting of these animals is forbidden. Children are particularly vulnerable to the harmful effects of magic sent from enemy shamans because their souls are not yet firmly implanted.

Nearly all tribes have rites of passage that young people must complete as they grow from childhood to adulthood. Not so the Yąnomamö. A girl's passage into womanhood is marked by her first menstruation, and she is confined for a week before settling into family life with a new husband. Boys have no ceremony marking the transition into manhood. The only clue that a boy is attempting to enter the world of men is the quick offense he takes at the use of his personal name. Adult men are only referred to by their kinship ties, and it is an insult to call them by their boyhood names.

Adornments of the Rainforest

The Yąnomamö are masters of adorning themselves with the flora and fauna of the rainforest, and I asked them to lay out some of the items on a mat of plantain leaves. Howler and spider monkey skulls are surrounded by toucan bills and tail-feathers, banded ariçari breasts, and waistbands woven of wild cotton. From the simple red-headed manakin worn in a hip string as a quotidian bauble, to full-blown ceremonial adornment of macaw feather armbands and intricate body painting, the Yąnomamö utilize everything available to them. When a toucan is plucked, its feathers to adorn the back of a hunter, the carcass is thrown like a chicken into a pot of boiling water. Hummingbirds are earrings, their narrow, curved beaks thrust through an earlobe.

The Yąnomamö will adorn themselves liberally with red bixin dye (the urucu of Brazil) on a daily basis. Black charcoal dyes are more unusual, used to indicate a state of mourning or as a display of bravery. Geometric designs follow the contours of the body; sometimes they are used to convey veiled messages between lovers or a courting couple. It is also believed that body painting affects the spirit world. Women and children pierce their lower lips and noses with sharp sticks, and personal elegance is enhanced by glass beads obtained through trade.

Men wear headbands of black spider monkey fur and stick parrot feathers in their earlobes. To make the soft white down of the curassow stick to their hair, they rub plantain peels on their heads. Adornment is hardly limited to this, though; one man wore a golden barn owl head suspended from a beaded necklace. Even prized hunting dogs are unable to escape decoration. One man dappled his white dog with dark charcoal and tawny earth, and then proudly posed with it in the shabono.

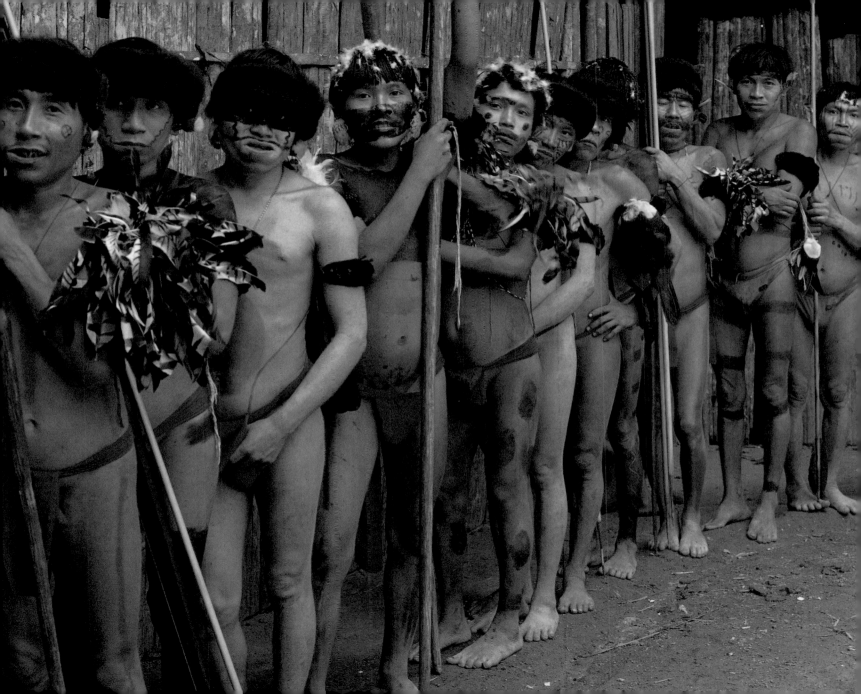

Bibliography

Allen, Tricia. *European Explorers and Marquesan Tattooing: The Wildest Island Style.* Honolulu: Hardy Marks Publications, 1991.

Anderson, Edward F. *Plants and People of the Golden Triangle: Ethnobotany of the Hill Tribes of Northern Thailand.* Portland, Ore.: Dioscorides Press, 1993.

Arden, Harvey. *Dreamkeepers: A Spirit Journey into Aboriginal Australia.* New York: HarperCollins Publishers, 1994.

Avea, Chief Sielu. *Tatau: The Art of Samoan Tattoo.* Honolulu: Sielu Enterprises, 1994.

Baker, Paul T., and Michael A. Little, eds. *Man in the Andes.* Stroudsburg, Pa.: Dowden, Hutchinson & Ross, 1976.

Barnard, Alan. "The Present Condition of Bushman Groups." Centre of African Studies, University of Edinburgh, Scotland, 1986.

Beckwith, Carol, and Angela Fisher. *African Ark.* New York: Harry N. Abrams, 1990.

Berntsen, John Lawrence. "Maasai and Iloikop: Ritual Experts and Their Followers." Occasional Paper #9, African Studies Program, University of Wisconsin, Madison, July 1977.

Birnbaum, Phil. *Faces of Papua New Guinea.* Darling-hurst, Australia: Emperor Publishing, 1990.

Boyes, Jon, and S. Piraban. *A Life Apart: Viewed from the Hills.* Bangkok: Silkworm Books, 1989.

Brown, Michael F. *Tsewa's Gift.* Washington, D.C.: Smithsonian Institution Press, 1985.

Burenhult, Goran. *Traditional Peoples Today: Continuity and Change in the Modern World.* San Francisco: HarperSanFrancisco, 1994.

Chagnon, Napoleon A. *Yanomamö: The Fierce People.* New York: Holt, Rinehart and Winston, 1983.

Cohen, David, ed. *Circle of Life: Rituals from the Human Family Album.* New York: HarperCollins Publishers, 1991.

Colchester, Martin, ed. "Health and Survival of the Venezuelan Yanoama, Document #53." Copenhagen: International Work Group for Indigenous Affairs, 1985.

Cotterell, Arthur. *The Macmillan Illustrated Encyclopedia of Myths and Legends.* London: Marshall Editions, 1989.

Davidson, Art, photos by Art Wolfe and John Isaac. *Endangered Peoples.* San Francisco: Sierra Club Books, 1993.

Drakakis-Smith, D. W. "The Long Walkabout: Aboriginal Urban Migrations in Central Australia," in *Tribes: Their Environment and Culture,* Maheshwari Prasad, ed. Delhi: Amar Prakashan, 1987.

Fisher, Angela. *Africa Adorned.* New York: Harry N. Abrams, 1984.

Glasse, Robert M. *The Huli of Papua: A Cognatic Descent System.* Paris: Mouton, 1968.

Heider, Karl G. *The Dugum Dani.* Chicago: Aldine Publishing, 1970.

Hirschfelder, Arlene, and Paulette Molin. *Encyclopedia of North American Religions.* New York: Facts on File, 1992.

Hopper, Janice H., ed. *Indians of Brazil in the Twentieth Century.* Washington, D.C.: Institute for Cross-Cultural Research, 1967.

Kennett, Frances. *Ethnic Dress.* New York: Facts on File, 1995.

Kirk, Malcom. *Man as Art: New Guinea.* New York: The Viking Press, 1981.

Leakey, L. S. B. *The Southern Kikuyu Before 1903.* New York: Academic Press, 1977.

Lederman, Rena. *What Gifts Engender: Social Relations and Politics in Mendi, Highland Papua New Guinea.* New York: Cambridge University Press, 1986.

Lowie, Robert H. "The Assiniboine" in *Anthropological Papers of the American Museum of Natural History,* vol. 4, pt. 1, Clark Wissler, ed. New York: Hudson-Fulton, 1909.

Markham, Beryl. *West with the Night.* San Francisco: North Point Press, 1983.

Matthiessen, Peter. *Under the Mountain Wall.* London: William Heinemann, 1962.

Maybury-Lewis, David. *Millennium: Tribal Wisdom and the Modern World.* New York: Viking Penguin, 1992.

McIntyre, Loren. *Exploring South America.* New York: Clarkson N. Potter, 1990.

McKnight, David. *Lardil: Keepers of the Dreamtime.* San Francisco: Chronicle Books, 1995.

Mitton, Robert. *The Lost World of Irian Jaya.* Melbourne, Australia: Oxford University Press, 1985.

Muriuki, Godfrey. *A History of the Kikuyu 1500–1900.* Nairobi: Oxford University Press, 1974.

Niethammer, Caroline. *Daughters of the Earth: Lives and Legends of American Indian Women.* New York: Collier Books, 1977.

Pavitt, Nigel. *Samburu.* London: Kyle Cathie, 1991.

Ramitanondh, Shalardchai, and Virada Somswasdi. "Impact of Deforestation and Reforestation Program on Household Survival Strategies and Women's Work: The Case of the Karen and Lisu in a Village of Northern Thailand." Women's Studies Center, Chiangmai University, Chiangmai, Thailand, 1992.

Ricciardi, Mirella. *Vanishing Amazon.* New York: Harry N. Abrams, 1991.

Rohde, David. "Australia's Aboriginal Policy Faulted" in *Christian Science Monitor* 87: 104, April 25, 1995.

Rosenberg, Donna. *World Mythology.* 2nd ed. Chicago: NTC Publishing, 1994.

Ruby, Robert H. and John A. Brown. *Indians of the Pacific Northwest.* Norman, Okla.: University of Oklahoma Press, 1981.

Simmons, D. R. *Ta Moko: The Art of Maori Tattoo.* Auckland, New Zealand: Reed Methuen, 1986.

Smole, William J. *The Yanoama Indians: A Cultural Geography.* Austin, Texas: University of Texas Press, 1976.

Strathern, Andrew J., photos by Phil Birnbaum. *Faces of Papua New Guinea.* Darlinghurst, Australia: Emperor Publishing, 1990.

Sweet, Jill D. *Dances of the Tewa Pueblo Indians.* Santa Fe, N.M.: School of American Research Press, 1985.

Tanaka, Jiro. *The San: Hunter-Gatherers of the Kalahari, a Study in Ecological Anthropology.* Tokyo: University of Tokyo Press, 1980.

Tapu, Talalelei. "The Tattoo Ritual in Samoa," in *Pacific Rituals: Living or Dying?* Gweneth and Bruce Deverell, eds. Suva, Fiji: University of the South Pacific, 1986.

Taylor, Colin F., ed. *The Native Americans: The Indigenous People of North America.* London: Salamander Books, 1991.

Thomas, Nicholas. *Marquesan Societies: Inequality and Political Transformation in Eastern Polynesia.* New York: Oxford University Press, 1990.

Tomatis, Claudio. *The Jade Sea.* Milan, Italy: self-published, 1992.

Turton, David. "The Mursi and National Park Development in the Lower Omo Valley," in *Conservation in Africa,* D. Anderson and R. Grove, eds. Cambridge, England: Cambridge University Press, 1987.

———. "Movement, Warfare and Ethnicity in the Lower Omo Valley," in *Herders, Warriors, and Traders: Pastoralism in Africa,* John G. Galaty and Pierre Bonte, eds. Oxford, England: Westview Press, 1991.

———. "'We Must Teach Them to Be Peaceful': Mursi Views on Being Human and Being Mursi," in *Nomadic Peoples* 31: 1992.

Verswijver, Gustaaf, ed. *Kaiapo: Amazonia: The Art of Body Decoration.* Ghent, Belgium: Snoek-Ducaju and Zoon, 1992.

Verswijver, Gustaaf. *The Club-fighters of the Amazon: Warfare Among the Kaiapo Indians of Central Brazil.* Ghent, Belgium: Rijksuniversiteit te Gent, 1992.

Villas Boas, Orlando, and Claudio Villas Boas. *Xingu: The Indians, Their Myths.* New York: Farrar, Straus & Giroux, 1973.

Waldman, Carl. *Atlas of the North American Indian.* New York: Facts on File, 1985.

———. *Encyclopedia of Native American Tribes.* New York: Facts on File, 1988.

Index

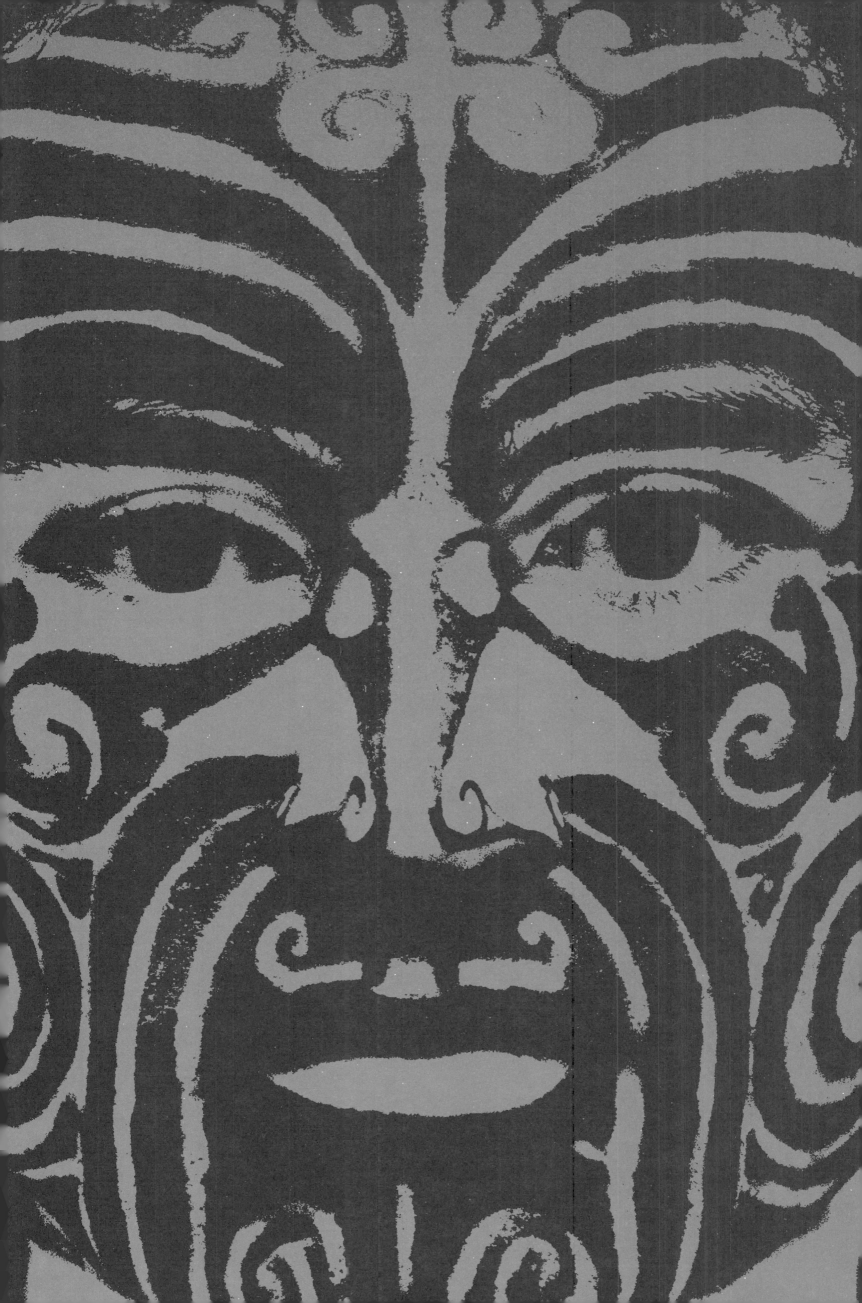

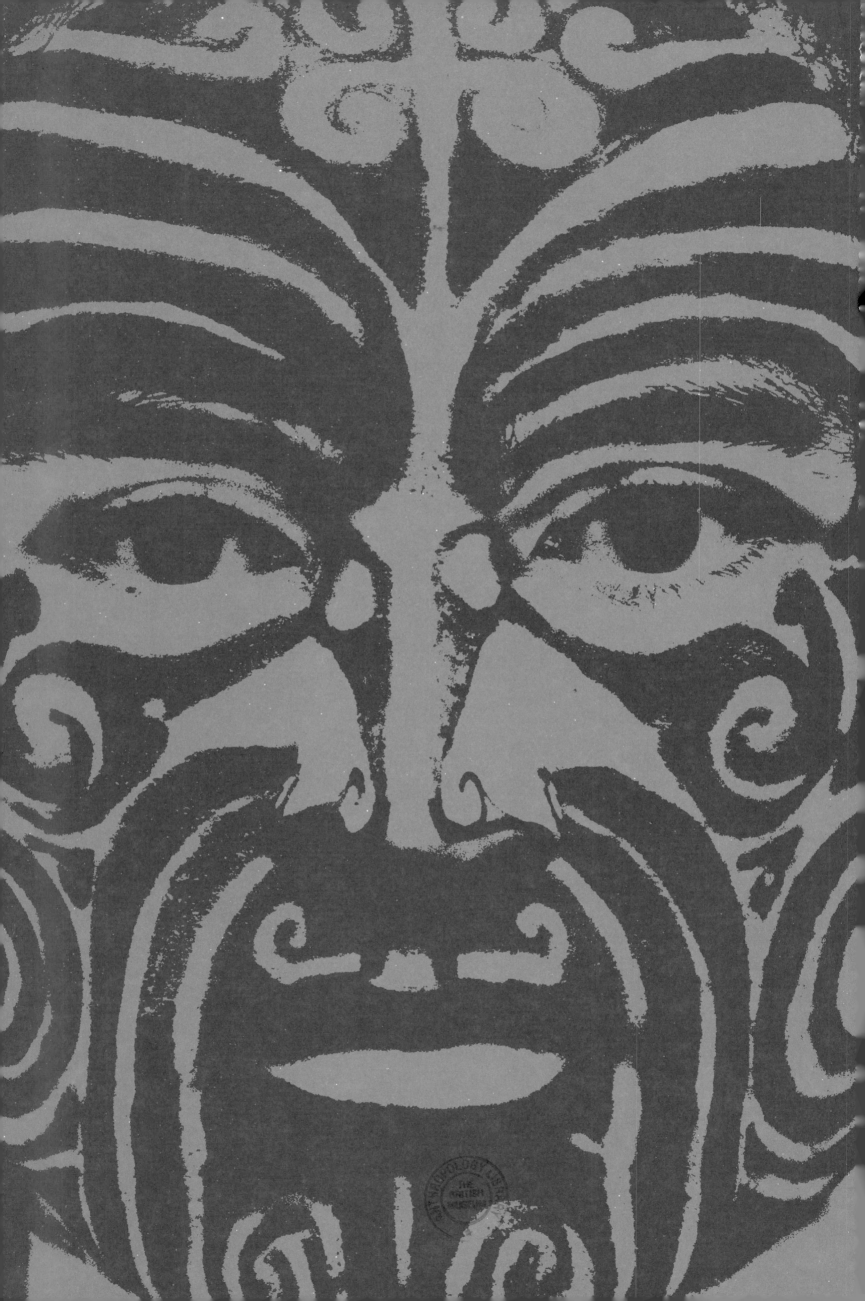